THE
NATURAL
HISTORY OF
UNICORNS

THE
NATURAL
HISTORY OF
UNICORNS

Chris Lavers

wm

WILLIAM MORROW
An Imprint of HarperCollins*Publishers*

Originally published in Great Britain in 2009 by Granta Books.

The illustration credits on pp. 249-250 constitute an extension of this copyright page.

HarperCollins books may be purchased for educational, business, or sales promotional use. For information please write: Special Markets Department, HarperCollins Publishers, 10 East 53rd Street, New York, NY 10022.

FIRST U.S. EDITION

Library of Congress Cataloging-in-Publication Data is available upon request.

ISBN 978-0-06-087414-8

09 10 11 12 13 RRD 10 9 8 7 6 5 4 3 2 1

For Rita and Peter

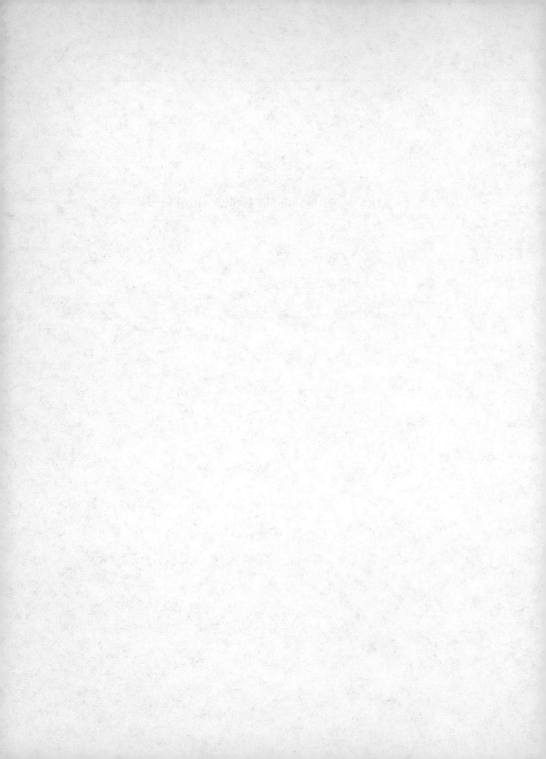

There are two things to avoid in dealing with a legend. The first is to make too much of it, the other is to disbelieve it entirely.

Harold Mellersh (1967)

CONTENTS

LIST OF ILLUSTRATIONS

INTRODUCTION

The unicorn in your head depends on your background. If you are steeped in the Christian tradition you may conjure up a small, gentle, goatlike animal, perhaps cradled in a woman's lap. If your upbringing was secular you may imagine a muscular, noble, equine creature, perhaps facing a lion on a coat of arms. If you have read your children to sleep or dallied with New Age mysticism your unicorn is most likely a soft-focus, airbrushed, magical beast, perhaps with a crystal about its person. At once we see that the unicorn has different faces. It has more than it presently shows.

Unicorn scholarship is almost as old as the beast itself, and what a tangled mess it is. Many have tried to track the unicorn's progress, and a few have glimpsed madness along the way. No attempt at a complete history will be found here. This book has more modest goals: to say a few things about the unicorn that have not been said before – on reflection, quite an ambitious aim – and to draw attention to the myth's natural history. Many animals have been caught up in the unicorn's story. The Indian rhinoceros, that archetypal one-horned quadruped, can often be seen in the beast's shadow. Most people know which animal supplied the unicorn's horn. But who

would have thought that the unicorn was related to the walrus? Or the mammoth? Or the orang-utan? On the fringes of the unicorn's tale lurk animals that are fascinating in themselves, and whose connections with our myth-making reveal much about our engagement with the natural world.

So to follow the unicorn is to track one aspect of mankind's progress across 2500 years. It is a windy road with many charming vistas, and many strange ones. Before stepping out on it let us deal with one negative expectation that might otherwise spoil the journey. For most of recorded history people thought that the unicorn existed. Recently we have come to know that it never did. So this book must end in disappointment. Not so. Unicorns did exist. There are photographs.

CHAPTER 1

A one-horned ass

A curious account of a one-horned beast was written in 398 BC or thereabouts by Ctesias of Cnidus. To this man we owe a legend that has lasted in the Western imagination for more than 2000 years.

There are in India certain wild asses which are as large as horses, and larger. Their bodies are white, their heads dark red, and their eyes dark blue. They have a horn on the forehead which is about a foot and a half in length. The base of this horn, for some two hands'-breadth above the brow, is pure white; the upper part is sharp and of a vivid crimson; and the remainder, or middle portion, is black. Those who drink out of these horns, made into drinking vessels, are not subject, they say, to convulsions or to the holy disease [epilepsy]. Indeed, they are immune even to poisons if, either before or after swallowing such, they drink wine, water, or anything

1

else from these beakers. Other asses, both the tame and the wild, and in fact all animals with solid hoofs, are without ankle-bones and have no gall in the liver, but these have both the ankle-bone and the gall. This ankle-bone, the most beautiful I have ever seen, is like that of an ox in general appearance and in size, but it is as heavy as lead and its colour is that of cinnabar through and through. The animal is exceedingly swift and powerful, so that no creature, neither the horse nor any other, can overtake it. When it starts to run it goes slowly but it gradually increases its speed wonderfully, and the further it goes, the swifter. This is the only way to capture them: when they take their young to pasture you must surround them with many men and horses. They will not desert their offspring and fight with horn, teeth and heels; and they kill many horses and men. They are themselves brought down by arrows and spears. They cannot be caught alive. The flesh of this animal is so bitter that it cannot be eaten; it is hunted for its horn and ankle-bone.[1]

Little is known for certain about Ctesias, but stitching together biographical fragments reveals the basic picture of his life.

Ctesias was a Greek native of Caria, a region in the far southwest

1 Shepard (1930).

of present-day Turkey, who spent nearly two decades in Persia, an empire centred on what is now Iran. Persia and Greece had a bloody history, the former having narrowly failed to overrun the latter in the Greco-Persian War of 490 to 479 BC. Though the two sides signed a truce in 449 BC it was never an easy one, and power struggles over settlements on Asia's Mediterranean coast were commonplace. Ctesias was probably captured during one such dispute, but records are so vague that we cannot be sure even of that. Whatever the circumstances Persia had been gifted a prize, for Ctesias was a physician with an impeccable provenance: his home town of Cnidus was a renowned centre of medical learning in the ancient world. While resident in Persia Ctesias ministered to the king and his court. From this we may surmise that he was highly respected, because the king of Persia, the most powerful man in the world, commanded the services of the best.

Like his more famous predecessor Herodotus, Ctesias had a characteristically Greek curiosity about exotic peoples and places, and when not attending kings and courtiers seems to have had the time and freedom to conduct a lot of what he considered to be, and later presented as, research – though not everyone since has rated his efforts as highly. So intrigued was he about Persian and Assyrian history that he amassed enough material to write twenty-three chapters on the subject. And his curiosity stretched much further. At the eastern edge of Persia's domain lay a land that was the most fascinating and magical of all: India. Greece was the pinnacle of literate culture

in 400 BC and Persia the powerhouse of international politics, but far-away India was, by the few reports of it, a tangle of wonders beyond imagining.

Though fascinated by everything Indian, and in spite of the opportunities offered by Persia's eastern borders, Ctesias never visited the subcontinent. Perhaps his medical duties prevented him from going. More realistically, Ctesias seems to have been a library type of fellow, a note-taker, a story-sponge, and not an adventurer.

Picture Ctesias rummaging in the Persian state archives, uncovering history never before seen by a Greek. Imagine him wandering wide-eyed through the streets of the Persian capital: everywhere the chatter of strange languages. If only he could understand what was being said, all the knowledge of the East would be his. Perhaps Ctesias' employers granted him their interpreters to indulge his intellectual hobbies, or perhaps he hired interpreters himself; either way, from Persian officials who had visited India, from Indian traders, from visitors to the royal court, Ctesias' knowledge of the lands beyond even Persia's influence grew and grew.

In 398 or 397 BC Ctesias returned to the Mediterranean. Perhaps homesickness finally overcame him. At last he had time to write up his research. His magnum opus was on the history of Persia. He also wrote a few minor works, known to us only from fragments reported by later authors. And then there was *Indica*, a rich and

strange mish-mash of Eastern geography, zoology, botany, medicine, anthropology and nonsense that has enchanted and infuriated scholars ever since.[2] In *Indica* Ctesias describes dog-faced people, fountains filled with liquid gold, mountain-dwelling griffins, tribes of one-legged men, pygmies with genitals hanging down to their ankles, and much else of wonder besides. Not surprisingly, scholars throughout history have branded Ctesias a fantasist and liar. If the nonsense in *Indica* came from Ctesias' imagination then the good doctor was indeed a fantasist and liar, but if he simply wrote down exotic travellers' tales we must judge him an honest, if perhaps slightly gullible, reporter.

It turns out that many of Ctesias' stories can be traced to Indian epics, sacred writings, folk-tales, and real animals and plants. Tellingly, when he writes about real things he usually does a good job. His account of the elephant is quite precise. He also describes a brightly coloured bird that he had heard speaking 'Indian', and spec-

2 *Indica* is a mess of a book. Had a faithful copy of the original survived perhaps it would have made more sense, but the most substantial version that has come down to us is a summary written 1300 years after the fact by Photius, leader of the Christian Church in Constantinople. Photius (or his literary predecessors) probably transcribed the interesting bits of *Indica* and left out some of the more pedestrian passages, an effective method of summarizing that would make a hash of any book. Fortunately, the passages of most interest to us must also have interested Photius, because he appears to have copied them out in full. Had he been less diligent the 2500-year history of the unicorn would have been very different.

ulates that the animal might have been able to speak Greek. Ctesias is describing a parrot, and doing it rather well. And even when he is inaccurate we can sometimes see through his mistakes. The giant toothed worm that lives in the mud of river beds by day and devours cows and camels by night is probably a crocodilian of some sort. The fearsome martikhora is as big as a lion, has a face like a man's and a tail like a scorpion's from which it fires stings. Absurd until martikhora is translated into Greek, whereupon it becomes man-eater. Ctesias goes on to say that these animals are numerous in India and hunted by natives riding on elephants. The martikhora would appear to be a tiger, or rather a cautionary tale about tigers that Indians employed to discourage children from playing within sting-range of the forest.

Experience has taught scholars that Ctesias, like other writers of antiquity, should be given the benefit of the doubt. But *Indica* is so rich in tales, some very tall indeed, that Ctesias' reputation hangs in the scholarly balance. For all the special pleading about elephants, parrots, crocodiles and tigers, the fact remains that Ctesias writes of the unicorn, and every child knows that unicorns do not exist. Where did this account come from? Did Ctesias make it up? If not, who did? And is it possible that, like the tale of the martikhora, it isn't made up? Perhaps we can use Ctesias' words to track the unicorn to its lair.

The best attempt at explaining Ctesias' ass was published in 1930 by the American Pulitzer Prize-winner and professor of English Odell

Shepard.[3] After ingenious detective work, Shepard concluded that the one-horned ass is a chimera, a composite beast forged from three little-known but real creatures. Shepard's approach was right but his conclusions probably awry. Let us follow his reasoning, amending as we go.

The first animal of the trinity is hiding in Ctesias' description of the single horn and the beast's great speed. In these elements Shepard saw the looming figure of the Indian rhinoceros (Fig. 1.1). Of the big three rhinoceros species, Indian rhinos from Nepal, Bhutan and northeast India are the least familiar to most people in the West; they have one horn on the tips of their noses, whereas African rhinos have two. A foot and a half (46 cm) is long for the horn of an Indian rhino – 6–18 in is the range, though 18-in horns are very rare – but the supposed medicinal and poison-neutralizing properties of rhino horn match Ctesias' description well. We also know that rhino horn was made into the sort of cups that Ctesias describes, some of which still exist in museums around the world. These animals were more

3 Shepard worked briefly at Harvard University in 1916–17, but spent most of his career (1917–46) at Trinity College, Hartford, Connecticut. His were the days when professors had the time and breadth of knowledge to engage in work outside their main specialist areas. Shepard wrote a biography of Bronson Alcott that earned him the Pulitzer Prize, the definitive treatise on the unicorn in the English language, several collections of poems, a novel and a fishing guide. He was also lieutenant governor of Connecticut between 1940 and 1943. He died there in 1967.

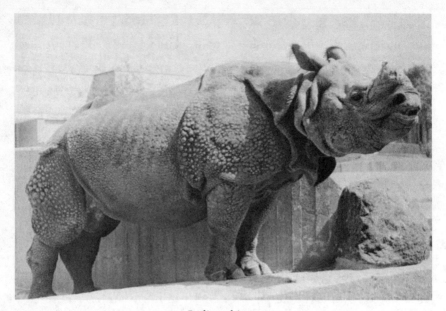

1.1 Indian rhinoceros

widespread in Ctesias' time than they are now, so travellers familiar with Asia may also have been familiar with rhinoceroses, or more likely with stories about them.

The gaudy colours of the horn described by Ctesias – red, white and black – do not fit the rhinoceros, but then they do not fit the horns of any other animal either. Odell Shepard thought that cups made from rhino horn may once have been decorated in red, white and black for religious reasons. Or perhaps Ctesias had seen paintings and textiles showing rhinoceros-horn cups tinted with the disregard for nature's subtleties so typical of Indian and Chinese art. Whatever

8

the reason for Ctesias' choice, authors of Roman times, whom we shall meet in the next chapter, begged to differ about the form and colour of the Indian ass's horn, and came closer to an accurate description of the real thing.

Shepard also thought that the rhino lurks behind Ctesias' claim that the Indian ass increases its speed as it runs. He calls this 'a closely observed trait of the rhinoceros' but, typically, adds no further explanation (Shepard was a literary scholar and charmingly self-deprecating character, who was fully aware of the dangers of studying natural history in a library; were he in a position to do so he would happily admit that zoology was not his strongest suit). Rhinoceroses do indeed speed up as they run, but then so do all animals: there would be no point running otherwise. However, big animals tend to have a low rate of acceleration, because it takes time and effort to propel a heavy body forward. And the speed at which a large mammal enters its fastest gait is roughly proportional to the square-root of its leg length, which is to say that short-legged animals gallop while moving quite slowly. A rhinoceros needs time to get its big body moving, and its short legs force it to gallop at low speed. Since its quickest gait is a gallop, a rhino has no choice but to accelerate steadily while galloping until it is running as fast as it can.

This drawn-out rhinocerine style of running perhaps led Shepard to his conclusion. But weight limitations apply to all heavy land animals, including some that, like rhinos, live in northern India (the Indian elephant, for example), while other Asian animals have big

bodies and relatively short legs. All things considered, there is no particularly good reason for singling out the rhinoceros as the archetypal heavy, stumpy animal.

Ctesias' claim that the Indian ass outruns horses does not sit comfortably with the rhinoceros either: speeds of 25–45 km/h are typical for rhinos, compared with 70 km/h for horses and wild asses. Ctesias also refers to the one-horned ass in the plural when describing its behaviour – 'when they take their young to pasture you must surround them with many men and horses. They will not desert their offspring . . .' – which suggests an animal that forms herds or family groups. Indian rhinoceroses do occasionally form small groups, but in general these creatures are even more solitary than their ungregarious African cousins.

And there is a more fundamental reason for being wary of the rhinocerine characteristics of Ctesias' ass. Both the Greek polymath Aristotle and the Roman encyclopaedist Pliny used Ctesias' *Indica* as a source for their own writings, yet neither man mentions the medicinal qualities of the ass's horn. Pliny in particular, who read everything, and who was attracted to matters of a medical nature, and even more to matters of a fantastical nature, would surely have noticed that the horn of Ctesias' beast had curative powers. Did Aristotle and Pliny overlook this aspect of Ctesias' text? Or was this aspect of Ctesias' text not there when Aristotle and Pliny read *Indica*? As argued forcefully by A. H. Godbey in 1939, it is quite possible that the antitoxic and medicinal properties of the ass's horn were

added to *Indica* by a later copyist, perhaps one who believed that Ctesias had tried to describe a rhinoceros. Godbey's work is notably partial, but his opinion is reasonable in this instance, and if it is correct there is even less room for the rhinoceros in Ctesias' description.

All in all it seems unlikely that the Indian rhino contributed much to Ctesias' account of the unicorn, despite Odell Shepard's analysis. The pharmaceutical properties of the Indian ass's horn do call to mind a rhino, but everything else is wrong. The horn is too long and its owner is too gregarious and too fast; rhinos do not fight with their teeth and heels either, and any hunter who tried to bring down a rhinoceros with an arrow would be in for a nasty surprise. A bit of rhino may have been in Ctesias' original description, and a bit more may be in the version that has come down to us, but for such a big animal it manages to hide itself remarkably well.

Curiously, only one aspect of the Indian ass's supposedly rhinocerine nature troubled Odell Shepard: Indian rhinos have horns on their noses, not on their foreheads. Had Ctesias' informant described an African rhinoceros he may well have placed a horn near the animal's forehead, because African rhinos have two horns, one of which is set back towards the eyes; but in describing the horn of the rhinoceros from his homeland, Ctesias' Indian source would surely have pointed to his own nose.

Odell Shepard had to explain how a horn ended up on the forehead of Ctesias' ass. He did so by invoking the second of his trinity of animals, the Tibetan antelope or chiru (Fig. 1.2). This enigmatic

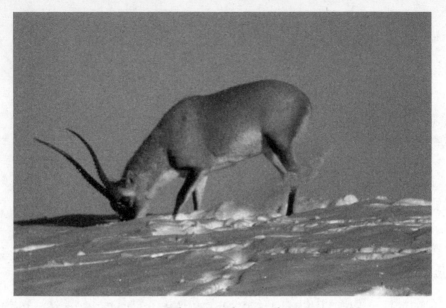

1.2 Tibetan antelope or chiru

creature, now known to be a goat rather than an antelope, is the basis of a persistent legend about a one-horned beast of Himalaya, documentary evidence of which dates back to the time of Genghis Khan (early thirteenth century AD). Chiru stand 80 cm at the shoulder, weigh 40 kg or so, and males have straight black horns rising almost vertically from their heads. These horns, 'considered by some to be the most beautiful in existence' according to the early twentieth-century British soldier and game hunter Captain Rawling, are much longer than those sported by Indian rhinos, more in line with the 18 in quoted by Ctesias for the horn of the Indian ass. In profile male chiru appear to have just one horn, which is probably how the myth

of their unicornity arose. Closer inspection reveals that they have two, of course, but chiru are wary animals and their environment consists of vast open plains, so close-up views are frustratingly rare. The horns of chiru were, still are, prized by local people, and were often sold to pilgrims from India and other countries. Combine the legend of the chiru with some basic rules of economics and the result is a trade in the animal's horns that, for the most part, would have taken place one horn at a time. It is difficult to think of a more effective way of disseminating a myth about a one-horned creature.

Chiru may have provided the pharmaceutical properties of the Indian ass's horn, too. Chiru horns are still used locally as a cure for diarrhoea and as an antibiotic. In Ctesias' time, and for more than 2000 years thereafter, nobody knew about bacteria, so when people became sick and feverish for no apparent reason they may well have blamed poisons (many of us still speak of blood poisoning, in spite of our physicians' calling such infections pyaemia or septicaemia). Ctesias' description of the poison-neutralizing qualities of the Indian ass's horn, assuming for the sake of argument that Ctesias and not a later interpolator penned it, may simply reflect the horn's general reputation as a cure-all medicine. So although rhino horn is the best candidate for the horn of Ctesias' ass, we should keep an open mind about the potential of chiru horn to fill the same role.

According to Odell Shepard, one more animal is concealed in Ctesias' description. 'There are in India certain wild asses,' Ctesias says, 'which are as large as horses, and larger . . . The animal is exceedingly

13

swift and powerful, so that no creature, neither the horse nor any other, can overtake it . . . When they take their young to pasture you must surround them with many men and horses. They will not desert their offspring and fight with horn, teeth and heels . . . They are themselves brought down by arrows and spears. They cannot be caught alive.' The most obvious clue here is the name Ctesias uses: ass. Ctesias would have been familiar with tame asses in Greece and both tame and wild asses in Persia, so we have little reason to question his use of this term (except in the broad sense that terms which we loosely regard as classificatory were used even more loosely in the pre-modern world; the rhinoceros was sometimes referred to as an ass, because rhinoceroses are closer in appearance to asses than to other kinds of domestic animal). Ctesias also says that the Indian ass is as large as a horse or larger – by implication not much bigger than a horse, if at all – so it seems unlikely that Ctesias' informant had described the Indian rhinoceros, which grows to 4 m in length and over 2 tonnes in weight. Ctesias' ass is also swift, fierce, and in the habit of using its teeth and heels when fighting. The speed and surefootedness of wild asses in their native habitats once made them the most revered sporting game of mounted hunters in the Near East; the deployment of teeth and heels as weapons also implicates a horse or ass of some kind and not the Indian rhinoceros or chiru (horses kick backwards using their heels, not forwards using their toes); and anyone who has seen wild asses or mustangs fighting will be in no doubt about the ferocity of members of the horse family.

Odell Shepard knew that a horse-like animal must be involved in Ctesias' description, and eventually he settled on the Persian ass, also known as the onager. Once common in Persia, these animals are about the right size (2 m in length), fight with their teeth and heels, and are renowned for their ferocity and swiftness. Owing to these characteristics the onager was a favourite quarry of Persian kings and an obsession of Arab poets. The flaw in Shepard's idea, however, is that Ctesias lived in Persia, so he must have known the onager well. Imagine Ctesias sitting with an informant, jotting down information about the one-horned ass of faraway Indica. Why would he embellish his notes with characteristics of an animal that he saw wandering around Persia every day? Ctesias may not have known very much, but he certainly knew where he lived, and where he lived was a long way from India.

There is a better explanation. The horse-like elements of the Indian ass were probably derived not from the onager but from the kiang, the largest of all wild asses at 2.1 m in length and 250–400 kg in weight (Fig. 1.3). Here is how Captian J. H. Walton, naturalist and medical officer to the British Tibet Frontier Commission in 1903–4, describes these creatures:

Of the larger mammals, that with which we became most familiar was the kiang . . . They went about, as a rule, in troops of ten to thirty . . . There is nothing horse-like about the kiang, but from his size and fine carriage he resembles a large mule, rather than an ass. The reddish chestnut colour of the upper

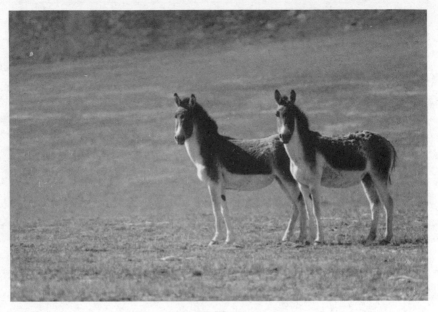

1.3 Kiang

parts is well shown off by the white belly and legs . . . As the kiang is not harassed by the Tibetans, those we saw were fairly tame and would allow one to approach to within about sixty yards of them . . . On several occasions I tried to get at close quarters with them. I rode slowly towards a herd and the moment the animals became in the least alarmed I galloped towards them as fast as possible; but the kiangs outdistanced me without an effort; indeed, I never succeeded in getting them to do more than make off at an easy canter. It is true that my Tibetan pony was not particularly speedy, but a greyhound that

belonged to one of the officers . . . was almost equally unsuccessful in the chase of these fleet-footed animals.[4]

An ass that can outrun a greyhound is a very fleet-footed and nimble animal indeed. Kiangs are also notoriously stubborn, to the extent that they have always resisted domestication. Perceval Landon, a correspondent of *The Times* newspaper who accompanied Walton on the 1903–4 expedition into Tibet, writes that the kiang 'has never been tamed, and the Tibetans, who should know, say that it is untameable'. The French missionary Evariste Huc came across the same set of beliefs:

This animal . . . is of the size of an ordinary mule; but its form is finer and its movements more graceful and active; its hair, red on the back, grows lighter and lighter down to the belly, where it is almost white . . . [I]ts speed is so great that no Thibetan or Tartar horseman can overtake it. The mode of taking it is to post oneself in ambush near the places that lead to the springs where they drink, and to shoot it with arrows or bullets . . . They have never been tamed to domestic purposes. We heard of individuals having been taken quite young, and brought up with other foals; but it has always been found impractical to mount them or to get them to carry any burden.

4 Appendix to Landon (1906).

The words of Huc in the nineteenth century and of Ctesias 2250 years earlier are almost interchangeable. The gaudy colours of the Indian ass have always been put down to Ctesias' active imagination, but kiangs are distinctly red and white, at least in their summer colours. Kiangs and Indian asses are so fast that they cannot be caught by horsemen, so they have to be ambushed in places where they naturally gather, using arrows and spears (*c.* 398 BC) or arrows and bullets (*c.* AD 1845). And, like the mythical Indian ass, kiangs are too wild and stubborn to be domesticated, which must always have been deeply frustrating for the semi-nomadic people who shared the kiang's landscape – so frustrating that the animal's intransigence eventually became legendary.

Huc says nothing about the ferocity and fighting tactics of kiangs, but the Russian colonel Nikolai Mikhailovich Przhevalsky in 1876 is one of several explorers of Central Asia who does: 'Should one of [the] stallions notice another approaching too near his troop, he rushes to the encounter and tries in every way by kicking and biting to drive him off . . .' In other words, kiangs fight ferociously with their teeth and heels, as all horses do.

Ctesias' chimera now makes a bit more sense. The kiang supplied the Indian ass with its personality and legendary speed. The chiru, a one-horned beast, or so the legend goes, which happens to live alongside troops of preternaturally fast and untameable kiangs, supplied the singular horn and perhaps some of the horn's pharmacological properties. And if the rhinocerine parts of Ctesias' account were

added at a later date, and if a big animal is needed to make sense of Ctesias' ass, there is an alternative to the rhinoceros that would fit the bill perfectly. In the past, though not so much today owing to hunting, three characteristic herd animals roamed the Tibetan plateau in huge numbers: the chiru, the kiang and the wild yak (Fig. 1.4). At up to 2 m at the shoulder, male wild yaks are the largest living members of the cow family (though some way short of the size of an elephant,

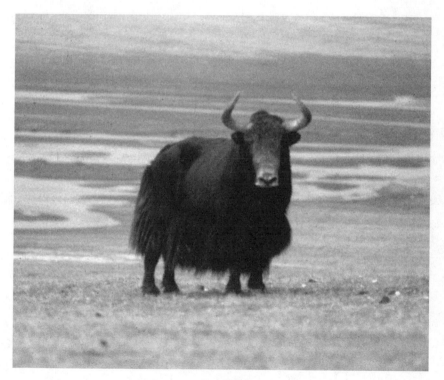

1.4 Yak

which was Marco Polo's estimate). Wild yaks have a reputation among Tibetans for being unpredictable and dangerous. Evariste Huc offers a typical nineteenth-century description:

> Wild cattle are of frequent occurrence in the deserts [wilder-nesses] of Hither Tibet. They always live in great herds, and prefer the summits of the mountains. During the summer, indeed, they descend into the valleys in order to quench their thirst in the streams and ponds; but throughout the long winter season they remain on the heights, feeding on snow, and on a very hard rough grass they find there. These animals, which are of enormous size, with long black hair, are especially remarkable for the immense dimensions and splendid forms of their horns. It is not prudent to hunt them, for they are said to be extremely ferocious.

Particularly in the breeding season, wild yaks are probably as fero-cious as any other kind of 1-tonne bull, quite ferocious enough to bear the weight of a myth or two. In the chiru, the kiang and the wild yak, then, we have the iconic herd fauna of the Tibetan plateau, while in Ctesias' one-horned ass we may have an embodiment of all three animals.

By the time that legends about the fauna of the plateau reached lowland India and then Persia, and certainly by the time that later writers added their own interpolations to Ctesias' text (if that is what

happened), the rhino had joined the corpus of tales, an animal that lives on the Himalayan slopes of Nepal, Bhutan and northern India. The rhino may have supplied the Indian ass with its medicinal potency, and is surely responsible for the part of Ctesias' account about anti-toxic beakers.

So Odell Shepard was partly right. He singled out the Indian rhino and the chiru as perpetrators of the myth of the one-horned ass, but he over-emphasized the rhino. He also plumped for the Persian ass as the equine member of the trio, a choice that removed all semblance of geographical coherence from Ctesias' tale. Replace the onager with the kiang and coherence returns: chiru and kiangs (and yaks if required) live in the same place, and rhinos are their next-door neighbours.

Who commingled these animals? Possibly it was Ctesias, but probably the myth reached him fully formed. Most likely, Himalayan peoples invented the one-horned ass. Lowlanders then mixed in a dash of rhinoceros, though perhaps the blame for that lies with later writers. Indian merchants transported the legend along with their wares to the wealthy land of Persia, where a wide-eyed Greek was waiting to send it on its way around Europe.

Here for the moment we shall pause our search for the unicorn's home. If you are not convinced that the one-horned ass is more than a creature of Ctesias' imagination, the next chapter may change your mind. But before leaving Ctesias' account there is one

part of it that bears a closer look. It tells us about our reporter's integrity and knowledge, and about whether we should take him seriously. The passage deals not with geography but with anatomy, and it is very revealing indeed. Far from being a gullible fool, Ctesias was more knowledgeable about animals than nearly everyone alive today.

Ctesias' remarkable understanding is secreted away in here:

Other asses, both the tame and the wild, and in fact all animals with solid hoofs, are without ankle-bones and have no gall in the liver, but these [Indian asses] have both the ankle-bone and the gall. This ankle-bone, the most beautiful I have ever seen, is like that of an ox in general appearance and in size, but it is as heavy as lead and its colour is that of cinnabar through and through.

Ctesias says, without preamble and seemingly without fear of being misunderstood, that among horse-like animals the Indian ass alone has ankle bones and gall in its liver. One implication of this is that no other horse-like animal has ankle bones, which raises the question of how common-or-garden horses bend their legs. Before jumping to conclusions about Ctesias' sanity it is worth remembering that he was a medical man of sufficient repute to be employed by the king of Persia, and that he would have been more familiar with the arrangement of animals' body-parts than most people in

first world cultures today. Ctesias deserves the benefit of the doubt, particularly from people who have become all but insulated from the natural world.

Ctesias was shown an ankle bone, perhaps by an Indian merchant, who told him that it belonged to a one-horned ass. This object probably was a bone from an animal's ankle, most likely an astragalus. Ctesias' contemporaries would have been familiar with astragali because they were used as dice in the ancient world.[5] Roughly oblong rather than cubic, an astragalus rolled around its long axis lands in one of four ways, so it was used to generate four numbers, typically one, three, four and six. In various games several astragali were rolled to produce a range of scores. The Romans enjoyed throwing one–three–four–six, which they called Venus, whereas one–one–one–one was so disappointing that they named it after the lowest creature in the Roman world: Canis, the dog.

5 The bone was known as an astragal to the Greeks, a talus to the Romans, a shagai to the Mongolians, and so on. Astragali were used as number- or pattern-generators in a wide variety of games of chance, the rules of most of which are now uncertain. They often turn up in disproportionately large numbers in archaeological excavations, which suggests either that astragali were commonly used by people for some purpose, or that sheep and goats once had more legs than they currently do. The oldest astragali are from ancient Egyptian tombs, and later Greek and Roman depictions of people playing games with them are quite common. Artificial astragali made of semi-precious stones, glass, ivory, silver, gold and lead are held, along with the real things, in museums around the world. The British Museum owns an exquisite Greek vase in the shape of an astragalus dated 460 BC.

So astragali would have been as familiar to the ancients as bicycles are to us. Ctesias would have known an astragalus when he saw one, and he would not have needed to elaborate on the subject for even the humblest of his readers. But what about his claim that only the Indian ass among horse-like animals has ankle bones? How do other horses bend their legs? This is where Ctesias' sophistication becomes apparent. Only certain creatures were plundered for dice in ancient times, typically sheep and goats. These animals are members of a large group of mammals called artiodactyls,[6] sometimes called even-toed ungulates.[7] The astragali of sheep and goats are four-sided and small enough for several to sit comfortably in the hand. Horses, asses, rhinoceroses and tapirs form another group of animals, called perissodactyls or odd-toed

6 The traditional grouping Artiodactyla does not fare well in modern classifications of animals, but the term is nevertheless still widely used.

7 Ctesias would not have used such labels, and he probably did not think about classifying nature in the way that we do. It is not even clear whether Greeks of Ctesias' time had a concept of nature in our sense of, roughly, Mother Nature. Aristotle, who lived after Ctesias, only rarely acknowledges nature as an entity composed of related and interacting parts worthy of hierarchical classification; had he thought about nature in this sense his writings on animals would be a lot less confusing to the modern reader than they are. However, we know that schemes for subdividing animal life dichotomously existed before both Ctesias and Aristotle. Animals with feet were divided into those with four feet and those with two; the class of four-footed animals was divided into animals with solid feet and those with cloven feet; and so on. Aristotle rejects the dichotomous approach and replaces it with his own system, which is far more subtle and puzzling.

ungulates. This group has a different type of ankle bone that, owing to its shape, is no good as a die. To us astragali are common to both artiodactyls and perissodactyls, though we recognize that sheep have one type and horses another. But to Ctesias and his audience of ordinary Greeks, astragali were bones of a definite shape used by everyone as dice. Sheep and goats have such bones; horses and asses do not. Therefore sheep and goats have astragali; horses and asses do not.

Now we can understand Ctesias. Someone showed him an astragalus and said that its owner was a one-horned ass. Ctesias knew that this bone was the kind that gamers used as dice. He also knew that ordinary horses and asses do not have dice in their legs. So Ctesias had stumbled upon the first exception to the rule. He reports his new-found knowledge unambiguously: 'Other asses,' he says, 'both the tame and the wild, and in fact all animals with solid hoofs, are without ankle-bones . . . but [Indian asses] have . . . the ankle-bone.' This statement is correct, except in the admittedly important sense that the Indian ass turned out not to exist.

We can narrow down the possible owners of the ankle bone that Ctesias was shown. He says it was like an ox's in size and shape, deep red throughout, and as heavy as lead. An astragalus the shape of an ox's disqualifies the horse and ass as donors, because horses and asses are not artiodactyls. Rhinoceroses are not artiodactyls either, and their astragali are very big in any case, so we can

rule out these animals too. By such reasoning one is led to the disappointing conclusion that the object seen by Ctesias resembled an ox's ankle-bone because it was an ox's ankle-bone, or perhaps, to grant Ctesias the sophistication on anatomical matters that he probably deserves, an astragalus belonging to an ox-sized and ox-like but otherwise unfamiliar large animal from Indica, possibly a yak. Needless to say, bones are never deep red or as heavy as lead, so the object of Ctesias' interest was probably a dyed and weighted gaming piece, charm or talisman derived from a large member of the cow family.

Ctesias goes on to distinguish himself further. He says that the Indian ass has gall in its liver and seems excited that such an animal should. Gall is the bitter-tasting substance produced by the liver that we call bile. It is used in digestive processes in our intestines. The terms gall and bile sit side by side in medical parlance today: we talk of the gall bladder, the muscular sac attached to the liver where bile is stored and concentrated, yet also of bile ducts, the tubes that channel bile into the small intestine. Ctesias must have known another anatomical pattern that few of us today appreciate. Most of the animals with which we are familiar have livers with gall bladders attached to them, but a few do not. Members of the horse family, along with rats, pigeons, dolphins and a few other creatures, lack gall bladders. Modern science tells us that horses and asses manufacture gall in their livers, but the fluid does not collect anywhere. Without this knowledge the simplest interpretation is that

animals with gall bladders produce gall, whereas animals without gall bladders do not.[8]

Ctesias had made another discovery: normal asses and horses never produce gall, but the one-horned ass, that remarkable denizen of Indica, does. 'Other asses,' he says, 'both the tame and the wild, and in fact all animals with solid hoofs . . . have no gall in the liver, but these have the gall.' Correct again, except, again, that the Indian ass turned out not to exist. But it would be churlish to hold this error against a man who could not have known whether the one-horned ass existed or not, who had no reason to doubt the word of his informants, who believed that India was a very strange place, and who knew more than most of us about anatomy.

Ctesias' account of the one-horned ass has never been taken very seriously, but it yields many insights. The body and spirit of his creature are beginning to coalesce in one place; already we can identify the home of the Greek unicorn. And we have certainly covered enough ground to repair Ctesias' battered reputation.

8 The distinction between gall-bearing and other creatures would have been widely known in ancient times and is a basic piece of practical knowledge in some cultures today. Gall was, still is, used as an ingredient in many traditional medicines. A hunter seeking gall to sell on to the medical profession would be wasting his time chasing horses and asses, whereas goats, bears, yaks, Tibetan antelopes and many other creatures might be worth the effort, depending on the going rate for the ingredient.

Few writers, ancient or modern, have been as misunderstood as Ctesias. His book on India is indeed fantastical in parts, but it is probably a mostly honest rendering of stories from and about the East that were current in Persia in the late fifth century BC. That Ctesias was a little gullible, that he misjudged on occasion, is not surprising considering that *Indica*'s topic was the most mysterious of all lands, the ancient equivalent, in our terms, of another planet. The more we learn about Eastern myths and legends in antiquity, the more Ctesias' tales make sense. Now even his most infamous tale makes sense.

Ctesias was the earliest writer of antiquity to be intrigued by the one-horned ass, but he was not the only one. Later authors adopted the beast and expanded on it, in some cases considerably. Now, if the legend of the Indian ass is a groundless fancy, Ctesias' literary descendants could have done no more than add embellishments drawn from their own imaginations. But if the legend has its roots in real animals, and if writers of later antiquity had a clearer notion of the home of the one-horned ass than we now do, they may have been able to converge on the truth of the matter. In other words, perhaps descriptions of the creature became not more imaginative over time, but more accurate, more sensible, more reflective of the animals and landscapes that gave birth to the myth in the first place. To find out which of these possibilities is closer to the truth we must let the empires of Greece and Persia wane with the passing of centuries and enter the world of the Romans.

CHAPTER 2

Where unicorns roam

The idea of the unicorn was kept alive by three ancient writers in particular. Aristotle (b. 384 BC), the greatest natural historian of antiquity and a man who, unlike Ctesias, has always been largely immune from criticism, mentions the Indian ass in his *History of Animals*: '[S]ome animals are horned, some hornless. Most of the horned ones are cloven-hooved, e.g., the ox, the deer, and the goat; we have seen no solid-hooved animals with a pair of horns. But a few, e.g., the Indian ass, have a single horn and are solid-hoofed. The oryx has a single horn and cloven hooves [see Fig. 2.1]. The only solid-hoofed animal with a huckle-bone is the Indian ass . . .' That is all the Master had to say on the matter, but, because it was Aristotle, the idea of the one-horned ass remained intact when Greek power waned and caught the interest of scholars in the next great world empire.

The Roman encyclopaedist Pliny the Elder (AD 23–79), whose *Natural History* allegedly drew on the work of a hundred of his

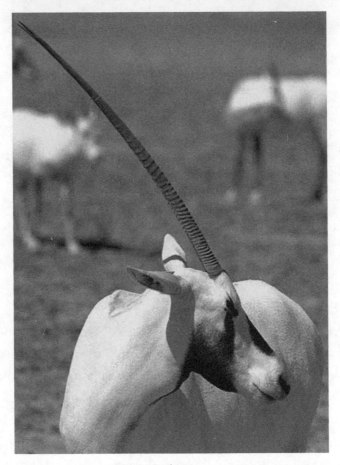

2.1 Arabian oryx

predecessors, and whose beliefs about the natural world became the beliefs of Europeans for 1500 years, also mentions a one-horned animal, which may be a pared-down version of Ctesias' ass crossed with the Indian rhinoceros: 'In India . . . the fiercest

animal is the monoceros, which in the rest of the body resembles a horse, but in the head a stag, in the feet an elephant, and in the tail a boar, and has a deep bellow, and a single black horn three feet long projecting from the middle of the forehead. This animal, they say, cannot be taken alive.'

Though Aristotle's and Pliny's accounts were the most influential, a later, more verbose author is most important to our story. Claudius Aelianus, or Aelian, a Grecophile Italian who lived between AD 170 and 235, wrote three passages in florid Greek about unicorns in his book *On Animals*. Two are based squarely on Ctesias' account, but the third (Book 16, Passage 20) is a treasure-trove of new information, and allows us to identify with some confidence the home of the unicorn:

In certain regions of India (I mean in the very heart of the country) they say that there are impassable mountains full of wild life, and that they contain just as many animals as our own country produces, only wild. For they say that even the sheep there are wild, the dogs too and the goats and the cattle, and that they roam at their own sweet will in freedom and uncontrolled by any herdsman. Indian historians assert that their numbers are past counting, and among the historians we must reckon the Brahmins, for they also agree in telling the same story.

And in these same regions there is said to exist a one-

horned beast which they call Cartazonus. It is the size of a full grown-horse, has the mane of a horse, reddish hair, and is very swift of foot. Its feet are, like those of the elephant, not articulated and it has the tail of a pig. Between its eyebrows it has a horn growing out; it is not smooth but has rings/spirals of quite natural growth, and is black in colour. This horn is also said to be exceedingly sharp. And I am told that the creature has the most discordant and powerful voice of all animals. When other animals approach, it does not object but is gentle; with its own kind however it is inclined to be quarrelsome. And they say that not only do the males instinctively butt and fight one another, but that they display the same temper towards the females, and carry their contentiousness to such a length that it ends only in the death of their defeated rival. The fact is that strength resides in every part of the animal's body, and the power of its horn is invincible. It likes lonely grazing grounds where it roams in solitude, but at the mating season, when it associates with the female, it becomes gentle and the two even graze side by side. Later when the season has passed and the female is pregnant, the male Cartazonus of India reverts to its savage and solitary state. They say that the foals when quite young are taken to the King of the Parsii and exhibit their strength one against another in public shows, but nobody remembers a full-grown animal having been captured.

Aelian was influenced by the Plinian tradition: the cartazon has ele-
phant-like feet and a pig-like tail, connoting the Indian rhinoceros.
The beast's great strength is perhaps also derived from the rhino. Yet
Aelian is certain that the cartazon is not the rhinoceros, writing else-
where that 'a description of the shape and appearance of the
Rhinoceros would be stale three times over, for there are many Greeks
and Romans who know it from having seen it [in the Roman
arena] . . . It has a horn on the end of its nose, hence its name.'

Aelian says nothing of the pharmaceutical properties of cartazon
horn or about antidotal drinking vessels, preferring to reserve these
characteristics for his other unicorned animals. The cartazon's horn is
black, ornamented with natural rings[9] and tapers to a very sharp
point. This is neither the horn of the rhinoceros nor the crimson,
black and white wonder of Ctesias' ass. Odell Shepard thought that
the owner might be an antelope. He was right, though genetics
would later reveal that the creature he had in mind is a different kind
of beast.

9 There is doubt about whether the word heligmos used by Aelian to describe
the ornamentation of cartazon horn should be translated as rings or spirals. If
Aelian meant spirals then he may have given us the first ever reference to the
type of horn that came to be associated with the unicorn of European art in
medieval times (see Chapter 5). But the rest of Aelian's description suggests that
the cartazon's horn was derived from the chiru and not from the creature that
supplied medieval unicorns with 2-m-long white or ivory-coloured horns.
Rings would seem to be the best translation. See Lavers (1999).

The modern-day biologist George Schaller describes the horn of the so-called Tibetan antelope thus: 'The male's most conspicuous antelope-like feature is the long, slender, black horns, which rise almost vertically from the head, curve slightly back in the distal half, and then terminate with smooth rapier-like tips pointing forward. The horns are laterally compressed and have about 15–20 ridges along the front for two thirds of their length.' The animal to which these horns belong is the chiru, which we now know is a type of goat (Fig. 1.2).

This supposed Tibetan unicorn was described by a number of nineteenth-century explorers. Evariste Huc, writing of his travels in Tibet in 1844–6, says that 'a Thibetan manuscript . . . calls the unicorn the one-horned *tsopo*. A horn of this animal was sent to Calcutta: it was fifty centimetres in length and twelve centimetres in circumference from the root; it grew smaller and smaller and terminated in a point. It was almost straight, black, and somewhat flat at the sides. It had fifteen rings, but they were only prominent on one side.' A number of horned animals roam the tablelands of Tibet, but the only one with this sort of horn is the chiru. If any doubt remains about the identity of the tsopo, Huc goes on to reveal another name used by nineteenth-century Tibetans for their local unicorn: the tchirou.

Chiru horns were prized by local people and visitors to Tibet and were often taken to other countries. The Russian explorer Nikolai Przhevalsky writes: 'The blood [of the chiru] is said to possess medicinal virtues, and the horns are used in charlatanism:

Mongols tell fortunes and predict future events by the rings . . .
these horns are carried away in large numbers by pilgrims returning
from Tibet, and are sold at high prices.' Chiru horns were no doubt
marketed as belonging to a one-horned animal, cementing the
chiru's reputation for unicornity. Perhaps chiru horns had reached
Aelian in Italy by the time he compiled his book; stories about them
certainly had.

Tales of the chiru's behaviour, too, may have reached ancient
Rome. Male and female chiru live apart for most of the year, which
could account for Aelian's statement that the one-horned ass
'. . . likes lonely grazing grounds where it roams in solitude, but at
the mating season, when it associates with the female, it becomes
gentle and the two even graze side by side. Later when the season
has passed and the female is pregnant, the male Cartazonus of
India reverts to its savage and solitary state.' Aelian also says that
male one-horned asses 'instinctively butt and fight one another . . .
and carry their contentiousness to such a length that it ends only in
the death of their defeated rival'. During the rutting season male
chiru can be very aggressive. Przhevalsky writes that combat
between male chiru 'is fierce, and the long sharp horns inflict ter-
rible wounds, often causing the death of both antagonists'. Captain
Rawling, in reports of his travels in the early twentieth century,
adds that 'if the opponents meet, a furious battle takes place, in
which blood flows freely, as was seen by us on several occasions. As
a rule, however, the weaker recognises his inferiority at a distance

and flees ignominiously.' Rawling and Przhevalsky were passing on tales told by Tibetans about the pugnacity of their chiru-unicorns, doing what other travellers had done for thousands of years.

Both Pliny and Aelian comment on the unicorn's voice: deep, powerful and discordant. Indian rhinos utter ten different noises, most are deep, and some could be called discordant. The yak also has a deep voice: it is called the grumbling or grunting ox. But Pliny's and Aelian's descriptions will strike a chord with anyone who has heard the extraordinary noises made by the chiru. After describing the chiru's ugly nostrils, Captain Rawling notes that 'during the rutting season . . . at which date the bucks are in a constant state of war, these nostrils are used for bellowing challenges to all and sundry. It is a deep-toned roar of rage or defiance, and seems to have a dispiriting effect on the courage of the younger or more timid bucks near by. The bellow is more what one would expect from a savage and carnivorous beast of the jungle than from an antelope.' When Aelian goes on to describe the unicorn's horn so precisely it is difficult to draw any other conclusion than that the discordant voice of the unicorn is the incongruous voice of the chiru.

The first paragraph of Aelian's account may seem a pedestrian introduction, but it is one of the most revealing parts of the piece. Aelian says that he is describing parts of India. He then adds a parenthetical qualification: 'I mean in the very heart of the country.' To us the heart of India suggests the middle of a triangle formed by the coastlines of India and Pakistan on two sides and the southern

escarpment of Himalaya on the third. But to the ancients India was a vaguer concept. At its least specific it meant east, or unexplored parts of Asia. Heart of the country, then, indicates somewhere further north than the heart of India as we would understand it. And the impassable mountains that occupy this heart must be the Himalaya and associated ranges. Aelian is referring to the highlands of Central Asia.

He goes on to give a useful list of the animals to be found there, and from it we can narrow the geographical field of view further. In this land live sheep, dogs, goats, cattle and animals with single horns, totalling 'as many animals as our own country produces', yet 'uncontrolled by any herdsman'. Even the sheep, goats and cattle run free. Only one place in 'India' – indeed only one place on the earth's surface – supports a community of domestic yet wild mountain-dwelling animals such as this: the Himalayan plateau. Aelian's sheep are probably argali, giant members of the family with huge curly horns; his dogs are wolves, the principal predators of the region; the goats may be bharal, also called blue sheep (though they are more closely related to goats); it is difficult to see anything other than yaks in Aelian's wild cattle; and we already know what his one-horned beasts are. Aelian's list connotes the obvious large mammal fauna of Tibet, complete with composite unicorns.

Aelian also says that the animals living alongside the unicorn are beyond counting. Big populations of large animals are not characteristic of the southern flanks of Himalaya where Indian rhinos live,

but huge herds were once common on the plateau to the north. The abundance of wildlife in Tibet, surprising considering the harshness of the environment, was commented upon by many explorers. The account of Captain Samuel Turner, published in 1800, is particularly instructive, because it compares the tablelands of Tibet with the landscapes of Bhutan on the southern rise of Himalaya:

Bootan presents to the view, nothing but the most mishapen irregularities; mountains covered with eternal verdure, and rich with abundant forests of large and lofty trees. Almost every favourable aspect of them, coated with the smallest quantity of soil, is cleared and adapted to cultivation, by being shelved into horizontal beds: not a slope or narrow slip of land between the ridged lies unimproved . . .

Tibet, on the other hand, strikes a traveller, at first sight, as one of the least favoured countries under heaven, and appears to be in a great measure incapable of culture [cultivation]. It exhibits only low rocky hills, without any visible vegetation, or extensive arid plains . . . Its climate is cold and bleak in the extreme . . . Yet perhaps Providence, in its impartial distribution of blessings, has bestowed on each country a tolerable equal share. The advantages that one possesses in fertility, and in the richness of its forests and its fruits, are amply counterbalanced in the other by its multitudinous flocks . . . As one seems to

possess the pabulum of vegetable, in the other we find a superabundance of animal, life.[10] The variety of wild-fowl, game, and beasts of prey, flocks, droves and herds, in Tibet, are astonishing. In Bootan, except domestic creatures, nothing of the sort is to be seen. I recollect meeting with no wild animal except the monkey, in all my travels, and of game, I saw only a few pheasants . . .

Nikolai Przhevalsky was similarly impressed by the wildlife of Tibet: 'Had we not seen with our own eyes it would have been impossible to believe that in these regions, left so destitute by nature, such immense herds of wild animals should be able to exist . . . But though food is scarce, they have no fear of encountering their worst enemy, man; and far removed from his bloodthirsty pursuit, they live in peace and liberty.' Incongruously, Przhevalsky goes on to describe the best way to kill each species. Przhevalsky travelled widely around Central Asia, but only in northern Tibet was he dumbfounded by the abundance of wild animals.

10 How can a superabundance of animal life survive in Tibet when there is apparently so little to eat? While vegetation is often sparse the plateau is immense, so the amount of vegetation available to grazing animals in total is huge. The trick for Tibetan mammals is to be wherever the food is. Herds of Tibetan animals move around the plateau, eating whatever they can find as they go. The immense herds of wildebeest that follow the rains backwards and forwards across the savannahs of Africa use the same ecological strategy.

The herds were still there in the early twentieth century, though not for much longer: 'Everyone in camp turned out to see this beautiful sight,' wrote Captain Rawling, 'and tried, with varying results, to estimate the number of animals in view. This was found very difficult however, more particularly as we could see in the extreme distance a continuous stream of fresh herds steadily approaching; there could not have been less than 15,000 or 20,000 visible at one time.' No doubt travellers have always been struck by the endless herds of grazing animals on the plateau. It is a modern tragedy that they are no longer there.[11]

One last parallel between the unicorn of the ancients and the animals of Himalaya deserves mention, though the text in which it appears was written after the fall of Rome. Cosmas Indicopleustes ('the India-farer') was a Greek traveller from Alexandria in Egypt, who stayed at a monastery in Sinai around AD 545 while writing *Christian Topography*, a book about his adventures. His description of the unicorn borrows heavily from Ctesias, but he adds an interesting detail: 'People say he is completely invincible and that his whole strength lies in his horn. When he knows he is being pursued by many hunters and about to be captured, he leaps up to a clifftop and

11 Chiru, kiang and wild yak still exist on the plateau, though in much reduced numbers (see Schaller 1998 for a recent assessment). At the time of writing the situation appears to be improving a little as a result of conservation measures implemented by the Chinese government.

throws himself down from it, and as he falls he turns himself in such a way that his horn completely cushions the shock and he escapes unharmed.'[12]

The unicorn seems here to be descending, literally and figuratively, into nonsense. But just such beliefs were once held about the musk ox, ibex, oryx, Rocky Mountain goat, Persian wild goat and, more important, the Tibetan argalis. The early twentieth-century explorer Sven Hedin even saw an argalis break its fall by landing on its horns, though it has to be admitted that one of his men had put a bullet into it. Nikolai Przhevalsky confirms the myth just long enough to dispel it: 'I have seen the males jump from heights of twenty or thirty feet, always alighting on their feet . . . but the stories told of argali throwing themselves down steep precipices, and alighting on their horns, are pure fiction.' Cosmas' stories have always troubled historians, not least because it is unclear where he travelled, what he saw, and which legends he picked up on the way. Even if we knew where Cosmas had been, legends travel so widely that we could not be sure about the geographical origins of his tales. But there is no doubt that Cosmas embellished the tale of the unicorn that Ctesias told, so it is an intriguing geographical coincidence that, of the animals supposedly able to survive a fall by landing on their horns, one happens to live alongside bellowing one-horned

12 Gotfredsen (1999).

chiru and lightning-fast red and white asses. Even Cosmas' gymnastic unicorn finds a home in Himalaya.

Between Ctesias and Aelian the legend of the one-horned ass developed considerably, by additions that were nearly always, in an important sense, correct. The one-horned ass might have ended up 10 m tall with a polka-dot hide and a horn made of gold; it might have come to share its landscape with dragons and satyrs. But in 600 years nothing outrageous was added to the myth.

The one-horned ass converges on a particular community of Himalayan creatures, and on one animal in particular. In Aelian's account of the cartazon the beast's horn has become that of the chiru, fundamentally different from the horn described by Ctesias. The cartazon inherits the chiru's breeding behaviour, including the sparring of males and the seasonal separation of the sexes (although these characteristics could apply equally to other Himalayan creatures). It also acquires the chiru's voice. And, like the chiru, the cartazon shares its landscape with a community of notably abundant large 'domestic' creatures, which, unlike the pastoral animals of Greece and Italy, 'roam at their own sweet will'. All lucky coincidences? If so, Aelian and his literary predecessors constitute an exceptionally fortunate intellectual lineage.

The legend of the unicorn is far from being a tall tale, and ancient texts give us many clues to the beast's identity and home. The fast, untameable, red-and-white kiang lives alongside another Tibetan

creature that has given rise to tales about one-horned animals at least as far back as the time of Genghis Khan, and no doubt for centuries, millennia, beforehand. The horn of the chiru is just as Aelian described it 2000 years ago. And if a more powerful animal is needed to account for descriptions of the one-horned ass, the wild yak is in the neighbourhood. Widen the field of view to include the southern flanks of Himalaya and we find creatures with stocky legs, pig-like tails and single horns. In times past, kiangs, chiru, argali, bharal, wolves and yaks roamed their high-altitude grasslands in numbers beyond counting, uncontrolled by man. The only place that fits the facts of the one-horned ass is the Tibetan plateau. How appropriate that the spiritual home of the unicorn is Shangri-La.

CHAPTER 3

The Judaeo-Christian unicorn

A century or so after Ctesias wrote *Indica* and long before Aelian added a wealth of detail to the legend of the one-horned ass, the unicorn suddenly, improbably, popped up in the writings of a religious movement destined to become one of the most influential of all time. Here is how the beast appears in the King James translation of Christianity's most revered texts.

In Numbers, 23. 22, God is lauded for his power and faithfulness to the people of Israel: 'God brought them out of Egypt; he hath as it were the strength of the unicorn.' In Deuteronomy 33. 17, there is more lauding in the same context: 'His glory is like the firstling of his bullock, and his horns are like the horns of unicorns: with them he shall push the people together to the ends of the earth.' In the most moving of the Psalms, 22. 21, which begins with Jesus' lament from the cross – 'My God, my God, why hast thou forsaken me?' – we find 'Save me from the lion's mouth; for thou hast heard me from the

horns of unicorns.' The unicorn appears again in Psalm 24. 6, when David praises God: 'He maketh [the cedars of Lebanon] also to skip like a calf; Lebanon and Sirion like a young unicorn.' In Psalm 92. 10, God is hailed for his promises to David: 'But my horn shalt thou exalt like the horn of the unicorn: I shall be anointed with fresh oil.' In Isiah 34. 7, the prophet warns that the powers of heaven will rain down on God's enemies: 'And the unicorns shall come down with them, and the bullocks with their bulls; and their land shall be soaked with blood, and their dust made fat with fatness.' The longest passage involving the unicorn describes God revealing his works to Job to show how puny man is by comparison (Job 34. 9–12): 'Will the unicorn be willing to serve thee, or abide in thy crib? / Canst thou bind the unicorn with his band in the furrow? or will he harrow the valleys after thee? / Wilt thou trust him because his strength is great? or wilt thou leave thy labour to him? / Wilt thou believe him, that he will bring home thy seed, and gather it into thy barn?'[13]

13 There is an eighth reference to a one-horned animal in the Bible, but it is a supernatural beast that emerges from a different tradition and set of concerns. The prophet Daniel had a vision of a two-horned ram that swung its head violently from side to side so that no one could get near it. He continues (Daniel 8. 5–7): 'And as I was considering [the ram/the situation], behold, an he goat came from the west on the face of the whole earth, and touched not the ground; and the goat had a notable horn between his eyes. / And he came to the ram that had two horns, which I had seen standing before the river, and ran unto him in the fury of his power. / And I saw him close unto the ram, and he was moved with choler against him, and smote the ram, and brake his two horns: and there was no power in the ram to stand before him, but he cast him

Whatever these snippets might mean – interpreting Judaeo-Christian scripture is never straightforward – their subject is similar to Ctesias' one-horned ass. Like his beast, the biblical unicorn is powerful (Numbers, Deuteronomy), dangerous (Isiah), impossible to tame and thus not much use domestically (the rhetorical questions asked by God of Job), and, in general, worthy of a great deal of respect. The animal is also as real as the bullocks, bulls, calves and lions that crop up around it in the text. But the biblical unicorn is not Ctesias' ass. Both timing and geography are wrong. The writers of the Old Testament lived between *c.* 1400 and 400 BC, and Ctesias did not write *Indica* until 398 BC or thereabouts, so the Hebrews did not copy Ctesias. Also, since Ctesias located the one-horned ass in Indica, correctly as it turns out, his account was unlikely to have been influenced by Near Eastern tradition, much of which he would have been familiar with through his knowledge of Persia and her empire.

down to the ground, and stamped upon him: and there was none who could deliver the ram out of his hand.' Here is an example of the kind of passage that Old Testament writers could pen when they put their imaginations to the task. Its subject is an imaginary animal, a one-horned goat whose hooves do not touch the ground and whose image casts a great shadow across the face of the earth. Of the other seven references to unicorned animals in the Bible only Isiah's prophetic warning hints at anything supernatural, and even here the unicorn is accompanied by ordinary bullocks and bulls. Later we learn that the one-horned goat represents the Greek conqueror Alexander the Great. Having stamped his Eastern enemies (Persia, Media) into the ground, the goat's single horn splits into four, signifying the four Diadochi, princes, who divided up Alexander's realm after his death.

And while the pagan and Hebrew unicorns could have sprouted from the same Indian rootstock, the biblical beast is sufficiently different from the one-horned ass and the ass's Indian parents (chiru, kiang, yak, rhino) to discount this explanation, too.

The most obvious difference between the pagan and biblical unicorns is that the latter does not actually appear to be a unicorn: none of the passages refers unambiguously to a creature with one horn.[14] Had the Hebrews wanted a one-horned animal in their holy texts we might expect them to have mentioned the beast's defining characteristic once in a handful of opportunities. Read the biblical passages a few times and the nagging feeling that something is not right, that a mistake has been made, grows ever stronger. Try to identify where an error could have crept in and clouds of suspicion gather over one important word. How did 'unicorn' find its way into the Bible?

A rough chronology of events will prove useful. A Greek translation of the Hebrew Bible was made mainly in the third century BC,

14 Psalm 92 hints at unicornity, but could any self-respecting writer or redactor live with a sentence of the form 'my horn is like the horns of a bull'? The interesting question about Psalm 92 concerns the meaning of the clause 'my horn shalt thou exalt', not with the follow-on phrase 'like the horn of the unicorn', which simply continues in the singular. What was this horn that the writer predicted would be exalted? Horn symbolism was common in religious writings of the ancient Near East, and clearly related to power in a number of senses, but divining the precise sense intended is rarely easy, the horn references in the Bible being a prime case in point.

although the dating is uncertain and parts of the translation were probably carried out centuries later. The New Testament, which describes the life and teachings of Christ, was written between AD 50 and 90. Around AD 95 the historian Josephus identified the thirty-nine books of the Old Testament that are canonical today (though some believe that Ezra did the same thing 600 years earlier). A meeting of Church leaders known as the Council of Carthage established the New Testament canon in AD 397. The first Latin version of the Old and the New Testaments, called the *Vulgate*, meaning in the language of the people, was written around AD 400, primarily by Saint Jerome (AD 340–420), one of the fathers of the Christian Church and the man best known for plucking a thorn from a lion's paw. For a long time Latin was the language of Christianity and Church power in the Western world (Greek in the East), which is why an English translation of the Bible did not appear until 1537.[15]

The original Hebraic manuscripts that became the Old Testament

15 The English theologian John Wycliffe began to translate the *Vulgate* into English in 1380. He was critical of Roman Catholic practices, and was persecuted to the extent of having his body dug up and burned long after his death. Between 1525 and 1530 William Tyndale translated the New Testament and the first five books of the Old Testament (the Pentateuch) into English, but he, too, fell foul of Church authorities and was burned at the stake in 1536. Tyndale's project was completed in 1535 by his assistants John Rogers and Miles Coverdale. Two years later Rogers and Coverdale published a complete version of the Bible.

have long since turned to dust, but the Hebrews so venerated their holy texts that copies were made with great care and rigorously checked before being allowed into the wider world (which is not to say that there was only ever one set of Hebrew writings – there were many). By the early third century BC when the first Greek translation of the Old Testament was produced, Hebrew scripture had been around for centuries, and many people, places and things mentioned in the text were no longer familiar, even to people who could read Hebrew (by this time many Jews, especially those living outside Palestine, spoke other languages, Greek in particular). Translating a complex, semi-historical and figurative text from Hebrew into Greek was challenging, and locating appropriate Greek words would occasionally prove a challenge too far.

Legend has it that Ptolemy II (285–247 BC), Alexander the Great's successor to the throne of Egypt, commissioned a Greek translation of the Hebrew Bible for his library at Alexandria, because few people in Egypt understood Hebrew. Ptolemy contacted the high priest Eleazar in Jerusalem, who arranged for six translators from each of the twelve tribes of Israel to undertake the task. These seventy-two scholars were treated to Ptolemy's hospitality before being sent to the island of Pharos near Alexandria to begin their work. One version of the tale maintains that each scholar sat on his own and produced his own translation. Seventy-two days later seventy-two translations were finished, all of them identical. Both the scholars and their translation became known as the Septuagint,

deriving from the Latin word for seventy, a figure presumably large enough to indicate the magnitude of the effort. In reality the *Septuagint* Old Testament was produced by an unknown number of people over decades or centuries.

At the same point in his deliberations, each scholar came across a reference to a horned animal called a reem.[16] A little further on the word appeared again. Then again. Curiously – and what follows is the most important crossroad in the unicorn's journey through history – none of the scholars knew what a reem was.[17] Their forefathers had obviously been familiar with the animal, but as far as the Septuagint knew it did not exist. The sense of the text dictated that the reem had to be large, horned, domestically useless, and sufficiently imposing that the writers of Hebrew scripture adopted it as a symbol of great power. It also had to be a real creature, like the bulls and other beasts that accompanied it in the text. But since the reem and the bull shared the same sentence on occasion, the reem could not be a bull, or at least not a bull of the common-or-garden variety. So, a large, powerful, horned animal, but not a bull. The scholars

16 Throughout this chapter the simplest, unaccented transliterations of Hebrew, Arabic and cuneiform words are used. Reem is often written re'em.
17 Such is the traditional interpretation. Schaper (1994) for one is uncomfortable with this idea, preferring to think that the Septuagint knew what a reem was but replaced it with a different kind of animal to manipulate the symbolism of the passages in question (introducing a Messianic subtext). Such ideas have met with scepticism from other biblical scholars, however (Dines 2004, Pietersma 2005).

trawled their memories, which evidently produced a very short list of candidates. Presumably the wider citizenry of Alexandria and the city librarians drew a blank, too, except – perhaps this is how it happened, though no one knows – for a vague correspondence between the reem and a powerful, one-horned, untameable, non-bull described in detail by a Greek doctor called Ctesias and mentioned in passing by the Greek polymath Aristotle.

Each member of the Septuagint independently decided to replace the Hebrew word reem with the Greek word μονόκερως. In anglicized Greek μονόκερως translates as monoceros, literally one-horn. One-horn in Latin is unicornus, and unicornus in English is unicorn. The reem of the ancient Hebrews became a monoceros in the Greek Bible, a unicornus in the Latin Bible, and eventually a unicorn, licorne, einhorn and so on when the Bible was translated into the vulgar tongues of Europe. Ctesias' ass, or a memory of it, wound up in arguably the most influential book in human history because it was, like the Hebrews' totemic reem, real, strong, horned, indomitable and, crucially, not a cow.

An early theory about the reem's *true* identity held that it was nothing more mysterious than the rhinoceros. The popularity of this idea among Christians is owed mainly to early translators of the Old Testament, in particular Saint Jerome (*c.* AD 340–420). In the *Vulgate* the reem is sometimes called unicornus, but elsewhere it becomes rhinoceros (nose-horn). Scholars and the worldly-wise in Jerome's time knew about rhinoceroses, and perhaps Jerome thought

that the Septuagint also knew of them, though by a different name.[18] Whatever the case, by employing two one-horned animals as stand-ins for the reem – unicornus and Indian rhinoceros – Jerome bolstered the authority of the Septuagint, who were responsible for foisting a one-horned creature on Judaism and Christianity in the first place.

With the weight of the *Vulgate* behind it the rhinoceros-is-reem idea became the default position among Christians for 1500 years. Those who opposed Jerome's view tended to do so vehemently, however, partly because the rhinoceros was widely thought to be an ugly brute who had no place in the Bible, partly because it was thought too puny to be the reem,[19] and not least because it was unclear how the authors of the Old Testament came to know a creature that was not native to biblical lands.

An alternative theory about the reem's identity became popular for a time under the leadership of a man who ranks among the greatest

18 The ancient Egyptians had extensive knowledge of the lands surrounding their own, much of which undoubtedly found its way into the libraries of Alexandria. Knowledge from all over the world ended up in these libraries, but we have only a vague idea of what was on the shelves. The Septuagint and other contemporary peoples of north Africa, the Middle East and Europe may have known about all sorts of things of which subsequent scholars were ignorant, rhinoceroses included.
19 The rhinoceros was frequently mixed up with the small, goatlike unicorn of Christian allegory (see Chapter 4), a confusion that led to the belief that the rhinoceros was less imposing than it is.

literary scholars in history. Samuel Bochart was born in Rouen in northern France in 1599, but undertook most of his voluminous life's work in Oxford, England. Bochart was fluent in French, Latin, Greek, Hebrew, Arabic, Italian, German, Flemish, Spanish, Celtic, Coptic, Egyptian, Ethiopic, Chaldean, Syriac, Persian and Phoenician. He spent some time at the court of Queen Christina of Sweden, from where he obtained a copy of the great book on the life of animals by the Arab scholar al-Damiri, which he used to compile his own master-work *Hierozoicon*, an analysis of the natures and histories of all the animals mentioned in the Bible. The fruit of a thirty-year period of astonishingly erudite linguistic and literary scholarship, the book was finally published in 1663, four years before Bochart's death.

Bochart dismisses the rhinoceros and the wild ox as potential reems because neither animal is native to Palestine or Arabia. The weakness of this argument, even if it were true – and in the case of wild ox it may not be, although Bochart could not have known this – should be obvious to anyone aware of the geographical history of the Hebrews. The ancestors of the Septuagint may have learned about rhinoceroses or wild oxen while detained in Egypt or Mesopotamia, or, indeed, from merchants or travellers visiting Palestine. Be that as it may, Bochart's argument allowed him to pass swiftly on to his speciality, the writings of distant cultures, particularly of the Arabs. An analysis of the relevant Near Eastern literature led him to conclude that the reem was a one-horned goat that in

Bochart's time was still common in Arabia. He believed that this animal was one-horned because Aristotle and Pliny said so. The Arabic name of the beast is rim – meaning white goat or something similar according to Arab and rabbinical sources – suggesting a connection with the Hebrew word reem. As the rim frequents biblical lands the ancient Hebrews may have been familiar with it. And though it is not an enormous animal it is a large member of what Bochart believed to be the goat family. References to the reem's great size and strength should not be considered absolute, Bochart argued, but rather relative: compared with other types of goat the rim really is large and powerful! Bochart's animal, reproduced in Fig. 3.1, does not look like the reem, nor even much like the rim, an animal better known as the Arabian oryx (see Fig. 2.1). As the unicorn scholar Odell Shepard once wryly commented, such are the charming results of studying zoology in a library. However, recast Bochart's argument in simpler terms having first removed some sixteenth-century zoological errors and his idea seems workable. Like this: the Septuagint did not know what a reem was, but context dictated that it had to be horned, indomitable and not a common-or-garden bull; Aristotle had mentioned in passing an animal that fitted the bill, the oryx, which he believed had only one horn; in Greek such an animal – such a notion – could be called monoceros; thus, perhaps the idea of the oryx lies behind the Septuagint's use of that word.

In any case, with Bochart's reputation behind it the rim-is-reem

3.1 Samuel Bochart's rim, supposedly the Arabian oryx (see Fig. 2.1)

idea gained many adherents. After a cooling-off period during the eighteenth century, when the study of unicorns and other inconsequential topics became unfashionable, Jerome's comfortable rhinoceros theory came back into vogue. Enthusiasm for the idea then ebbed away again, mostly because it was felt that the rhinoceros was neither strong nor fast enough to be the reem, which leaves one wondering what type of animal would have been satisfactory.

Then came a linguistic breakthrough. From approximately 3000 BC to around the time of Christ the inhabitants of Mesopotamia used a type of writing known to scholars as cuneiform – 'wedge-shaped', referring to the triangular marks made by pressing a tapered reed stylus into clay. Until the second quarter of the nineteenth century

no one knew what cuneiform squiggles meant, but in 1835 Henry Rawlinson, an English army officer serving as the British consul at Baghdad, studied an inscription carved into a remote cliff at Behistun in Persia. Made in the reign of King Darius (522–486 BC), the carvings recorded identical texts in three languages, Babylonian, Elamite and Old Persian. Having deciphered the Old Persian, Rawlinson and others began the task of figuring out the more exotic texts. The Elamite inscription was the next to be partially deciphered, and by 1851 200 ancient Babylonian characters had been translated (linguists now understand 600 or so). Unsurprising to those familiar with Persian history, the inscriptions recorded that Darius and his works were Extremely Great.

Mesopotamian cuneiform texts contained many instances of a word that brought to mind an old controversy about the origin of the biblical unicorn. The word transliterates as rimu – about as close to reem as Bochart's rim – and the animal to which the word was always attached, sometimes symbolically when warrior-kings compared themselves to one, was a huge, powerful and dangerous creature that had been venerated by ancient Mesopotamians thousands of years before Judaism came into being. The writers of the Hebrew Bible may also have known it, though no one knows when the rimu died out in the Near East. Whether the Hebrews knew it in the flesh or merely as a cultural memory, they would have been in no doubt about the kind of animal that it was: a large and fearsome, though otherwise ordinary, ox.

Called *Bos primigenius* by scientists and known among Germanic peoples as the aurochs, the rimu was native to Eurasia from the last Ice Age until AD 1627, when, upon the death of the last female in the forests of Jaktoròw in Poland, the species succumbed. Humans were responsible for the decline and fall of this magnificent animal, which had formed the raw material from which pastoralists 8000–9000 years ago fashioned a user-friendly ox, which gave rise to 1000 breeds of *Bos taurus*, more familiarly known as the domestic cow.

The size of the aurochs has been the source of controversy. Modern estimates vary between 1.4–2.1 m at the top of the shoulder for males. The former figure is on a par with modern domestic cattle, whereas the latter would make the aurochs a monster. Taking a middle estimate of 1.75 m, a man of average height would have to look upwards into a bull's eyes. Curiously, the aurochs was almost as tall as it was long, like a very large box on legs. Fully grown bulls probably weighed up to a tonne.

Information on the animal's behaviour is old, scant and not very reliable. Nevertheless, it is clear that during the mating season bulls fought spectacularly. Aurochs were also unafraid of humans – a terrible misjudgement – and renowned for becoming hot tempered when teased or hunted, perhaps not surprising for a not-too-distant relative of the Spanish fighting bull.

Having found the reem we can at last read Deuteronomy 33. 17 as its author intended. He meant us to understand that God's glory

can be compared with that of a firstborn,[20] and that his horns are like the horns of a very big ox: with them he will push everyone in the world together. Which makes a lot more sense.

Those who would keep the mysteries of Judaism and Christianity mysterious may favour the Septuagint's traditional translation, but from another point of view the coming together of the rimu and the reem is a relief. After more than 2000 years of semantic confusion it is comforting to know that Judaism's and Christianity's spiritual fore-fathers, who bequeathed their descendants such joy and inspiration, and upon whose words so many people in our troubled world rely, were the sort of folk who could count up to two and who knew a big cow when they saw one.

Once the unicorn had been inserted into scripture by the Septuagint the question of its corporeality and geographical home became a scholarly side issue. The riddle of the unicorn's meaning took prece-dence: what it heralded, what it had been put on earth and into the holy books of Judaism and Christianity to signify. References to the animal in scripture are vague, and observing unicorns in the wild has never been easy, so figuring out the beast's significance required cre-ative thinking. The full breadth of the Christian imagination was let loose on the problem of the meaning of a creature that was of the

20 In the Old Testament writer's culture, firstborns, human or bovine, were of particular significance and much celebrated.

utmost importance to God (it was in the Bible) but which otherwise did not appear to exist.

Among the earliest writers to glimpse – one might say manufacture – a link between the unicorn and Jesus was Tertullian of Carthage (AD 160–220), a lawyer born seventy years after the New Testament was composed. His interpretation of Deuteronomy 33. 17 – 'His glory is like the firstling of his bullock, and his horns are like the horns of unicorns: with them he shall push the people together to the ends of the earth' – is more obscure than the passage it attempts to explain, but within it can be seen glimmerings of the unicorn's future.

It is not the rhinoceros that is designated as a Unicorn and the Minotaur as two-horned, but Christ is designated thereby: as a bull on account of two characteristics: For some He is cruel as a judge, for others mild as a Saviour. [The bull's horns are] the furthest ends of the cross. For on the yard of a ship, which is part of a cross, the outermost ends are called horns. But the pole in the centre is called one-horn. Finally, it is by virtue of this cross that, according to the custom of horned animals, He pierces every race with faith, lifting them from earth to heaven.[21]

21 Gotfredsen (1999).

Here is a rough translation: it would be missing the point to think that the bull and unicorn refer to animals, that is, the minotaur and rhinoceros. Bull and unicorn together refer to Christ. Bulls are sometimes brutal, sometimes mild, just as Christ was. Moreover, a bull's horns are like the horizontal beam of the cross (the ends of a ship's yard-arm are called horns, which just goes to show). And the yard-arm forms a cross-shape with the vertical mast of a ship, the mast being called one-horn. The centre-post of the cross is thus the unicorn's single horn. Together, therefore, these animals' horns represent the cross. People of all races will be pierced and lifted from earth to heaven by the sharp horn of faith as prophesied by Moses in the Old Testament, just as the bull and the unicorn pierce things with their horns.

Tertullian's exegesis is actually far from straightforward. Deuteronomy is in the Old Testament, yet the bull and the unicorn supposedly represent the cross and thus Christ, who lived centuries after the Old Testament was compiled. Tertullian is interpreting the Old Testament as prefiguring the important part of the Judaeo-Christian story as he sees it, which is the life of Christ. Needless to say, those who consider the Old Testament to be the Only Testament are rarely happy with Christians taking this sort of liberty with their sacred texts. The title of the work in which Tertullian's interpretation appears – *Against the Jews* – offers a hint about the extent to which the author's reasoning was driven by his desire to arrive at a particular conclusion.

Be that as it may, people throughout history, including the medieval artists, stonemasons, manuscript illuminators and tapestry weavers who represented the unicorn in their work, interpreted Tertullian's and other Christian thinkers' words in simple ways. A cursory reading of Tertullian's exegesis suggests that the unicorn is a symbol of the cross, or at least of part of the cross, and the cross is the most emotive symbol of Christ. The unicorn and Christ are moving together, and in a symbolic sense they are beginning to fuse.

More influential than Tertullian was Bishop Ambrose of Milan, who lived and worked in the fourth century AD (340–397), later revered as one of the four Latin fathers of the Christian Church. 'Who is this unicorn,' he asks, 'but God's only son? The only word of God who has been close to God from the beginning! The word, whose horn shall cast down and raise up the nations?'[22] Ambrose leaves his readers in no doubt that the unicorn represents Christ – God's son and God's word – adding that Christ/the unicorn is the only word to have been with God from the start. Since God preceded Creation the unicorn must have been with God in the Garden of Eden before the advent of Adam and Eve. The conjunction of God, the unicorn and the Garden of Eden became a favourite motif among artists, craftsmen and writers thereafter, cementing the idea that the unicorn represented the most important character in the Christian story.

22 Gotfredsen (1999).

By such interpretive convolutions, by Tertullian, Ambrose and other commentators of the early Church, a Jewish cow gradually metamorphosed into a symbol of Christ. But being partially dehorned, forced into the Greek Bible and reshaped into Jesus' doppelgänger was only the start of the reem's career within Judaism's burgeoning offshoot. The Christian fathers left no stone unturned in their interpretation of scripture, but the unicorn was just one small stone among many. The full flowering of the unicorn's symbolic potential required more elbow room than the codified framework of scripture would allow. Fortunately for the unicorn and posterity the Bible was not the only source of revealed wisdom on Christianity's bookshelf. In another text, in which the Christian imagination truly ran riot, the unicorn would be placed centre stage.

CHAPTER 4

The iconic unicorn

Having fused with Jesus through the imaginative interpretations of early Christian theologians, the unicorn became ever more closely associated with key figures and scenes from Christ's life. Among the most important of Jesus' friends and relations was his earthly mother. To understand the relationship between the unicorn and Mary we turn to *Physiologus*, a book of animal stories that in its time was almost as influential as the Bible. The cultural and geographical context of *Physiologus* is described by Odell Shepard:

Readers of Tertullian, Cassiodorus, and even Origen, will not need to be told that the habit of allegorizing not merely everything in the Scriptures but everything outside of them was at this time fastening upon the Christian mind. The world of nature, seldom valued for its own sake by the typical Christian, was more and more regarded as a storehouse of edifying

metaphors. What we should call facts were felt to be of little worth in comparison with the moral truths that alleged facts could be supposed to signify and it was considered that God had created the lower animals, particularly those that seemed to have no other use, solely for the moral and spiritual instruction of mankind. Very little of Aristotle's objective spirit and method was carried over into the Christian thought centring at Alexandria, disabled as that was from the start by a puerile moral-hunting and phrase-making, by the determination to make facts bend to the uses of edification and to see, almost literally, books in the running brooks, sermons in stones, and good – or, what was considered the same thing, moral significance – in everything.

So knowledge about the natural world, in particular pagan knowledge about animals gathered in previous centuries, much of it lodged in Alexandria's famous libraries, was turned to the edificatory and moralistic purposes of Christianity. Roger French clarifies a few matters:

For the Christian, God was so important that everything in His Creation signified Him. Parts of Creation become symbolic of God's actions. The natures of animals are . . . allegories of God. Perhaps indeed, thought the Christians, they have been put into the world for that very purpose, to repre-

sent aspects of God's creation and remind man of his Creator. If it was assumed (as some Christians did) that the lion was symbolic of the Devil, then it gave added understanding to the biblical statement to this effect if one knew about the nature and action of lions, [which] meant that looking at the natural world (or reading about it) was a religious affair, if not an actual Christian duty.

No one knows who wrote *Physiologus*, though Didymus of Alexandria, a Christian author of the late second century AD, is believed by some to be a candidate. In the past even Aristotle and King Solomon have been credited with authorship. Neither man had anything to do with the book, but such associations demonstrate the esteem in which *Physiologus* was held, at least by some, and in the case of Aristotle that the book's animal lore was thought to be authoritative. No trace of the original Greek manuscript remains, but versions in many languages, including Arabic, Armenian, Old and Middle English, Ethiopic, Flemish, Georgian, Greek, Icelandic, Latin, Provençal, Russian, Romanian and Syriac, have turned up all over Christendom and beyond. Around a hundred Latin versions and sixty or so more exotic translations of *Physiologus* and its offspring, the Medieval Bestiary, have come to light.

The title *Physiologus* translates approximately as he who talks about nature, or Natural Historian. The book unfolds in a formulaic way. Typically each chapter begins with words of wisdom

from Physiologus himself. Often he is referred to in the past tense – 'Physiologus said . . .' – suggesting that the Christian author drew on an existing stock of stories. Physiologus' contribution is then followed, interrupted or cut short by one or more morals. These allegorical pieces are usually rendered in the present tense and addressed to the reader. Thus Physiologus describes a beaver:

[There] is an animal called Castor the Beaver, none more gentle, and his testicles make a capital medicine. For this reason, so Physiologus says, when he notices that he is being pursued by the hunter, he removes his own testicles with a bite, and casts them before the sportsman, and thus escapes by flight. What is more, if he should again happen to be chased by a second hunter, he lifts himself up and shows his members to him. And the latter, when he perceives the testicles to be missing, leaves the beaver alone.

Then the moral:

Hence every man who inclines toward the commandment of God and who wants to live chastely, must cut off from himself all vices, all motions of lewdness, and must cast them from him in the Devil's face. Thereupon the Devil, seeing him to have nothing of his own about him, goes away from him

confused. That man truly lives in God and is not captured by the Devil who says: 'I shall preserve and attain these things'.

The creature is called a Beaver (Castor) because of the castration.[23]

People are prey for the devil just as the beaver is prey for people. The beaver protects himself by biting off his testicles and throwing them onto the ground, distracting the hunter and escaping with his other virtues intact. And should another hunter try his luck, the beaver lifts up his tail to show that his prize is already missing. To extract a Christian moral from this piece of natural knowledge the allegorist simply had to turn the hunter into the devil, the beaver into mankind, and the beaver's testicles into mankind's vices. Ordinary Christians who read (or more likely heard) the tale of the beaver would have thrust upon them a mental image that would be very difficult to get rid of.

Many of the moralistic stories in *Physiologus* and later bestiaries involve animals that are real and familiar to us, but others employ creatures that have long since passed into myth. The tale of the unicorn is one such:

UNICORNIS the unicorn, which is also called Rhinoceros by the Greeks, is of the following nature.

23 White (1954).

He is a very small animal like a kid, excessively swift, with one horn in the middle of his forehead, and no hunter can catch him. But he can be trapped by the following strategem.

A virgin girl is led to where he lurks, and there she is sent off by herself into the wood. He soon leaps into her lap when he sees her, and embraces her, and hence gets caught.

And the lesson:

Our Lord Jesus Christ is also a unicorn spiritually, about whom it is said: 'And he was beloved like the Son of the unicorns'. And in another Psalm: 'He hath raised up a horn of salvation for us in the house of his son David'.

The fact that it has just one horn on its head means what he himself said: 'I and the Father are One'. Also, according to the Apostle: 'The head of Christ is the Lord'.

It says that he is very swift because neither Principalities, nor Powers, nor Thrones, nor Dominations could keep up with him, nor could Hell contain him, nor could the most subtle Devil prevail to catch or comprehend him. But, by the sole will of the Father, he came down into the virgin womb for our salvation.

It is described as a tiny animal on account of the lowliness of his [Jesus'] incarnation, as he said himself: 'Learn from me, because I am mild and lowly of heart'.

It is like a kid or scapegoat[24] because the Saviour himself was made in the likeness of sinful flesh, and from sin he condemned sin.

This unicorn often fights with elephants, and conquers them by wounding them in the belly.[25]

Several versions of the unicorn tale exist in *Physiologus'* texts and bestiaries. The man who leads the virgin into the woods is frequently identified as a hunter or trapper. Once the maiden has pacified the

24 In Leviticus 16, the goat upon whose head Aaron symbolically put the sins of the people on the day of atonement, after which it was led away into the wilderness; more broadly, any animal or person onto which sins or misfortunes are symbolically placed in order to be rid of them.

25 In the Latin bestiary from which these passages have been taken (White 1954) there are two one-horned animals, unicornis and monoceros, the former small and the latter large. In earlier times the two beasts were often wholly or partially mixed together. Eventually they parted company, because even Christian allegorists had trouble imagining an animal that was both small and large at the same time. The little unicornis took most of the Christian symbolism, whereas the monoceros retained the characteristics of the one-horned creature of Greek and Roman authors (though in the first line of the passage quoted the supposedly tiny unicornis is equated with the rhinoceros, and in the last line it apes its larger cousin and picks a fight with an elephant). The monoceros passage in the same Latin bestiary harks back to Pliny (Chapter 2); it reads: 'The MONOCEROS is a monster with a horrible howl, with a horse-like body, with feet like an elephant, and with a tail like a stag's. A horn sticks out from the middle of its forehead with astonishing splendour to the distance of four feet, so sharp that whatever it charges is easily perforated by it. Not a single one has ever come alive into the hands of man, and, although it is possible to kill them, it is not possible to capture them.'

unicorn, he leaps from his hiding place, captures or kills the soporific beast, and takes it to the palace of the king.

The Christian interpretation of the tale is straightforward. The unicorn is small, as Christ was lowly and humble; it evades huntsmen, as Jesus evaded the power of human institutions and hellish influences; it is like a (scape)goat that rids people of problems, just as Christ rid us of sin; its one horn symbolizes salvation and the oneness of Christ and God; and the primal unicorn is tamed and brought into the sphere of men with the aid of a virgin, as Jesus was sent by God into the womb of Mary, from where he was born into the world. The hunter is usually identified with the will of God or the Holy Spirit, since God is the controlling force behind the whole Christian story. The conjunction of the unicorn, Mary, God and the Holy Spirit refers to Christ's Incarnation, a theme that would be developed by artists until its allegorical complexity became quite bewildering.

Some of the parallels between zoology and Christian dogma in the *Physiologus* tale of the unicorn and the maiden are so obvious that one wonders whether Christian allegorists invented the Natural Historian's contribution to mirror the relationships between God, Christ and Mary as revealed in the New Testament. The Latin *Physiologus* was only one translation of the original Greek text, however, and by the time we arrive at medieval bestiaries of the second millennium the story had passed through so many Christian hands that it would be surprising if zoology and moral remained very far apart. Clues to the origin and early development of the tale lurk in older *Physiologus* texts.

The diversity that must once have existed among different versions of the unicorn–maiden tale can be seen in a surviving copy of a Provençal bestiary in which the unicorn plays the role of the devil. The Christian moral tacked onto the end implies that evil can be outwitted only by virtue, represented by the maiden who subdues the unicorn. The more typical story is set out in a translation of *Physiologus* into Syriac (a form of Aramaic, a semitic language related to Hebrew and Arabic), perhaps composed as early as AD 300:

There is an animal called *dajja*, extremely gentle, which the hunters are unable to capture because of its great strength. It has in the middle of its brow a single horn. But observe the ruse by which the huntsmen take it. They lead forth a young virgin, pure and chaste, to whom, when the animal sees her, he approaches, throwing himself upon her. Then the girl offers him her breasts, and the animal begins to suck the breasts of the maiden and to conduct himself familiarly with her. Then the girl, while sitting quietly, reaches forth her hand and grasps the horn on the animal's brow, and at this point the huntsmen come up and take the beast and go away with him to the king.

Likewise the Lord Christ has raised up for us a horn of salvation in the midst of Jerusalem, in the house of God, by the intercession of the Mother of God, a virgin pure, chaste, full of mercy, immaculate, inviolate.[26]

26 Shepard (1930).

The zoological section is familiar, though the beast has not yet been dwarfed to reflect Christ's lowliness (he is already gentle, however). The middle of the passage is where we see a departure from the story as it was eventually codified. The author implies that the maiden is a virgin, emphasizing the point with the phrase pure and chaste, yet once the unicorn has thrown himself upon her she begins to behave in a way that, far from evoking her chastity and innocence, suggests a good deal of experience and not a little knowledge of technique. She exposes her charms and he takes up the offer. Having distracted her quarry, the girl reaches out and grasps the unicorn's horn, after which his wild and carefree days appear to be over. As Odell Shepard once delicately put it, 'In the Syriac bestiary . . . the decoy is so obviously not a virgin that no unicorn with the slightest discernment in such matters should have been deceived by her.'

The moral also seems out of place: it is not so much harmonized with the zoological section as ripped from somewhere more appropriate and inexpertly nailed on. It foists a Christian interpretation upon a tale that was far from adequately prepared to receive it. We can even guess how the story might have been perpetuated, since it was probably passed down through a lineage of male storytellers and scribes, each of whom may have found himself strangely reluctant to delete the good bit.

In any event, the Syriac *Physiologus* suggests that Christians did not

make up the unicorn–maiden tale, for had a second-century Alexandrian Christian invented the platonic version of the story we would need to imagine a third- or fourth-century Christian changing it to imply a sexual relationship between Christ and his mother. What we appear to have is an echo of an ancient non-Christian tale about a wild creature, symbolizing the younger, carefree, wilder side of maleness, and its life-changing interaction with the feminine sex. Over the centuries this primeval story was remodelled to serve a Christian purpose. The tale of the unicorn and the maiden joins a host of other pagan ideas, natural knowledge, religious practices and seasonal festivals that were gradually adapted and finally absorbed into the traditions of Christianity in the 1000 years or so after Jesus' death.

Having found its way into *Physiologus* the unicorn's double-act with the maiden blossomed, especially in the visual arts. An early representation of the story can be seen in a manuscript illumination from the Theodore Psalter (Theodore was an eleventh-century priest) held in the British Museum (Fig. 4.1). The maiden is seated calmly and not provocatively before a dangerous-looking one-horned animal. Above the main illustration Theodore has drawn a golden medallion depicting the Madonna and Child, linking the main scene to Christ's becoming flesh and blood via Mary. The unicorn is Jesus, the maiden is (or is becoming) Mary, and the scene depicts the Incarnation.[27]

27 See Gotfredsen (1999).

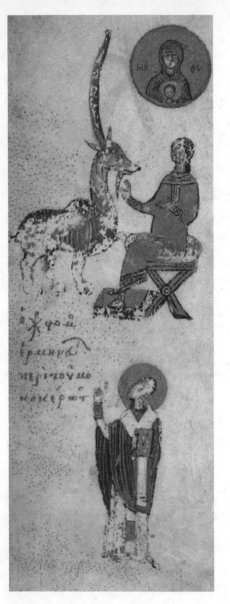

The maiden in the Theodore Psalter is an interesting mix of present and absent symbols. Her robe is blue, the colour traditionally associated with the Virgin Mary (blue was once the most expensive colour in an artist's palette and usually reserved for the most important parts of an illustration), yet she lacks a halo, an accessory that would later become the default symbol of the divine in Christian art. On the same page in the original manuscript the Greek Church father John Chrysostum is drawn with a golden halo above his head, so the absence of a halo above the maiden suggests her equivocal status. In early illustrated psalters and

4.1 Illuminations from the
Theodore Psalter, 1066

Physiologus texts, a dozen or so of which are known from the period AD 800–1000, the maiden is rarely shown with any of the trappings of divinity, perhaps indicating that the attitude towards the allegory at this time was weighted on the side of the unicorn with the maiden playing a supporting role. The antiquity of the Theodore illustration can be seen in the unicorn itself, which is large and powerful, echoing the animal of Hebrew scripture and the Indian ass of the Greeks and Romans.

As the Middle Ages progressed Christian imagery became symbolically ever more complex, leading to some of the most information-laden images in the history of art. An example is the unicorn–maiden coupling illustrated in a bestiary of the thirteenth century (*c.* 1210), 150 years after Theodore's Psalter (Fig. 4.2). The most obvious additions are the two characters entering stage right. These supporting actors began to appear around 1100, and embody references in *Physiologus* texts to the hunters who capture or kill the unicorn and take him to the palace of the king. Artists had begun to catch up with elements of the tale that had been lurking in Christian literature for hundreds of years. Who or what do the hunters represent?

Physiologus usually implies that the hunters symbolize the Holy Spirit or the will of God, but to see why we have to excavate through an intervening layer of meaning. To Christians, the king can only be God. Christ agreed to do God's bidding and be born a man. He was captured in Mary's womb and delivered into the mortal world to die at the hands of mankind. From these parallels it might at first seem that

the huntsmen represent the enemies of Jesus, the people who were involved in his persecution and crucifixion. This impression is strengthened by the hunter who pierces the unicorn with his spear (Christian artists eventually settled on the spear-carrier as the obligate assassin), since Jesus was speared in the side as he hung from the cross.

Yet the hunters-as-enemies explanation is not satisfactory. Christian

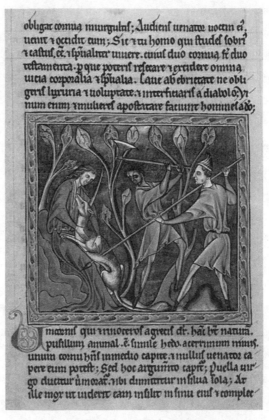

4.2 Scene from the Ashmole Bestiary, *c.* 1210

artists clearly represented Jews or other figures they considered sinister when they wanted to, and neither of the armed characters is obviously Jewish. Some early *Physiologus* texts do implicate the Jews, but this illustration does not, and generally speaking Christian thinkers of the period had moved on from scapegoating to more complex ideas. Nor is either hunter obviously Roman. The man wielding the axe is conspicuously dark-skinned, and while Roman soldiers were drawn from all over the empire, axes were not archetypal Roman weapons. In fact foreign hunters, usually equipped with axes or exotic hats to symbolize their otherworldliness, are common in medieval depictions of this allegory. Further, if the hunters represent Jesus' enemies we might expect to see some sign of evil or aggression in their faces, but their expressions are quite placid, and Mary is as emotionally unaffected by the grisly business as her son's attackers. If the artist intended to inveigh against the people responsible for Jesus' death, he did not do a very good job.

The key to understanding this piece of artwork is the historical and theological soil from which it grew. Foreign-looking people were often used in Christian art to represent people of other nations. The Bible implies in several places that the grace of God is available to all people, regardless of where in the world they happen to live, whatever they happen to look like, and whatever they might currently believe in. So perhaps the armed men are not so much hunters as seekers of God's grace, of his salvation, represented in the world of men by Jesus, who in turn is represented by the unicorn.

Looked at in this way the axeman and spear-carrier might be agents of God, mortals who are nevertheless essential elements of, and honourable participants in, God's divine plan. Perhaps this is why they look so serene. Mary's benign demeanour would make more sense in this context too.

The illustration, then, appears to be a religious reinterpretation of the unicorn–maiden tale. God is all-knowing, so he must have known that his son would die in pain and misery; moreover, since God is infallible, he must have approved. The hunters who were responsible for ushering Christ to the palace of the king are carrying out God's will, as is Mary. The hunters are the seekers of God's grace, which they find through the blood of Christ, and they symbolize all the peoples of God's creation who will find salvation in the same way. We have come a long way from the Syriac *Physiologus* and its erotic tale of the unicorn and the virgin.

Another branch of unicorn iconography makes the relationship between the hunter and the will of God more explicit. An example can be seen in a tapestry dating from *c.* 1500 (Fig. 4.3). Scenes of this type started to appear in the mid-thirteenth century and developed over the next few hundred years into complex symbolic representations of iconic Christian personalities and relationships. On the right of the scene we find the now familiar figure of the maiden – the divine Mary, complete with halo – with the unicorn, Jesus, in her lap. The hunters have disappeared, but on the left a different character has taken their place. He has wings on his back,

a trumpet in his mouth, dogs at his feet, and a banner inscribed with the most famous greeting in the Bible: Ave Maria, Gracia Plena (Hail Mary, Full of Grace). The winged being is the Angel Gabriel, that ubiquitous carrier and interpreter of God's messages, who was sent to Mary with the news that she had been chosen to bear God's son. In such scenes Gabriel's hunting dogs often, though not always, have banners attached to them, inscribed with a selection of Christian virtues, typically mercy, truth, righteousness and

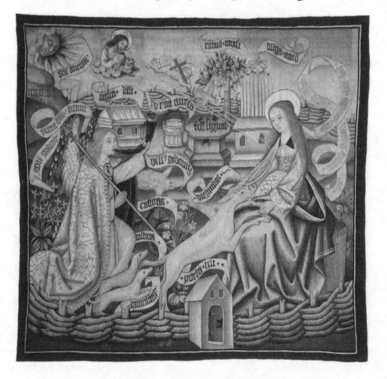

4.3 'Holy Hunt' tapestry, lower Rhineland, *c.* 1500

peace.[28] God's judgement (truth and righteousness) and forgivness (mercy and peace) were reconciled through the Incarnation of Jesus, a notion prefigured in Psalm 85.10: 'Mercy and truth are met together – righteousness and peace have kissed each other.' The number and meaning of the virtues can vary: when two dogs are present they usually represent mercy and peace, the less forgiving characteristics having been removed to emphasize God's forgiveness and grace; three dogs usually refer directly to Mary and her principal virtues: faith, hope and charity.

There are many references in the tapestry to Mary, and more broadly to the idea of the virgin birth. The garden in which she sits

28 In the sixth century, St Gregory the Great identified what came to be known as the seven deadly sins: anger, envy, gluttony, greed, lust, pride and sadness (the last was later replaced by sloth). Seven heavenly virtues were later coined: fortitude, justice, prudence, temperance (cardinal virtues), faith, hope and charity (theological virtues). Even earlier, at the end of the fourth century, the Spanish poet Prudentius wrote a poem called *Psychomachia* that became influential among Christian artists, in which virtues and vices were pitted against one another. To pair with Gregory's seven deadly sins artists settled on seven corresponding virtues: humility (versus pride), patience (anger), chastity (lust), liberality (greed), kindness (envy), abstinence (gluttony) and diligence (sloth). Animals were sometimes associated with particular virtues or vices, but absolute codification was never achieved; artists sometimes chose virtues, vices and their associates according to artistic circumstance or whim, or perhaps we do not understand what they were thinking, which in many cases is just as likely. Animal characters associated with the virtues or vices often appear to be little more than carriers, devices used to prevent the banners on which the words are written floating in mid air.

is the hortus conclusus, the enclosed garden of the biblical Song of Solomon, indicating Mary's chastity (the garden is closed) and the womb in which Christ was destined to grow. At the bottom centre of the picture is another reference to Mary's unsullied state, the closed portal of the Old Testament prophet Ezekiel, through which 'the King passed gloriously in and out', just as God alone passed in and out of Mary. Yet another device lies under Gabriel's outstretched hand, Gideon's fleece, which, according to the Old Testament, 'God sprinkled with his celestial dew'. In the minds of medieval artists this reference offered an irresistible metaphor for Mary's primary function in the Christian story.

So far we have little more than a restatement of the Incarnation imagery of previous centuries with the addition of Gabriel and his dogs, who together symbolize the Annunciation. But there is more than mere potential in the tapestry's composition. At the top of the image, peering down from on high, is God the Father, now an active participant in events. From top left to bottom right he breathes his will into Mary. Along the path of God's breath, slanting down towards Mary and by implication the rest of humanity, crawls a baby kitted out with a tiny crucifix. Much of the Christian story and not a little Christian dogma have been compressed into a dense symbolic composition showing the relationships among the major characters in the Christian drama, Christianity's view of itself and its iconic personalities, and unmistakable allusions to the Annunciation, the Incarnation, the Passion, the Crucifixion and,

with the unicorn cradled in Mary's lap, perhaps even the post-Crucifixion scene of the Pietà.

And this tapestry may proclaim even more. From the eleventh to the late thirteenth centuries a number of alternative forms of Christianity swept across Western Europe. The most important was the Catharist interpretation, which, contrary to orthodox doctrine, held that the universe was split with equal power between good and evil, and that the earthly realm was entirely the domain of Satan. The Catholic Church maintained that heaven and earth had been unified by the coming of Jesus: Christ's becoming human healed the rift between God and mankind caused by Adam and Eve's behaviour in the Garden of Eden. Catharists denied the Incarnation, since a union between Satan's and God's realms was beyond imagining. Jesus and the Virgin Mary might be spirits or angels, Catharists argued, but they could not be human. The controversy ended badly for the reformers, orthodoxy emerging victorious after a battle that descended into barely imaginable savagery. In the tapestry we perhaps see a subtle stratagem for promoting the Catholic view through art. Note the conjunction of Mary's divine and earthly natures; the dense references to her virginity, which make explicit the intimate connection between the earthly and the divine; Gabriel's descent from heaven to Mary on earth to deliver the Annunciation, underlining the immaculate union of the divine seed and the corporeal womb; the downward descent of the baby Jesus to the world of sinners, already carrying the cross on which his mortal body would be tortured and killed, and

thus also the promise of God's greatest gift, the blood of Christ. Finally there is the unicorn. The beast may seem superfluous given that the infant Jesus is crawling down God's breath towards Mary, but in the scene both mother and son are represented as divine – they are fitted with halos – whereas the unicorn is, as *Physiologus* makes clear, an earthly creature. All in all, the image overflows with symbols of the physical connection between the world of God and the world of people, and even contains symbolic arrows emphasizing that *this* aspect of the divine connects with *that* aspect of the earthly. Such images may well have served as powerful Church propaganda from the eleventh to the thirteenth centuries, and by the year 1500 perhaps we have the kind of emphatic, triumphant imagery, imbued with tacit warnings about the consequences of further miscreance, that the winners of wars throughout history have typically churned out.[29]

The unicorn may thus have been part of a complex representation of Church dogma and power in the early centuries of the second millennium, but at the same time unicorn iconography began to leak out of its traditional religious context into settings that were partly or wholly secular. In the later Middle Ages much of Europe became obsessed by the idea of courtly love, of chivalry, of woman-worship, of the longed-for but invariably ruinous attractions of the female. The basic link between the unicorn and the maiden offered poets and

29 See Mohacsy (1988).

artists a ready-made metaphor for love, from the nobly unrequited to the distinctly earthy. At the erotic end of the spectrum French poets and artists frankly articulated the latent potential of a bestial symbol of maleness equipped with a phallic object in close proximity to a woman, but more often than not the secular and religious elements of unicorn iconography are difficult to disentangle.

Perhaps the most famous religious–romantic works of medieval unicorn art are the Verteuil Tapestries of around 1500. There are seven panels in the series, four of which are shown in Figs. 4.4–7.[30] The first shows the unicorn as the object of a hunt. The many hunters in the scene, nobly born and otherwise, along with their weapons, horns and dogs, correspond with contemporary descriptions of medieval stag chases. In this panel the participants have reached the most exciting stage of the day's activities: the quarry is

30 The story runs (Freeman, 1976) that in the 1850s a farmer's wife called in on Elizabeth de la Rochefoucauld at the Chateau of Verteuil to enquire whether madame might be interested in taking a look at some old curtains that her husband had been using for years to protect his potatoes from the frost. The farmer's improvised fleeces turned out to be the Verteuil Tapestries. If this story is true it is surprising that six of the seven panels have survived in such good condition. Whether or not the tapestries form a series as such has been the source of some controversy over the years, since the first and last panels are stylistically similar to each other but different from all the others (note the different treatment of the backgrounds in the two scenes in Figs. 4.4 and 4.7). Iconographically the scenes all hang together, however, and it seems likely that the middle panels were intended for one function in a building or room and the first and last for another.

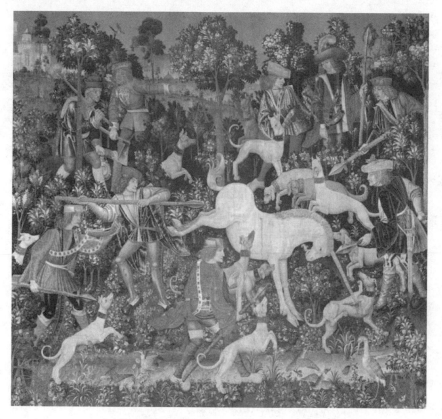

4.4 Scene from the Verteuil Tapestries, *c.* 1500

cornered and at bay. This was the most dangerous part of a stag hunt, during which both dogs and men were often injured or killed. The unicorn is an even more forbidding opponent, of course, since unicorns are too belligerent and strong to be captured by men with swords and spears.

The presence of the unicorn in an otherwise normal medieval stag hunt reminds us that there is probably more to this scene than meets the eye. Notice the handsome chap in the bottom left of the image, wearing a golden hat and blowing a horn. Hunters in medieval chases communicated messages to each other using horns, so his behaviour is not out of place in a secular context, but the message on his scabbard is curious. It appears to read (though part of it is hidden under his tunic) Ave Regina Coelorum. This is a variant of the greeting Hail Mary, Full of Grace, and also the title of a popular hymn of praise to the Queen of Heaven. What is the Angel Gabriel doing in the middle of a medieval hunt? He is heralding the conjunction of the unicorn and the maiden, which in the Verteuil series takes place in the next tapestry. In a religious context he is announcing the Incarnation; in a secular context he appears to be saying to the hunters, 'This is hopeless; you'll never take this brute; bring on the maiden!'

The tapestry that once showed the unicorn with the maiden was badly damaged – shredded it seems – at some point in the past (Fig. 4.5). Of the original scene only two thin strips survive, and of the maiden only a sleeve under the unicorn's chin and a hand at the base of his mane (the presence of the better preserved woman with the ambiguous expression is a puzzle). In spite of the damage it is clear that the maiden has worked her traditional magic on the unicorn. In the next panel (Fig. 4.6, top left) the pacified unicorn is slain, mirroring the *Physiologus* account of hunters leaping from their hiding place to capture or kill the beast. The defeated unicorn is slung across

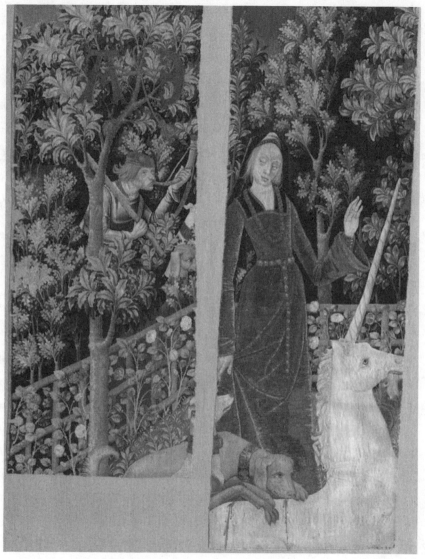

4.5 Scene from the Verteuil Tapestries, *c.* 1500

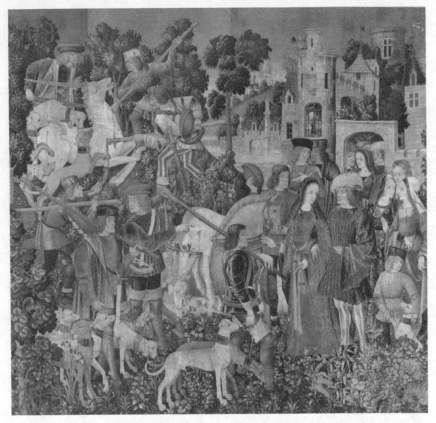

4.6 Scene from the Verteuil Tapestries, *c.* 1500

a horse's back and is on its way to the palace of the king, which in this case comprises a gathering of noble folk and their courtiers in front of a medieval castle.

Though the simplest, arguably the most interesting panel is the last (Fig. 4.7). It contains a host of symbols that can be interpreted in

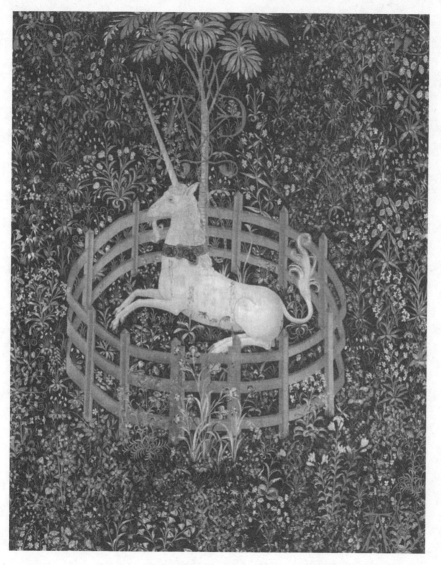

4.7 Scene from the Verteuil Tapestries, *c.* 1500

the context of traditional religious iconography or the late-medieval fascination with courtly love. These contexts have been intimately intertwined, one suspects on purpose. The unicorn is, of course, Christ. Having been slain by the hunters he is resurrected and now resides in heaven, the ultimate palace of the king. The divine sphere is indicated by the fence enclosing the unicorn, which forms a circle, the symbol of heaven, rather than a square, the symbol of earth (the fence in the damaged fifth panel, which depicts Christ's earthly incarnation in Mary, forms a square). The resurrected unicorn is chained to a tree. No one has managed to identify which species of tree this is. Probably no one ever will. The makers of the tapestries were accomplished at representing oak trees (strength, fortitude, faith) and holly trees (Jesus' suffering) when to do so was symbolically appropriate, and it is quite difficult to draw a realistic-looking tree without connoting its kind. It is likely, then, that the tree is supposed to be free of obvious symbolic associations. The artist depicted not *a* tree, but *the* tree, most obviously in the present context symbolizing Christ's cross, the tree of redemption. Less obviously it symbolizes the tree of life, which was denied to Adam and Eve because they partook of the fruit of that other tree in the Garden of Eden, the tree of knowledge of good and evil. Thus were Adam, Eve and the rest of humanity refused eternal life; until, that is, Christ, the new Adam, healed the rift between God and mankind by sacrificing himself on the tree of redemption. According to medieval legend the tree of redemption was made from the tree of life. More broadly, the

Christian tree carries echoes of the ancient idea that trees connect the underworld, the human world and the heavens (roots, trunk and twigs), which in many ancient tales allowed mortals to climb from the earthly plane to the realm of the gods. Tellingly, though the tree appears to be generic, the fruits hanging from it are not. They are pomegranates. The blood oozing from the unicorn's wounds is pomegranate juice – seeds are visible in larger format images. Pomegranates were a common Christian symbol of the Church, new life, eternal life and resurrection, because they are full of seeds and the potential for rebirth.

Alongside the dense religious symbolism can be read a more earthly interpretation. The unicorn is male. The hunter is subdued by love and by the maiden – his earthly lover, his heart's desire – and is now tied by a chaîne d'amour, a standard pictorial and poetic device of the time, to the tree, an ancient symbol of woman, because trees give sustenance and produce new life once a year. The circular fence represents the male's divine view of the lover who has captured his heart and also the womb within which he hopes new life will be created. And from symbolic associations that are even older than Christianity, dating back at least to the ancient Greeks and probably much further, the pomegranate with its abundance of seeds represents fertility in general and male fertility in particular, and thus the hope that the chained couple's love will one day bear fruit of its own.

So intimately are secular and religious contexts entwined that a

finely conceived commingling of traditions was surely not the result of the artistic endeavour so much as the point of it. The deconstruction of such a work, isolating and explaining its contexts and elements one by one, is a very modern way of trying to understand, but one suspects that the tapestries' designer would be horrified to witness the systematic unravelling of his work in such a way. So let us halt the interpretation game and appreciate the Verteuil Tapestries for their mastery, their quite exquisite beauty, and for their remaining symbolic mysteries.[31]

How strange, wonderful and human that all the complexity and subtlety of unicorn art is rooted in the misunderstanding of a single word, a confusion that turned an ordinary two-horned ox into a one-horned beast of indeterminate taxonomy. The case of the unicorn is not isolated. If there is any implication in Hebrew scripture that the Messiah's mother was a virgin, it is only slight. In Hebrew, Isiah's chosen word means young woman, not virgin, and in any case all that the prophet had predicted was the birth of a royal prince in the late eighth century BC.[32] It was later interpreters who connected Isiah's young woman prophetically to Mary. So in the symbolic conjunction of the unicorn and the virgin we have the coupling of two highly

31 See Freeman (1976) and Gotfredsen (1999) for extensive treatments of the Verteuil Tapestries and unicorn iconography in general.
32 See Lane Fox (1991).

questionable acts of biblical exegesis. To atheists such quirks are ammunition, but to agnostics and enlightened theologians they are simply treasures, part of the richness of human culture without which the study of history would be much less interesting.

Though the unicorn and the virgin cropped up in art for the next 500 years, the dense symbolism seen at the height of their popularity in the fourteenth and fifteenth centuries would never be witnessed again. The allegory fell out of favour around the time of the Council of Trent (1545–63), which drew up guidelines on styles of art acceptable to the Church. With its ambiguous symbology, the unicorn fell foul of the moralizing atmosphere of the time. Perhaps this is a blessing in disguise: the iconography we have has propelled scholars around in interpretative circles for centuries; no doubt they will be going around for some time to come.

While the unicorn's days as a religious symbol were numbered in the mid-sixteenth century, its secular career was expanding. Partly this was due to the leakage of unicorn symbolism from Christian to secular art and literature, but mainly it reflected escalating demand for the beast's defining characteristic.

CHAPTER 5

Beneficent unicorns

The unicorn's most prominent feature is the horn on its head. This cranial spike is usually called alicorn by modern writers, a term popularized by Odell Shepard to avoid, in his words, the repeated cacophony of phrases such as horn of the unicorn, unicorn horn, unicorns' horns, the substance of which unicorns' horns are made, and so on. Alicorns are thus unicorns' horns, an alicorn is a unicorn's horn, and alicorn is the material of which a unicorn's horn is composed. The term is based on the old Italian word alicorno, which seems to have been born of three parents: Arabic (al for the), French-Romance (li for the) and Latin (cornus for horn). The doubled definite article was no doubt accidental, but the emphasis is fitting – *the* horn.

In late-medieval and Renaissance times, alicorn was among the most sought-after commodities in Europe. Many alicorns circulated during this period, often passing as prestige gifts from one royal

house to another. Some of these noble horns were donated to churches, and on occasion the Church stooped to outright purchase. By such means did most of Europe's alicorns end up in the hands of royalty or the clergy, where most examples remain.

Prices quoted for alicorns vary greatly, and one wonders how seriously to take many of them. In 1609 Thomas Dekker reckoned the value of a single horn at half a city, presumably an estimate intended to express wonder rather than any useful information. In 1553 an alicorn owned by the king of France was valued at £20,000, a figure that may be accurate or an illustration of the centuries-old competition between European royal families to be seen as the most magnificent. Half a century later the great horn of Windsor, one of several alicorns owned by the British royal family, was valued at £100,000.[33] When the alicorn bubble was fully expanded a complete horn was worth twenty times its weight in gold. Even diced or powdered alicorn was worth ten times its weight in gold.

Objects of great value elicit great admiration. A homage to alicorn typical in tone is provided by the Reverend Edward Topsell in his

[33] In this case we may have an early example of the phenomenon known to computer scientists everywhere as a decimal-point error. The valuation was made by the German traveller Hentzner in 1612, but a later reference to his work quotes £10,000. While it is tempting to interpret the latter value as a corruption rather than a correction of the former, £100,000 does seem an awful lot of money, even for an alicorn.

History of Four-footed Beasts, published in 1607. Of the horn owned by King Charles I, Topsell gushes:

> I never saw anything in any creature more worth of praise than this horn. The substance is made by nature, not art, wherein all the markes are found which the true horn requireth . . . It is of so great a length that the tallest man can scarcely touch the top thereof, for it doth fully equal seven feet. It weigheth thirteen pounds. The figure doth plainly signifie [it looks like] a wax candle (being folded and wreathed within itself) being far more thicker from one part, and making itself by little and little less towards the point . . . The splents of the spire are smooth and not deep, being for the most part like unto the wreathing turn-ings of snails, or the revolutions of wood-bine about any wood. But they proceed from the right hand toward the left, from the beginning of the horn even unto the very end . . . [B]y the weight it is easy to conjecture that this beast which can bear so great a burden in his head, in the quantity of his body can be little less than a great ox.

Agreement was reached about the archetypal nature of alicorn at an early stage, at least among the devout. White or ivory-coloured spirally twisted horns of the type described by Topsell began to appear on the foreheads of unicorns in Christian art around the year 1200. Within a century or so alicorns of this kind had become the iconographic

standard. From the thirteenth century onwards they were invariably described as unicorn horns in royal and ecclesiastical records. A few alicorns are known from inventories from the twelfth to the fourteenth centuries and many more from the fifteenth and sixteenth, so it seems likely that Christian artists remodelled the unicorn in response to an influx of new or previously rare biological artefacts.

Let us expose this horn without delay, for we have more perplexing matters to deal with. It belongs to a marine mammal known as the narwhal (Fig. 5.1), the only animal on earth that sports a 2-m-long spiral tooth. Nowadays most narwhals frequent the seas around

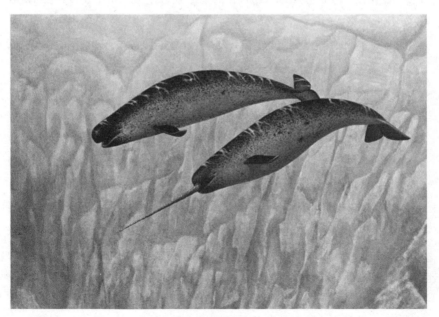

5.1 Narwhal

eastern Canada and Greenland, but in earlier times they were more numerous in Arctic waters right around the pole. Occasionally narwhals wash up on beaches as far south as Britain and Germany; presumably they have always done so; perhaps Europeans made the connection between narwhal teeth and the unicorn of their religious books because of such strandings. Narwhal tusks also made their way south as items of trade, usually changing hands several times en route. Some of these hands belonged to Arab traders, others to Vikings. The seas around Greenland, an island settled by the Norse[34] in the late tenth century, supplied most of the alicorns imported into Europe, though tusks from northern Eurasia probably ended up on the market too.

As far as the literary evidence allows us to discern, some Europeans in the twelfth century came to believe that the unicorn had medicinal powers. By the end of the fourteenth century the belief had become attached to alicorn and known to scholars, as had the idea that alicorn could detect toxic substances. Between the fifteenth and seventeenth centuries alicorn was regularly used by aristocrats, popes and other rich people as a guard against poisoners: it was widely thought that the material perspired in the presence of tainted food and drink, even though it didn't. Towards the end of this period nobles and notables were suspicious of, or no longer believed in,

34 Germanic tribes from northwestern Eurasia, mostly comprising Norwegians and a number of peoples usually lumped together as Danes.

alicorn's alexipharmic abilities, but many continued to deploy the substance nonetheless, partly out of a sense of tradition and partly because of the continuing faith in alicorn's power among the lower classes.

Alicorn was primarily associated with the wealthy for most of its European history, but from the late sixteenth century the less fortunate entered the market in increasing numbers. The economics of the phenomenon had changed. Most of the alicorn in Europe was being sold in powdered form for the treatment of all manner of ailments. Powdering was the key to tapping the dispersed wealth of ordinary people, because the constituents of powders are difficult to identify. Needless to say, narwhal tusks played a minor role in the trade. Powders of alicorn were concocted from the bones, horns and hooves of wild and domestic animals, the remains of long-dead creatures and the rocks in which they were entombed (so-called fossil unicorn), horn-shaped stalagmites and stalactites, and goodness knows what else. By repackaging a fashionable but inherently useless commodity for the mass market – and the health market at that – the mercantile classes of the seventeenth century illuminated the path to modernity for the whole Western world. Europe and the unicorn have a lot to answer for.

The alicorn bubble was pricked in the 1630s, though it took a century or so to deflate. Ole Wurm, Regius Professor of All Denmark, was asked by the merchants of Copenhagen to identify the object that they had been marketing as unicorn horn. His

answer came as a surprise. Wurm explained that alicorns were the tusks of an animal that lived in the North Atlantic. Confronted with a choice between truth and profit the merchants of Copenhagen carried on plying their trade. Princes and sick people continued to demand alicorn to combat poisoners and sniffles. If only to avoid awkward questions from relatives of the deceased, physicians continued to prescribe the stuff (alicorn remained in the official London *Pharmacopoeia* of drugs for a century after Wurm). The professor was adamant that unicorn horns were narwhal tusks, but ironically this conclusion bolstered the view that unicorns existed, because at the time it was widely believed that all terrestrial animals had marine counterparts. If unicorns existed in the sea, it stood to reason that they also existed on land. And so the unicorn refused to go away.

How did this curious saga begin? The earliest medieval reference to the prophylactic properties of unicorn body-parts is in the strange and engaging works of a German abbess named Hildegard of Bingen (1098–1179). The leader of a religious house, Hildegard had access to a number of luxuries, including books, traditionally denied to women of her time. Hildegard's musings on the unicorn in *Physica*, essentially a text on natural history, mark a subtle change in attitude towards the beast, perhaps mirroring the growing influence of European nunneries, and thus of women, on medieval thought. Hildegard first reworks the *Physiologus* allegory into a more proprietous form:

The unicorn, you know, wonders when it sees a maiden from afar, that she has no beard, although she has the form of a man. And when two or three maidens are together, it wonders all the more and becomes all the easier to catch while it has its eye fixed on them. But the maidens with which one wishes to catch it must be aristocratic and not boorish, also not too grown up, but also not too small, but in the true bloom of youth, for this it loves because it recognizes this as gentle and pleasing.

She concludes with her knowledge of the unicorn's medicinal virtues:

Pulverise the liver of a unicorn, give this powder in fat prepared with yolk of egg and make a salve, and there will be no leprosy, of whatever nature it might be, which would not be healed, if you often rub it with this salve, except if death overtakes him who has it or God will not heal him. For the liver of this animal has a salutary heat and cleanliness in it and the egg fat is very valuable and esteemed as a salve. The leprosy comes of course oftentimes from the black bile and from the black stagnant blood.

If you make a girdle from the hide of the unicorn and gird yourself with it, no plague however severe and no fever will harm you. Also if you make shoes from the hide and wear them, you will always have sound feet, sound legs and sound

joints, and also will no pestilence harm you while you are wearing them.

Her instructions are added to by a later hand with these words:

If a man is afraid of being poisoned, he should place the hoof of a unicorn under the plate on which the food is or under the cup which contains his drink, and if there is poison in it, they become boiling hot if they are warm, but if they are cold they will begin to steam and thus will he know that poison is mixed therewith.[35]

The unicorn's liver, hide and hooves are credited with medicinal qualities, but alicorn is not mentioned. Hildegard does say elsewhere that under the animal's horn lies a piece of metal in which a man can see his reflection, so she knows that unicorns have horns and that they are unusual structures. Yet in spite of the interest in medical matters around which many of Hildegard's writings revolve, she seems unaware of any pharmacological uses for alicorn. Taking her account at face value, we may infer that the unicorn's medical potency had yet to become fully connected with alicorn. Two centuries later the transfer of virtue to alicorn was complete and the

35 Miller (1960).

tusk of the narwhal had become the archetypal carrier of the unicorn's power.

Where did Hildegard get her ideas about unicorns from? In the versions of Ctesias' and Aelian's works that have come down to us the one-horned ass is credited with medicinal and alexipharmic powers, so allusions to pharmacology were lurking in the unicorn literature of the ancients, waiting for someone to lift them. But here's the strange thing: none of the iconic medical authors of Greek and Roman times – Hippocrates and Galen were the most influential – makes any mention of the therapeutic properties of one-horned animals. The Latin *Physiologus* is silent on the matter too.[36] The Bible likewise. From such omissions we may conclude that the curative value of unicorns was not keenly appreciated in the ancient world. Nor do our earliest medieval sources for the unicorn's alexipharmacy mention drinking vessels, so important in ancient accounts of the one-horned ass. Poison-neutralizing beakers were later adopted by Renaissance writers, as were most classical ideas, yet even then they formed no more than a side branch of the alicorn story. All in all there seems no obvious connection between the ancients' writings on unicorns and the development in Europe

36 There is a tale linking the unicorn with poison in the eastern lineage of *Physiologus* which we shall meet in Chapter 10, but it differs markedly in content from Hildegard's description and was probably unknown in the West in her time.

of alicorn's reputation as a medicine and detector of toxins. We need to look elsewhere.

Odell Shepard blamed the Arabs for subjecting Europe to 500 years of alicorn mania. In *The Lore of the Unicorn* he makes his case by mentioning a few Eastern ideas about unicorns and pointing out connections between the development of Muslim and Christian civilizations before passing sentence on the Arabs and swiftly moving on. His analysis is odd for a number of reasons, and for one in particular: Shepard was a knowledgeable, clever and assiduous man, and not at all renowned for glossing over a subject, especially when he still had books to talk about. Perhaps he saw where an investigation of such matters would lead and decided not to get involved. Readers as wise as Odell Shepard should shut their books now.

In the seventh and early eighth centuries AD[37] Muslim armies did their best to overrun the world. Up to the year 632 Islam was mainly confined to the Arabian Peninsula, but after the death of the Prophet Muhammad Muslim armies took Syria and Iraq in 633, Jerusalem in 638, and much of North Africa by the end of the seventh century. In the opposite direction Asia fared little better. In 711 an invasion force crossed the Straits of Gibraltar and advanced into Europe, reaching Poitiers in France in 732 before falling back a little (experience of a northern European winter

37 The first and second centuries as far as Muslims are concerned. For consistency's sake the Western AD/BC system is used.

convinced the newcomers to settle for what they already had). In one extraordinary century Islam acquired an empire stretching from India in the East to Lisbon on the Atlantic coast in the West. Muslim knowledge and ideas then shuttled back and forth along this vast strip of land.

Muslim culture reached a pinnacle in the East, especially in Baghdad, in the ninth and tenth centuries, and in the West, especially in Spain, in the eleventh and twelfth. So the European high-point was reached slightly before and during the time of Hildegard. While unoccupied Europe continued to trust in God for solutions to its problems, scientists of the Muslim empire, including some with geographical and religious roots in recently assimilated cultures, made enormous intellectual strides. Via Muslim scholars and translators Europeans recovered much of the learning of the ancients, including the works of Euclid (mathematics), Ptolemy (geography), the Hippocratic School (medicine) and Aristotle (nearly everything). Almost as significant for Europe was the work of Muslim scholars themselves, including al-Razi (b. 865, known in the West by the Latinized name 'Rhazes') and Ibn Sina ('Avicenna', b. 980), physician-philosophers who built on the classical ideas of Hippocrates, Aristotle and Galen. Al-Razi wrote *Al-Hawi* (*The Comprehensive Book*), a vast compendium of pre-Islamic Arab, Greek, Indian and Chinese medical knowledge, while Ibn Sina left the world *Al-Qanun* (*The Canon*), a similarly breathtaking synthesis of Greek and Arab knowledge on similar topics. Translated into Latin,

Al-Hawi and *Al-Qanun* became the basic textbooks of European medical schools, a position they held for 500 years.

In Hildegard's time Latin translations of Arabic texts were filtering into Europe, and many aspects of Muslim and earlier Arab culture filtered in too. It is suspicious that the medicinal unicorn appeared when this momentous transfer of knowledge was taking place. In *Physica* Hildegard talks about the malign influence of black bile and parses the natural world into hot and cold, echoing Greek and Roman ideas about health and disease upon which Muslim medical writers based much of their work (though these ancient notions in basic form were among the few that survived in Western Europe after the fall of Rome). Hildegard's concoction of unicorn's liver and egg yolk also has the whiff of Eastern pharmacology about it. Another clue can be found in the tenor of Hildegard's *Physica*, a decidedly odd book for its time, place and even for its author. Unlike Hildegard's other works, *Physica* has virtually no revelatory or divine content. Most likely its author could not mesh her Eastern source material with the Western tradition in which her religious beliefs were grounded.

Did Eastern ideas about unicorns influence the Hildegardian branch of the unicorn legend, and, if so, how? Muslim culture generated several one-horned animals. The harish, for example, ends up being captured by a human female, not infrequently of the alluring variety. Here Christian and Near Eastern ideas are similar, and we need only remember that *Physiologus* was translated into Syriac and

Arabic at an early date to see where the tale of the harish came from. The Christian unicorn–maiden and the Muslim harish–seductress grew from a shared literary rootstock.

The karkadann is a different beast altogether. Here is how al-Biruni, a polymath of the late tenth and early eleventh centuries and a key figure in most of what follows, describes the karkadann in his book on India: 'It is of the build of a buffalo, has a black, scaly skin, a dewlap hanging down under the chin. It has three yellow hooves on each foot, the biggest one forward, the others on both sides. The tail is not long. The eyes lie low, farther down the cheek than is the case with all other animals. On the top of the nose there is a single horn which is bent upwards . . .'[38] A fragment of al-Biruni's work preserved in the writings of another author adds that the horn is conical, bent back towards the head and longer than a span, that the animal's ears protrude on both sides like those of a donkey, and that its upper lip forms into a finger-shape, like the protrusion on the end of an elephant's trunk. There is not a shadow of doubt about the identity of this animal: the Indian rhinoceros, about which al-Biruni learned when he was in India.[39]

Al-Biruni was one of only very few medieval writers who saw a

38 Ettinghausen (1950).
39 Al-Biruni was a native of Khiva, Uzbekistan. The region fell to Sultan Mahmud in 1017, after which al-Biruni went to northwestern India. Here he seems to have lived and travelled on and off, mainly in the Punjab and the borders of Kashmir, until c. 1030. Then he returned home. He died around 1048.

rhinoceros, and he was an assiduous, critical and tirelessly inquisitive scholar. Such care was not universal among Muslim writers and artists of this and later periods, which is why the karkadann diversified into several lineages of strange mythical animals. Some of these creatures look like cows, others like lions, wolves and even hares. Tracing the influences that generated the karkadann's variety of physical forms would take a whole book[40] and even a summary would lead us too far astray; suffice to say that confused descriptions of the karkadann littered with vague or ambiguous terms (old Arabic script is particularly prone to misinterpretation) worked upon by the imaginations of artists and writers in the absence of any real rhinoceroses resulted in an array of imaginary karkadanns with a shadowy rhinocerine ancestor. The real horn of the karkadann, therefore – the physical substance used by people for one purpose or another – cannot be attributed to one animal. With hindsight we can see that rhinoceros horn is the best candidate, but karkadann horn is really a murky category with all sorts of things in it, just as karkadann is a category with lots of strange animals in it.

The wedge between the rhinoceros and the karkadann was driven in further by Muslim artists' representing the karkadann with a long, straight horn, whereas, as al-Biruni correctly pointed out, the horn of the Indian rhinoceros is short and bent. Artists also moved the horn

40 Already written: Ettinghausen (1950).

from the rhino's nose to the karkadann's brow. No one knows why. The karkadann, then, was nearly always represented as a creature with a long horn sticking out of its forehead.[41]

The horn of the karkadann had become linked with poisons by the end of the thirteenth century. An early reference is made by al-Qazwini (d. 1283), who says that the substance is used both as an antidote and in the manufacture of knife handles. He does not say that the horn perspires in the presence of poison, but later writers do. The link between the karkadann and alexipharmacy remained weak and inconsistent in the Muslim world: a few references pop up in the fourteenth and fifteenth centuries, but these are more than counterbalanced by contributions to karkadann lore by writers who ignore the matter entirely. Nevertheless, according to some Muslim writers at least, the karkadann was a large four-legged animal whose single horn sweated in the presence of poison. Here we seem to have the unicorn's geographically distant but genealogically close relative. However, the literature on both the Muslim and the Christian side is so sparse that we cannot say for sure whether alicorn acquired its alexipharmic reputation from karkadann horn or vice versa.

Luckily, al-Qazwini left us a clue. That karkadann horn was used

41 In the sixteenth century rhinoceroses became better known and the dominant artistic school began to focus on realism. From this time on representations of karkadanns become increasingly recognizable as rhinoceroses.

in the manufacture of knife handles may seem inconsequential, but it is actually the key to the puzzle. The use of karkadann horn in cutlering predates its use as an antidote by centuries, at least three judging from the literature. So the antidotal myth seems to have become attached to a substance long used for a more mundane purpose. Lots of materials were used in the manufacture of knife handles; craftsmen and their clients knew what most of these were and where they came from, but some were more mysterious. Cutlers told stories about the origins of their raw materials, which hybridized readily. By some such infidelity, it seems, did karkadann horn acquire its reputation.

Picture the cutler's box. In it are local woods, the bones and horns of domestic animals, interestingly patterned rocks, crystals and shells for inlay work. Now picture the cutler's hidden box. In this one, carefully wrapped, sit precious woods, a fine hippopotamus-tooth blank, bones of distinction, pieces of a material our cutler calls karkadann horn, and other substances of unsuspected but no doubt equally exotic provenance. If our cutler was the sort of craftsman who attracted wealthy customers, perhaps he even had some khutu horn in his box. We know that some cutlers used khutu horn because contemporary writers tell us that they did. What is khutu horn? It is like karkadann horn, only different.

Muslim writers were clear on one point: khutu reacted in the presence of poison. We also know that khutu was used as an antidote in the Muslim world from the first half of the eleventh century at the

latest, because al-Biruni, who wrote several books at this time, describes the material and the uses to which it was put.

Karkadann horn and khutu were similar in certain respects: both were enigmatic horns used in the manufacture of knife handles. These parallels brought the two materials together in the minds of medieval Muslims. At some point khutu's alexipharmic properties became attached to karkadann horn, the transfer showing up in Muslim texts of the thirteenth century. At about the same time European alicorn began to sweat in the presence of poison. The literary record is too fragmentary to tell whether alicorn acquired its reputation as a poison-buster directly from khutu or indirectly from the karkadann, but the long history of alexipharmic horns in the Muslim world allows us to infer with reasonable confidence which way the mythological tradition flowed: East to West, very much the intellectual downhill direction at the time.

Only one problem remains. What is khutu?

Khutu is a mystery that is 1000 years old and counting. Its identity has always been a literary conundrum because the evidence lies in medieval manuscripts, mostly written in idiomatic Arabic and Chinese. Fortunately the relevant texts were translated into English by scholars in the first half of the twentieth century. Now we must go hunting the shadowy ancestor of the unicorn and the karkadann, the rightful owner of khutu.

CHAPTER 6

Hunting the khutu

The hunt for khutu crosses many countries and centuries.[42] The material is mentioned in connection with cutlering in the anonymous *Hudud al-'Alam* of 982, but the first man we can name who writes extensively on the subject is al-Biruni (973–1048), the most acute Muslim natural historian of medieval times. Later writers typically base their accounts on al-Biruni's. A fragment of his work preserved in a text by al-Khazini dated 1121 describes khutu thus:

It is asserted that it is the frontal bone of a bull living in the country of the Kirgiz who, it is known, belong to the northern Turks . . . The Bulgar bring from the northern sea teeth of a fish over a cubit long. White knife hafts are sawed out of them for

42 See Lavers and Knapp (2008).

the cutlers. The middle portion is distributed among the single hafts, so that every piece of the tooth has a share in them; it can be seen that they are made from the tooth itself, and not from ivory, or from the chips of its edges. The various designs displayed by it give the appearance of wriggling. Some of our countrymen bring it to Mekka where the people regard it as white chutww [a variant spelling of khutu]. The Egyptians crave it and purchase it for a price equal to two hundred times its value. Likewise I conclude from the appearance of the chutww that it [the frontal bone of the bull] is [also] the main portion of a tooth or horn.[43]

In another passage preserved in al-Khazini, al-Biruni adds information on khutu's shape and colour and mentions the material's supposed alexipharmic properties:

It originates from an animal; it is much in demand, and preserved in the treasuries among the Chinese who assert that it is a desirable article because the approach of poison causes it to exude. It is said to be the bone from the forehead of a bull. Its best quality is the one passing from yellow into green; next comes one like camphor, then the white one, then one colored like the sun, then one passing into dark-gray. If it is curved, its

43 Laufer (1913).

value is a hundred dinar at a weight of one hundred drams; then it sinks as low as one dinar, regardless of weight.[44]

A text on precious stones by Ibn al-Akfani (d. 1348) includes a passage derived from al-Biruni that offers another theory about the material's provenance:

Chartut [another spelling] is also called chutww. Abu'l Raihan al-Biruni says: it originates from an animal. It is said to be obtained from the forehead of a bull in the region of the Turks in the country of the Kirgiz, and it is said also that it originates from the forehead of a large bird which falls on some of these islands; it is a favorite of the Turks and with the Chinese. Its value comes from the saying that the approach of poisoned food causes it to exude. The Ichwan al Razijans state that the best is curved, and that it changes from yellow into red, then comes the apricot-colored one, then that passing into a dust color and down to black. Formerly there were pieces whose price amounted to from one hundred to one hundred and fifty dinars. It has been established by experience that together with the vapors of perfume it has an excellent effect in the case of hemorrhoids.[45]

44 Laufer (1913).
45 Laufer (1913).

Ibn al-Husayn Kashghari's definition of chatuq (another spelling) written in the eleventh century offers two more theories of the origin of khutu and expands on the material's reaction to poisons:

> Horn of a sea fish imported from China. It is said that it is the root of a tree. It is used for knife handles. The presence of poison in food is put to the test by it because when broth or other dishes in the bowl are stirred with it the food cooks without fire, or if the horn is placed on a bowl it sweats without steam.[46]

References to the Chinese and their liking for khutu crop up regularly in Arab sources. A description by T'ao Tsung-i, author of *Cho keng lu* (1366), offers the most common Chinese theory about the origin of khutu:

> Ku-tu-si [the equivalent Chinese term] is the horn of a large snake, and as it is poisonous by nature, it can counteract all poisons, for poison is treated with poison. For this reason it is called ku-tu-si.[47]

A passage in al-Ghaffari's work on mineralogy written in 1511–12 expands on khutu's nature and geography:

46 Dankoff (1973).
47 Laufer (1913).

The hutu [another spelling] is an animal like an ox which occurs among the berber and is found also in Turkistan. A gem is obtained from it; some say it is its tooth, others, it is its horn. The color is yellow, and the yellow inclines toward red, and designs are displayed in it as in damaskeening [damascening]. When the hutu is young, its tooth is good, fresh and firm; when it has grown older, its tooth is also dark-colored and soft. The padishahs purchase it at a high rate. Likewise in China, in the Magrib, and in other countries it is known and famous. It is told that a merchant from Egypt brought to Mekka a piece and a half of this tooth and sold it on the market of Mina for a thousand gold pieces. Poison has no effect upon one who carries this tooth with him, and poison placed near it will cause it to exude. For this reason it is highly esteemed.[48]

There are other examples of this kind of description, but the problem for anyone wanting to identify khutu should already be apparent. The material is described as a horn, a tooth, a bone and the root of a tree. It is derived from a bull or a bird, while something similar to khutu, though seemingly not it, is sported by a fish. Chinese writers attribute khutu to a snake. The Turks, a huge group of central, eastern and northern Eurasian peoples, crave khutu, as do the Chinese,

48 Laufer (1913).

Egyptians and the residents of other countries. By al-Biruni's time khutu was used in Muslim countries for detecting poisons,[49] though the earlier *Hudud al-'Alam* mentions only that it was used by cutlers. The curved variety of khutu is expensive, from which we may infer a cheap variety that is straight. Lastly, the colour of khutu varies from white to black.

Berthold Laufer, an early twentieth-century scholar who worked on the Chinese branch of the khutu problem, and Richard Ettinghausen, who worked thirty years later on the Arabic branch, went to great lengths to track khutu to its owner. After arduous detective work both men concluded that khutu was without much doubt (Laufer), or most likely (Ettinghausen), walrus ivory, though perhaps occasionally narwhal ivory too.

The teeth of walruses and narwhals look very different to modern eyes (Figs. 5.1 and 6.1), so the idea that both the narwhal and walrus might be sources of khutu requires some explanation. While walrus ivory was Laufer's and Ettinghausen's prime suspect, khutu is occasionally called a thousand years' old snake in the Chinese literature, a description that connotes the long, twisted tusks of narwhals. The teeth of narwhals and walruses were probably also cut up before being traded, and ivory from both species may have been processed

49 Khutu was the original alexipharmic horn in the Muslim world. Muslim writers do not link rhinoceros horn with poisons until the late thirteenth century. Rhino horn probably acquired its alexipharmic reputation from khutu. See Ettinghausen (1950).

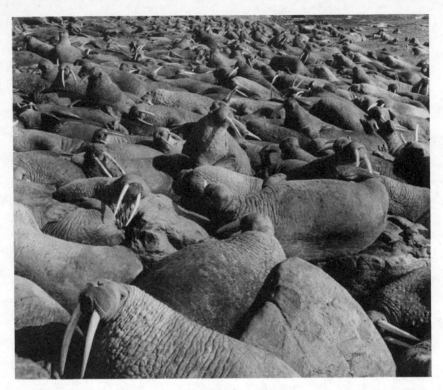

6.1 Walrus

in various ways before being exported; sectioning, sanding and pol-
ishing would have obscured differences between the two types of
ivory. More fundamentally, medieval peoples were less concerned
about taxonomic niceties than we are. Craftsmen and their clients
may have recognized two types of khutu and attributed both to the
same animal, or, conceivably, might not have drawn a distinction
at all, regarding both substances as knife-handle material from the

north and thinking no more about the matter. The word khutu might thus have covered what we recognize as two materials that were linked in people's minds because they travelled along the same trade routes and were used for the same purpose.

Ibn al-Husayn Kashghari, however, calls the khutu-bearer a fish, a label that does not sit comfortably with either the walrus or the nar-whal. But this reference is not too problematic. A number of mammals were once called fish because they live in water, and a few still are: the Persian for dolphin translates as Jonas's fish, while in Turkish the seal is a bear-fish and the hippopotamus a horse-fish. Accepting, then, that the teeth of walruses and narwhals might have been confused by medieval peoples in a number of ways, we can move on to ask how marine ivory matches up with the various descriptions of khutu.

No other animal has tusks like those of the walrus. The material on the outside of a walrus tusk is typically tooth-like, but the tusk's core is made of a substance called osteodentine, which has an attractive porridge-like appearance (Fig. 6.2). When al-Biruni refers to the middle portion of the fish tooth he implies that this core is different from the material surrounding it; he also says that the core cannot be confused with elephant ivory, which suggests that the material on the outside of the tooth could be so confused. Al-Biruni describes a tooth that is ordinary on the outside and special on the inside borne by a creature living in the northern sea. Only one animal fits the bill: the walrus.

However, al-Biruni also says that the patterning of the fish tooth

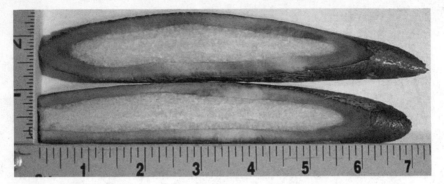

6.2 Section through an ancient walrus tusk

brings to mind the word wriggling. The granular texture of walrus osteodentine may perhaps be likened to a mass of maggots, a mental image that could have prompted al-Biruni to use a word that translates as wriggling. But whether osteodentine can be described as wriggly in our modern sense of wavy is another matter. The same issue arises with al-Ghaffari's reference to khutu's damascening properties. In the sense intended by al-Ghaffari, damascening refers to the production of a wavy pattern on metal, a technique particularly associated with armourers of the Near East. Medieval armourers with an eye for harmony no doubt complemented damascened blades with damascening handles, just as modern-day knife-makers sometimes strive for the same sense of balance in their own designs. But modern knife-makers do not use walrus ivory for this effect, because osteodentine resembles rice pudding. So al-Ghaffari's allusion to khutu's damascening, like al-Biruni's reference to khutu's wriggling, does not

fit the walrus very well.[50] Perhaps the use of these words reflects a confusion between materials traditionally used to make knife handles in the medieval Muslim world, of which more anon.

Patterning aside, other elements of the khutu literature confirmed Laufer and Ettinghausen in their suspicion that marine mammals were the source of khutu. Al-Biruni says that the Bulgar brought fish teeth from the northern seas. In al-Biruni's time the Bulgar were a group of merchants settled on the Volga River who specialized in trading furs. The most luxuriant furs are borne by mammals in the coldest environments, and the coldest environments in Eurasia are in the far north. If fish teeth were an adjunct to the medieval fur trade it would not be surprising if their owners lived in the Arctic Ocean.

Another clue that both the walrus and the narwhal influenced the literature on khutu relates to the shape of these animals' teeth. Al-Biruni comments that the expensive variety of khutu is curved, which implies a cheaper kind that is straight. Walrus tusks are usually gently curved whereas narwhal tusks are straight, so perhaps the two varieties belong to the walrus and narwhal respectively. If so, it would make sense that expensive khutu (curved, attractive core) came from the walrus and cheap khutu (straight, hollow) from the narwhal.

The walrus and narwhal, then, are prime candidates for the role of

50 Al-Ghaffari clearly copied al-Biruni or some intermediate source, but his contribution shows that the notion of wavy khutu had lurked in the literature for centuries.

khutu-bearer. But there are other possibilities. Another text by al-Biruni, unknown to Laufer in the 1910s and discovered by Ettinghausen only as he was putting the finishing touches to his 1950 treatise, throws a different light on the matter. The piece appears to be the original upon which the passages preserved in al-Khazini were based. Having belatedly read this long description of khutu, Ettinghausen must have spent some time with his head in his hands. Unable to face the prospect of rewriting his closely argued thesis, Ettinghausen penned a few pages of frustrated reinterpretation and appended them as a supplementary note to his chapter on khutu. We shall look at part of this note shortly, but first the text that prompted it. In al-Biruni's magisterial work on precious stones we find the following:

Although khutu is an animal product, yet people like it and collect it as a treasure. It is held in considerable regard in China and eastern Turkistan . . . People like it because if a person is brought close to it, it begins to perspire, as is said of the peacock. Whenever any poisonous food comes before it, it begins to quiver and shake.

When I enquired about the khutu from the members of the diplomatic mission which had come from the Qata'i Khan,[51]

51 Ruler of the Qata'i. It is from the word Qata'i and its variants (khitan, qidan, etc.) that the word Cathay (China) was derived. In al-Biruni's time the Qidan ruled a large area centred on northern China as the Liao Dynasty (947–1125).

they said: 'The only merit about it is that it lets out perspiration when any poison comes into contact with it. This is why it is held in such esteem. It is the bone of [the] forehead of [a] bull.'

This is what has been said in books, although the only additional information we could get is that this bull is found in Khirkhiz. Its forehead is thicker than two fingers which would show that it cannot be the forehead of the Turkish bull, as it is smaller bodied. But it could well be the horn. As for the belief that it is the forehead of a bull, it would be the forehead of the mountain goats of Khirkhiz. Only they can have such foreheads. It is not brought from Iraq and Khurasan.

Some say it is the forehead of the hippopotamus which is also called aquatic elephant. It has patterns described over it and bears resemblance to the pith of the teeth of the fish which the Bulgarians bring to Khwarazm [Khiva] from the North Sea which is adjacent to the ocean. It is bigger than the hand in size and the pith is longer in the middle . . .

A Khwarazmian happened to find a tooth which was very white on the sides. He had hasps of daggers and knives made from it. The natural patterns described upon it were very thin, white and pale. It resembled the down of a cucumber if peeled in such a manner that that the seed grains are also cut off. This Khwarazmian carried it to [Mecca], passed it off as the khutu and sold it at a high price to the Egyptians.

If the peeled portion of khutu is thrown into fire, it gives out a fishy smell. This fact would show it to be a marine creature. It is said that the fumes of its smoke are good for piles just as the fish bone is good for them.

A tradition which runs about it – and it is extremely difficult to check the veracity of the factual truth behind this tradition – has it that it is the forehead of a big bird. When it dies and falls upon an island, its flesh putrefies and scatters, but people preserve its forehead. Someone has mentioned that he was travelling in the wilderness of China along with some natives.[52] The sky suddenly darkened and the people dismounting from their horses prostrated themselves. They did not raise themselves up until the darkness cleared. When he asked them about it they said: 'It is God', and began to describe in an ignorant fashion the attributes of God, saying that it was a fowl in appearance . . . They believe it to be a very large fowl residing in uninhabited regions beyond the sea of Zanj and China, eating large ferocious elephants in the way in which the domestic fowl pecks at wheat grains . . .

The Razi brothers say: 'The best kind is that which is like the scorpion. It should be pale reddish, followed by the varieties that are camphorine, white, apricot-like, dusty and the

52 The traveller is named as Ibrahim Sandani in al-Biruni's *Kitab al-Saydanah* (*Book on Pharmacy and Materia Medica*). This text says that Sandani travelled in the desert of China with a nomadic tribe.

khardanah (which is like the bone). The most inferior kind is the peppery one . . .'

Amir Abu Ja'far bin Banu had a large box-like case made of long and broad khutu planks . . . Amir Yamin al-Dawlah had also an ink-pot made of khutu . . .[53]

The plot thickens. Some of the information in this passage, particularly in its first half, points to a new khutu-bearer that lives in one of the most extreme terrestrial environments on earth, but before we can track down this animal we must deal with an interloper.

According to both al-Biruni and al-Akfani (the latter probably copied the former), it was widely believed in medieval Asia that khutu was derived from a bird. Al-Biruni was sceptical of this theory, but the notion was sufficiently entrenched that he felt the need to report it. Berthold Laufer offered two explanations of the khutu-bird. Though birds are renowned for not having teeth a kind of bird 'ivory' does exist. Above the beak of the helmeted hornbill grows a horny excrescence, which ivory carvers of the East sculpted into small items such as brooches, combs and rings. The hornbill lives in southeast Asia, a long way from the Arctic home of the walrus; nevertheless, if beaks and teeth from these two creatures ended up in the medieval craftsman's box, stories belonging to one could have become attached to the other.

53 Said (1989).

6.3 Woolly rhinoceros skull and horn

By some such confusion, Laufer thought, did people come to believe that khutu was derived from a bird.

Laufer's alternative theory involves myths about the Ice Age mammals of Siberia. Stories about giant birds were once common in this part of the world, and were probably based on the skulls of woolly rhinoceroses: a woolly rhino's arched skeletal snout resembles a bird's beak, while its horn looks like a bird's claw, albeit an enormous one (Fig. 6.3). Adolf Erman, a German physicist who travelled around the world in 1828–30, notes that:

> By comparing numbers of the bones of antediluvian pachyderms, which are thrown up in such quantities on the shores of the Polar Sea, [northern peoples] have got so distinct a notion of a colossal bird, that the compressed and sword-shaped horns, for example, of the rhinoceros *tichorinus* are never called, even among the Russian promuishleniks and merchants, by any other name than that of 'birds' claws'. The indigenous tribes, however, and the Yukagirs in particular, go much further, for they conceive that they find the head of this mysterious bird in the peculiarly vaulted cranium of the same rhinoceros; its quills in the leg-bones of other pachyderms [mammoths], of which they usually make their quivers; but as to the bird itself, they plainly state that their forefathers saw it, and fought wondrous battles with it.[54]

54 Howorth (1887).

The result of this creative palaeontology was a rich vein of tales about monstrous birds invented by people who lived alongside not only woolly rhinos and mammoths, but also walruses and narwhals. That avian legends might have become conflated with khutu-bearing marine mammals is thus an obvious possibility.

When Ettinghausen read the passage on khutu in al-Biruni's book on precious stones he realized that yet another explanation of the khutu-bird was possible. Al-Biruni speaks of 'a very large fowl residing in uninhabited regions beyond the sea of Zanj [Africa] and China, eating large ferocious elephants . . .' This particular bird would appear to be the rukh (or roc), archetypally an elephant-eating bird of the wilderness, which entered the mythological canon of Arabic-speaking peoples in the seventh or eight century, eventually reaching the West in the works of Marco Polo and the tales of Sindbad the Sailor.

So parsing the khutu-bird into its ancestral elements is not an easy task, and it is probably unwise to try too hard. A more realistic approach is to ask why avian influences of one sort or another came together in the medieval literature on khutu. As Laufer suggested, the hornbill fits the role of khutu-bearer because so-called ivory from this bird sat beside marine ivory in the cutler's box. The most obvious link between khutu and the rukh is that the woolly-rhino-bird and the rukh are associated with elephants, mammoths in the former case. Medieval Muslims knew all about ordinary elephants, and a little about mammoths. In the early tenth century Arab visitors to the

hub of trade on the Volga run by the Bulgars learned about a skull resembling an Arab hut furnished with teeth like those of an elephant. The travellers also found out that such teeth were sometimes taken to Khiva, where they were sold at a high price and fashioned into the kind of items usually made from elephant ivory. These parallels could have encouraged the merging of stories about rukhs and woolly-rhino-birds. At the least, nothing about the avian references in al-Biruni and al-Akfani rules out a connection between khutu and the geographical home of walruses and narwhals, and one has the suspicion that the khutu-bird would make perfect sense if we knew more about the medieval myths of Siberia.

The genealogy of the khutu-bird will most likely always remain a puzzle. We have explored the motif partly because it is prominent in the literature, and partly because it leads on neatly to our next suspect.

Was khutu derived from the woolly rhino's constant companion, the mammoth? Mammoth ivory was coveted by medieval Chinese craftsmen, who must have acquired it, no doubt along with a hatful of stories, from northern Eurasia (mammoth remains are not confined to frozen areas of the north, but they are rare and usually poorly preserved in warmer climates, unless they have been protected in caves). The theory that khutu was mammoth ivory had been floated before Laufer proposed his walrus idea, and try as he might Laufer could not convince himself that khutu and the mammoth were unconnected. At the end of his 1913 monograph, essentially one long argument that khutu was walrus ivory, he suddenly admits that mammoth ivory

and khutu might have been confused in the minds of medieval peoples. Why the about turn? If walrus teeth and narwhal teeth had been mixed up because both originated in the far north, it is possible that the teeth of mammoths became caught up in the same confusion. Laufer was tempted to discount the mammoth as a source of khutu on the grounds that medieval Muslims and Chinese were familiar with elephant ivory. But it is not clear that either people would have classed mammoth ivory with elephant ivory knowing that the two materials came from different places (they were the product of different trade routes, one heading north and the other south). And if the teeth of walruses and narwhals were cut up and processed before export, mammoth ivory certainly would have been.

Prominent references to the Kirghiz in Muslim texts simply underlined Laufer's suspicion that mammoths were involved in the khutu mystery. The *Hudud al-'Alam* says that Kirghiz lands supplied large quantities of khutu. The name Kirghiz (Khirkhiz, Kirgiz, Kyrgyz, etc.) can be confusing, since the people known by this name today live predominantly in and around Kyrgyzstan, but in al-Biruni's time the Kirghiz lived further to the northeast across a huge area of Siberia. Their homeland occupied a strategic position between Arab and Chinese civilizations to the south and various reindeer-herding, hunter-gathering and marine-mammal-hunting peoples to the north. Laufer conceded in 1916 that 'when we recall the commercial relations of the Arabs with the Kirgiz, the whole question [of khutu's nature and origin] seems to assume a new turn. It is possible . . . that al-Biruni's

bull furnishing ivory may be an allusion to the mammoth . . .' Three decades later Ettinghausen agreed, writing '. . . the sources of supply seem to point to a land animal. Thus the possibility of an identification with mammoth bones . . . poses itself again.' As we shall see, the land-living bull furnishing ivory may be an allusion to a different kind of animal, but nevertheless there are good reasons for thinking that mammoth ivory had more of an influence on the medieval literature on khutu than either Laufer or Ettinghausen suspected.

The connection between the mammoth and khutu is another series of inferences, this time based on a combination of geography and palaeontology. The detective work of Laufer and Ettinghausen leads us to the far north: the walrus appears to be the primary supplier of khutu and the narwhal is also implicated; either way we arrive at the Arctic. From the eleventh century walrus teeth travelled in ever increasing numbers along trade routes connecting Greenland with the civilizations of southern and eastern Asia, but khutu was already known to the Chinese and Arabs when Norse traders settled Greenland in the 980s (it is mentioned in the *Hudud al-'Alam* of 982), which suggests that the trade in khutu originated elsewhere. Most likely the marine-mammal hunters of northeastern Siberia and the Bering Strait region gathered the walrus and narwhal tusks that ended up in China. Focusing on the northeast of Eurasia and the region's characteristic animals, other themes within the khutu literature make more sense. Both Laufer and Ettinghausen downplayed the colours attributed to khutu, perhaps because neither man could

see how bones or teeth could be anything other than white or yellow. The hard parts of recently expired mammals are indeed ivory-coloured, but in the ground they may change. The early twentieth-century 'mammoth hunter' Bassett Digby describes Siberian mammoth ivory thus:

> I doubt if there is any other natural growth, animal or vegetable, extinct or existent, that varies in colour so much as the mammoth tusk as found in Arctic Siberia.
>
> Two or three that I examined were as white as modern elephant tusks. They must have come straight out of clean ice.
>
> Then there are tusks that look like stained mahogany, highly polished near the point, though coarsening toward the butt.
>
> There are blends of mahogany and white and mahogany and cream.
>
> There are bright blue tusks, with a powdery bloom on them that you can rub off with your finger; tusks of steely blue; tusks of walnut and russet and brick red.
>
> Not only are these tints present, but there are rich and delicate combinations – superimposed one on another – of several tints on the same tusk, polished surfaces of softly blending tints ranging the entire spectrum.[55]

55 Digby (1926).

The eighteenth-century Swedish military officer P. J. von Strahlenberg writes that mammoth tusks are 'like elephants' teeth, only somewhat more crooked', adding that snuff-boxes, combs and many other things were made out of them. They are 'of a brown colour like cocoanuts; sometimes of a blackish-blue'. He goes on to describe a characteristic of mammoth ivory that was particularly important to craftsmen:

If the latter [decayed teeth] are sawn into thin leaves and polished, one may observe upon them all sorts of figures of landscapes, trees, men and beasts, which likewise proceeds from the decay of these teeth caused by the air. Because it is observed that the more they are decayed, the greater variety of figures is found upon them, and those thin leaves which are made of that thin part which is not quite mouldered away, serve to inlay and cover small boxes and little cabinets with, as is done with amber.[56]

On the same theme of patterning, Henry Howorth adds:

. . . the famous Scotch traveller, Bell of Antermony, tells us he observed in most of the towns he passed between Tobolsk and

56 Howorth (1887).

Yeniseisk many mammons' horns, so-called by the natives. Some of them were very entire and fresh, like the best ivory in every circumstance excepting only the colour, which was of a yellowish hue; others of them mouldering away at the ends, and, when sawn asunder, were prettily clouded. The people made snuff-boxes, combs and divers sorts of turnery-ware of them.

So the bones and teeth of Siberian mammoths may be almost any colour, depending on the composition of the soil or ice in which they have lain. Old walrus ivory washed up onto the land from the sea, exposed in cliffs and river banks or disinterred from old Inuit/Eskimo settlements may be multicoloured for the same reason. Ivory also decomposes, and rotting bits often show complex patterns on their surfaces. Siberian craftsmen sawed veneers from attractive pieces of mammoth ivory and used them to decorate boxes. With cabinet-making in mind, an odd aspect of the khutu literature suddenly makes sense, namely Amir Abu Ja'far ibn Banu's 'large box-like case made of long and broad khutu planks'. It is simply not possible to pare down the tusks of walruses or narwhals and end up with broad planks suitable for the construction of a large case. Only ivory from an elephant or mammoth fits the bill. Since the Arabs knew all about elephant ivory, Banu's box of exotic khutu planks was probably made of mammoth. More generally, mammoth ivory was used by northern peoples for the same purposes that southerners used wood, so if

khutu really was mammoth ivory it is no surprise that some people thought it was the root of a tree.

A combination of northern ivories, then, may account for much of the medieval literature on khutu. But some elements of the texts remain puzzling. Richard Ettinghausen's frustration at the end of his investigation is apparent in his supplementary note on the belatedly discovered text by al-Biruni:

Al-Biruni seems to imply that that he has actually seen khutu pieces. It is therefore significant that he distinguishes between the khutu and the fish tooth, i.e., the walrus tusk . . . The issue then is to find two animals which have 'teeth' of marked similarities . . . Unfortunately I cannot offer any satisfactory solution of the problem. It seems unlikely that al-Biruni is speaking of the tooth of the sperm whale [Ettinghausen examined sections of sperm-whale tooth] . . . The narwhal [tooth] has no core with a design...[I]t is not likely that Egyptians would have paid a high price for hippopotamus teeth, which must have been fairly common in their country. Furthermore, [the hippo] was known as 'water horse' . . . and the structure of its tooth differs greatly from that of the walrus. In case there is no other tooth like that of the walrus – nor a horn resembling it – the only remaining possibility would be that al-Biruni makes a distinction between two types of walrus teeth, perhaps teeth of different sizes or in different states of preservation; or

we would have to assume that the cause of the whole confusion is of a semantic nature . . .

Why our author called [khutu] a forehead bone remains another puzzle, especially since he himself preferred to call the khutu a horn.

Particularly noteworthy is the distinction al-Biruni draws between khutu and fish teeth, saying '[khutu] has patterns described over it and *bears resemblance to* the pith of the teeth of the fish which the Bulgarians bring . . . from the North Sea . . .' Al-Biruni thought that khutu and walrus ivory were different things. This is confirmed by his observation that khutu resembles 'the down of a cucumber if peeled in such a manner that the seed grains are also cut off'. Strangely in light of the lengths to which Ettinghausen went to identify the owner of khutu, he seems not to have taken the trouble to pare down a cucumber lengthways using a potato peeler. Had he done so he would have found a rice-pudding-like pattern of translucent seeds set in an opaque matrix that very closely resembles walrus osteodentine. A Khwarazmian reportedly took a piece of this cucumber-like material to Mecca, where he succeeded in passing it off as khutu. If the Khwarazmian passed off walrus ivory as khutu, khutu would appear to be something other than walrus ivory.

Another animal is needed to make sense of the khutu literature. Fortunately there is no shortage of clues to the kind of creature we are looking for. Allusions to the belief that khutu belonged to a living

land animal (so not a walrus, narwhal or mammoth) are not hard to come by in the Chinese and Arabic literature, and several sources state that khutu's owner is a bull or an ox. Al-Biruni says that the phrase 'bone from the forehead of a bull' was used to describe khutu both by the authors of books he had read and by the Far Eastern emissaries of whom he enquired, so it seems that the idea of a bull-like creature was bound up with the notion of khutu in al-Biruni's time.

Animals that can loosely be described as bulls exist in most parts of the world, so we need to narrow the geographical field of view. Hornbills aside, the work of Laufer and Ettinghausen provides over-whelming evidence that khutu was exported south in medieval times, essentially from or through the domain of hunter-gatherers and nomadic pastoralists such as the Kirghiz to the settled civilizations of central and eastern Asia. Let us define a broad search area: east of the 60°E line of longitude, west of the Pacific, north of the 30°N line of latitude, and south of the North Pole. Inside this region lies Eurasia east of the Urals and north of Nepal. Forty-five species of land-living artiodactyl with prominent horns, tusks or antlers live here: four musk deer, fourteen true deer, twenty-six bovids (cattle, antelopes, sheep and goats) and the wild boar. The Indian rhinoceros, a peris-sodactyl, makes forty-six.[57]

57 Chinese forest musk deer *Moschus berezovskii*; Alpine- *M. chrysogaster*; Dusky- *M. fuscus*; Siberian- *M. moschiferus*; Gong Shan muntjac *Muntiacus gongshanensis*; Indian- *M. muntjak*; Reeves's- *M. reevesi*; tufted deer *Elaphodus*

From his informants al-Biruni learned that khutu was a bone from the forehead of a bull. He appears to have examined khutu in the raw, however, and on the basis of his observations rejected this traditional explanation. Of khutu's owner al-Biruni says 'its forehead is thicker than two fingers, which would show that it cannot be the forehead of the Turkish bull, as [the Turkish bull] is smaller bodied. But it could well be the horn. As for the belief that it is the forehead of a bull, it would be the forehead of the mountain goats of Khirkhiz. Only they can have such foreheads.' One suspects that something important lurks in these sentences in part because they are so emphatic. Several points may be inferred. Khutu is surprisingly thick, too thick to be a bone from the forehead of a Turkish (Eurasian semi-nomadic pastoralist's) bull. Further, khutu is unlikely to have come from the forehead of a bull of any description, because bulls do

cephalophus; Thorold's- *Cervus albirostris*; swamp- *C. duvaucelii*; red- *C. elaphus*; sika- *C. nippon*; axis- *Axis axis*; hog- *A. porcinus*; Pere David's- *Elaphurus davidianus*; eastern roe- *Capreolus pygargus*; elk (moose) *Alces alces*; reindeer (caribou) *Rangifer tarandus*; Indian gazelle *Gazella bennettii*; goitered- *G. subgutturosa*; Mongolian- *G. gutturosa*; Tibetan- *G. picticaudata*; Przewalski's- *G. przewalskii*; chiru *Pantholops hodgsonii*; saiga *Saiga tatarica*; wild goat *Capra aegagrus*; markhor *C. falconeri*; domestic goat *C. hircus*; Siberian ibex *C. sibirica*; argalis *Ovis ammon*; domestic sheep *O. aries*; snow- *O. nivicola*; urial *O. orientalis*; Himalayan tahr *Hemitragus jemlahicus*; bharal *Pseudois nayaur*; takin *Budorcas taxicolor*; musk ox *Ovibos moschatus*; red goral *Naemorhedus baileyi*; Chinese- *N. caudatus*; common- *N. goral*; Sumatran serow *Capricornis sumatraensis*; domestic yak *Bos grunniens*; wild- *B. mutus*; domestic cattle *B. taurus*; wild boar *Sus scrofa*; Indian rhinoceros *Rhinoceros unicornis*. See Nowak (1999) and Duff and Lawson (2004).

not have foreheads of the right kind. More likely khutu belongs to a goat, because goats do have foreheads of the right kind.[58] Regarding the nature of the material, al-Biruni would not have equivocated if he had examined a regular horn, so if a horn was what he saw it was irregular in some way. More broadly, there is no indication that al-Biruni examined the antler of a deer (a branching pattern is not mentioned anywhere in the khutu literature), a tusk (al-Biruni thinks it is a horn), or the horn of a rhinoceros (he was familiar with the Indian rhinoceros from his time in India). Incidentally, the walrus, narwhal and mammoth can be discounted again, because it is inconceivable that al-Biruni examined the remains of one of these literally extraordinary creatures and then fretted over whether he had seen the forehead of a cow or of a goat, that is, of one or another animal with which he was completely familiar.

Which zoological material fulfils the following criteria? It must fit the description 'bone from the forehead of a bull', though is more likely to be from a goat-like animal. It is probably a horn, though one

58 The horns of cattle usually grow from the sides of the skull, whereas the horns of goats usually grow from the top, most often from just above the eye sockets. Cattle horns are usually simple in external structure and ornament, dark in colour, and relatively homogenous in internal texture. The horns of goats and sheep, by contrast, are variable in all of these characters. Goats, and especially sheep, typically have air-filled chambers in their skull-bones below the horns; in many species this feature is highly developed and obvious, particularly in males. The chambers cushion impacts between head-butting rivals (hence the more obvious development in the males of many species).

sufficiently odd in appearance that someone of al-Biruni's stature was not entirely sure what it was. It is bigger than a man's hand and has 'patterns described over it', perhaps patterns that wriggle or damascene. It is suitable for the manufacture of knife handles and may be linked with the walrus, narwhal and mammoth owing to its appearance, use, provenance, or association with medieval north–south trade routes.

One species fits this template quite well. The animal is a large bovid that looks like a bull but is not. It has a tremendously thick forehead from which sprout horns so curiously formed that the phrase 'bone from the forehead of a bull' springs irresistibly to mind. And unlike, say, the Siberian ibex, the argalis, and many other species on our list of forty-six, this animal is not obviously a goat or a sheep, which is to say that it lacks the kind of skull and horns that al-Biruni would have recognized as belonging to such a creature. What is more, the animal's horns have long been used by northern cutlers in the manufacture of knife handles, not least because a wavy, damascene pattern of growth lines is often present on polished surfaces (Fig. 6.4 shows a knife made using this material by the author's colleague Mark Knapp; note the damascene pattern on both blade and handle).[59] Finally, this animal is one of only very few on the list that lives alongside walruses and narwhals and among the remains of mammoths.

59 This chapter could not have been written without Mark Knapp's knowledge of knife-making and the materials used by northern cutlers.

6.4 Knife with khutu handle?

The new suspect in the khutu case is the musk ox (Fig. 6.5). In spite of its common name and appearance, the musk ox is more closely related to goats and sheep than to cattle, though its Latin name, *Ovibos*, literally sheepcow, shows how confused even experts have been about the matter. The horns of a fully grown male musk ox form a thick pad across its forehead called a boss.[60] The boss is typically 5–8 cm thick, while the skull cap underneath, which is usually imprinted with the horn's wavy pattern, can be 10 cm thick. The horn

60 The only other animal with a comparable structure on its head is the African buffalo, whose horn material is dark in colour.

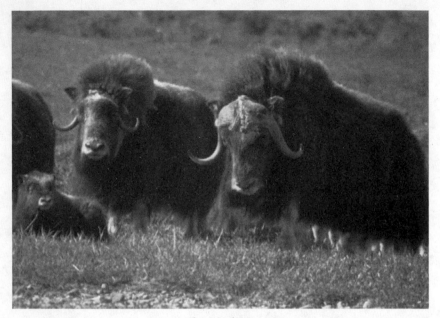

6.5 Musk ox

and skull are so robust because during the breeding season males use their foreheads as battering rams, occasionally meeting head to head in one of the most crunching collisions in the animal kingdom.

Could musk-ox horn be the missing piece of the khutu puzzle? The idea seems irresistible. But there is a problem with the theory: most authorities, though not all, think that the musk ox died out in Eurasia before al-Biruni's time.[61] If the musk ox was extinct in

61 The species made it onto our long list because it was reintroduced to Eurasia by humans and so is listed in Duff and Lawson (2004).

Eurasia in the Middle Ages, how did contemporary knife-makers in China and the Near East acquire musk-ox horns?

There are a number of possibilities. Musk oxen lived in Greenland in medieval times. Greenland was settled by the Norse in the last decades of the tenth century, but Norse sailor-merchants were carrying on a trade in northern luxury goods in the ninth century. The Norwegian chieftain Othere told the court of King Alfred of England at this time about a voyage he had made around Scandinavia to the White Sea in search of walruses. Though this is the earliest reference to the trade, the tenor of Othere's account suggests that walrus teeth had been a valuable commodity for some time. Othere and his kin probably acquired walrus ivory by hunting the animals themselves and by trading with northern peoples such as the Saami, from whom they also sourced rope made from walrus hide and the furs of land-living mammals. As specialists in the sourcing and trading of northern materials the Norse could have acquired musk-ox horns from islands in the North Atlantic before as well as after they settled Greenland. Perhaps some of these horns found their way to Muslim countries; perhaps some even ended up in China. However, a west to east supply route before the tenth century seems unlikely, not least because the Chinese appear to have sourced khutu from people living to their northeast, suggesting that the trade route's origin lay in that direction.

A musk-ox refugium – a safe area where a population is insulated from comings and goings in other parts of the world – existed on the

Arctic slope of North America until the middle of the nineteenth century. Our knowledge of Arctic peoples is very sketchy, but it is now accepted that Bering Strait has never presented much of a barrier to the movement of people and their goods. Laufer believed that walrus teeth were traded to China from the northeast; he writes: 'Chinese trade in marine ivory leads us back to the culture of those arctic peoples settled along the northern shores of Asia and America who hunt the walrus and the narwhal for the sake of their flesh, blubber, and tusks . . .' These Arctic peoples also hunted the musk ox. It is possible that the tusks of walruses and narwhals and the horns of musk oxen travelled from the Arctic to China along the same trade routes. If these three materials were mixed together in consignments of Arctic goods, even if musk-ox horns were present only occasionally, southern recipients might well have become confused about the distinction between a fish tooth and a bull forehead.

A third possibility leads to an established controversy. Until recently it was widely assumed that musk oxen died out in Eurasia when mammoths and woolly rhinos did, but this is now known to be wrong. Nikolai Vereshchagin, a Russian authority on Eurasian mammals, speculated that the species might have survived in parts of Siberia long enough to encounter seventeenth-century Russian explorers. Vereshchagin's was a minority view, but recent radiocarbon analyses of Eurasian musk ox remains are intriguing. Dates of 1000–700 BC for bones from the Taimyr Peninsula and Lena River Delta are now accepted, which means that musk oxen were alive in

Eurasia at least 7000 years after the extinction episode in which mammoths and woolly rhinos succumbed. Further, dating techniques reveal only the earliest date on which an extinction might have occurred, because scientists would have to be outlandishly fortunate to find the remains of the last Eurasian musk ox that ever lived, even assuming that the animal's bones have not rotted away or been smashed in a river. The remains that researchers have found must therefore be earlier in date, perhaps much earlier, than the date on which the last animal died (in palaeontological contexts this phenomenon regularly pushes estimated extinction dates millions of years backwards in time). For the same reason the radiocarbon date of the last known musk ox will move forward in time as more bones are found and analysed. It has already moved forward 7000 years and only another 2000 would place musk oxen in Eurasia in al-Biruni's time. Most likely the last musk-ox populations lived where people did not, in areas that were, and still are, remote, barren and hostile, for bone collectors as much as for anyone else. At the time of writing the field is wide open for further surprises.

One such surprise has already turned up, in a burial complex in the Noin Ula Mountains of Mongolia. The graveyard probably dates from the first century BC, 700 years or so later than the latest radiocarbon date for a Eurasian musk ox. Two plaques were found in the complex rendered in the local Siberian style typical of the region and period, suggesting that they had not travelled far before being interred. Both are impressed with an animal figure that looks very

much like a musk ox (Fig. 6.6). The idea that these plaques show musk oxen has been controversial, not least because archaeologists and historians, along with most biologists, have assumed that musk oxen died out in Eurasia before the first century BC. But we now know that this good reason for caution may not be as good as it once

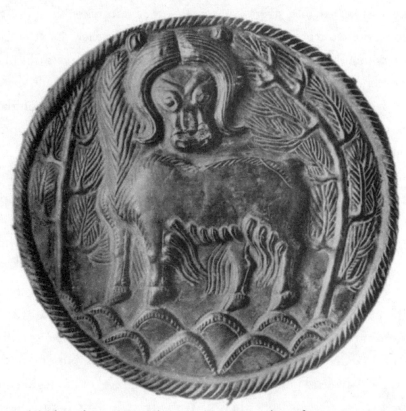

6.6 Silver plaque, Noin Ula Mountains, Mongolia, *c.* first century BC

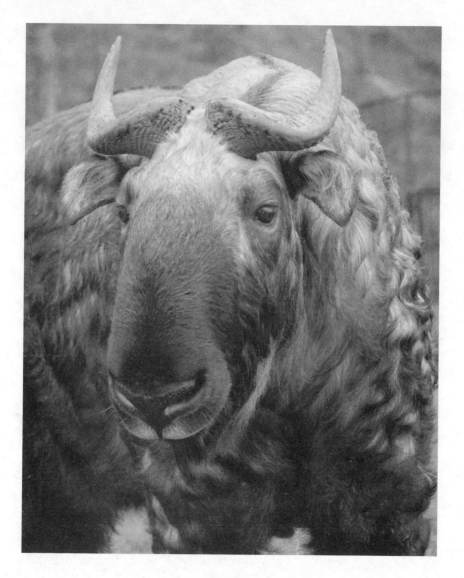

6.7 Takin

was. A compromise theory put forward by Wolfgang Soergel in the 1940s holds that the Noin Ula beast is a chimera, having the body of a takin (Fig. 6.7) and the head of a musk ox, the latter being known to the artist by way of 'fossil' skulls from northern Siberia. The idea is thought-provoking: if Mongolians were familiar with the horns of prehistoric musk oxen, why not also the Chinese and Arabs? If ancient horns picked up from the Eurasian tundra formed part of the trade in medieval knife-handle materials, the colours attributed to khutu would make more sense (ancient musk-ox horns are variously coloured for the same reasons that the teeth and bones of long-dead walruses and mammoths are). But one can only wonder whether Soergel would have put forward his theory had he known about the radiocarbon dates that have appeared in the last few years. Perhaps the artist who made the Noin Ula plaques depicted a flesh-and-blood musk ox. And perhaps his geographical descendants hunted the animal and sold its horns to entrepreneurs from the south, who in turn passed them on to armourers in China and the Near East, along with bits of walrus, narwhal and mammoth and a collection of enigmatic tales.

So, from where did Christians get the idea that alicorn had alexipharmic powers? From the East. Muslims told Christians, probably about the karkadann, though perhaps about khutu. Where did Muslims get the idea from? From the Chinese, one would have thought. But here's the strange thing: if the Chinese knew about

khutu's power before Muslims, they were strangely reluctant to write about it. And when they did write about it, 200 years after al-Biruni's death, they implied that the notion was Muslim.[62] So perhaps the Kirghiz, or some other entrepreneurial Turks, told Muslims about khutu's power, having first made the whole thing up. After all, the Chinese paid a fortune for the *real* magic horn. The Kirghiz did not have the real magic horn – that came from the south – but they did have horns from the Arctic. To these they attached a lie and sold them on to Muslims. The Kirghiz did not try their lie on the Chinese because the Chinese would have laughed. The writer Ko Hung explained the real horn to his countrymen in the fourth century AD: it is toxic, he wrote, because its owner eats toxic plants, and, since poison cures poison, it is an antidote.

Ko Hung's beast? The rhinoceros, which is probably where the myth began. We have gone as far as we may in our search for the source of alicorn's power. A best guess would go something like this. Poisonous plants made the rhino's horn toxic. Poison counteracts poison, it was believed, so rhino horn was an antidote. Sooner or later, perhaps nefariously, someone attached this myth to the walrus, perhaps also to the narwhal, almost certainly to the

62 Al-Biruni attributes such beliefs to the Chinese, but extant Chinese sources do not mention the alexipharmic properties of khutu until the middle of the thirteenth century, at which time the material is listed as a product of western Muslim countries and Central Asia.

mammoth, perhaps even to the musk ox, and at any rate to animals from a particular place, which we call the Arctic. Later the myth jumped to the karkadann, a literary and artistic chimera that, ironically, was originally the rhinoceros. Karkadann was a one-horned concept whereas khutu usually was not, so most likely the myth passed from the karkadann to the unicorn. The unicorn then concentrated the myth in the narwhal's tusk on its brow, and made Europeans look as foolish as the Arabs and Chinese.

CHAPTER 7

A great way off!

Having got thoroughly lost in Asia, let us return to the West and pick up the unicorn's story where we left it.

In 1687 Isaac Newton published *Principia Mathematica*, and by 1700 his rationalist approach to understanding the universe was sweeping across Europe. The breathtaking scope of Newton's achievements confirmed what many intellectuals had suspected for a long time: the Bible was not a reliable guide to the workings of the natural world and neither were the ideas of Aristotle. The ensuing Enlightenment – a catch-all term for the culture of rationalism that came to dominate scholastic thinking in the eighteenth century – was bad news for the unicorn. Speculations about a creature widely thought to be mythical had no place in an intellectual system rooted in reason. Worse, the French scientist Baron Georges Cuvier, the Newton of biology, reasoned that unicorns were anatomically all but impossible. In his vast experience of living and fossil animals he had

encountered neither a symmetrical horn nor one that attached to a suture between two bones, let alone to the frontal suture of the skull from where a unicorn's horn would have to grow. Cuvier was too smart and cautious to state that one-horned quadrupeds cannot exist – new categories of creatures might be discovered, animals are sometimes born with deformities, Indian rhinoceroses are unicorns of a sort, and he was a *scientist* – but the implication of his reasoning was clear: the time of scholars and explorers would be better spent on less trivial pursuits. In his *Discourse on the Revolutionary Upheavals on the Surface of the Globe and on the Changes which they have Produced in the Animal Kingdom* (1825) he makes the point bluntly:

Let us excuse those who use up their time revealing the wisdom hidden in the sphinx of Thebes, the Pegasus of Thessaly, the minotaur of Crete, or the chimera of Epirus. But let us hope that no one will seriously search for them in nature. One might as well look there for the animals in Daniel or the Beast of the Apocalypse. Let us not seek in nature further for . . . mythical animals . . . the marticore or destroyer of men . . . the griffon or guardian of treasurers, the cartazon, or wild ass, whose forehead is armed with a long horn.

Cuvier's scepticism triumphed in the universities of Europe, but travellers were less easily swayed. Explorers were discovering more of the world's geography, and some recounted exaggerated experiences

of foreign landscapes, peoples and animals. Scholars did their best to ignore these new tales, but the rapidly growing literate population of Europe found them harder to resist. Even better for unicorns, in the late eighteenth and nineteenth centuries an outlook on the world developed that offered more scope for wonders than Enlightenment scholars had been willing to concede.

The growth of the romantic movement was a reaction against, or at least a counterpoint to, the straitjacket of Enlightenment thinking. Romantics were attracted to the irrational, the passionate, the supernatural and spiritual. Where Enlightenment thinkers had revelled in man's mastery over nature, romantics delighted in the power of storms, the enormity of mountains, the emptiness of deserts, the loneliness of oceans. Eventually a Europe-wide phenomenon, romanticism took different forms depending on the cultural soil from which it grew. In Britain it stood in contrast to the Industrial Revolution, which had blackened townscapes and isolated people from the variously picturesque and awe-inspiring landscapes of the British countryside. The yearning for all that was idyllic or wild extended to dramatic European landscapes such as the Alps and the exotic lands of Europe's overseas colonies.

A reaction against romanticism then set in. This crystallized into a movement known as neoclassicism, which looked to classical writers, architects and artists for inspiration. The tension between these worldviews is particularly clear in architecture, exemplified by the rendering of London's Euston station in refined neoclassical and

the adjacent St Pancras in romantic neogothic. As is usually the case at such times in history, ordinary people were happy to mix elements of the opposing intellectual positions of the day. Classical thinking within a romantic milieu led to renewed interest in writers of antiquity, including those who had written about exotic countries, peoples and creatures. Classicists and romantics alike reread Ctesias, Aristotle, Pliny and Aelian and couldn't help but wonder. Exploration had shown that the ancients were mistaken in many of their beliefs, but not all of the places about which they had written had yet been explored. So it was that hope of connecting with the classical, or with the romantic, and either way with the one-horned, began to focus on two blank spaces on Victorian maps of the world.

Britain's entanglement with India had grown more intimate throughout the eighteenth century, mostly through the commercial activities of the British East India Company. Like the Portuguese and Dutch before them, British travellers and colonists were fascinated by the Himalayan mountains and the little-known lands that lay beyond the escarpment. Early contact with peoples of the region had been driven by inquisitiveness and trade, but as the decades rolled by interest became more political, because Himalaya separated the British in India from the expanding Russian empire. These two powerhouses of international politics flexed their muscles either side of the plateau, curried favour with its inhabitants, and did their best to gain the strategic upper hand.

The first emissary from Britain to publish an account of his travels in Tibet was Captain Samuel Turner, an army officer of the East India Company commissioned to negotiate diplomatic and commercial relations between the two countries. Turner spent most of the year 1783 hiking through Bhutan and Tibet before returning to his military duties in India. Intrigued by the exotic stranger travelling through his domain, the rajah of Bhutan invited Turner to his court. In *An Account of an Embassy to the Court of the Teshoo Lama in Tibet* (1800), Turner relates how:

We were treated, on our arrival, with tea, &c. which was followed by strawberries, and another fruit, growing wild, smaller, but not unlike a ripe sloe . . . Two musicians, placed at a distance, played upon reed instruments, in wild but not unharmonious strains, while the Raja held us in conversation, on the customs and produce of foreign countries; subjects on which he sought for information, with insatiable avidity. I selected the most striking peculiarities of all nations for his entertainment, and he, in turn, told me of wonders.

Turner was particularly surprised to learn of a strange animal owned by the rajah:

He had a very curious creature, he told me, then in his possession; a sort of horse, with a horn growing from the middle of its

forehead. He had once another of the same species; but it died. I could not discover from whence it came, or obtain any other explanation other than *burra dûre*! a great way off! I expressed a very earnest desire to see a creature so curious and uncommon, and told him that we had representations of an animal called an unicorn, to which his description answered; but it was generally considered as fabulous. He again assured me of the truth of what he told me, and promised I should see it; but I never had a sight of it.

Even in this short account of the one-horned beast of Himalaya, many of the sociological and psychological characteristics of unicorn tales of the modern era emerge. The rajah and his guest strike up the sort of conversation that people from different cultures often do, swapping stories about their homelands over tea. Not to be outdone by Turner's revelations about Europe, the rajah conjured up some striking peculiarities from his part of the world, including unicorns, 8-ft-tall men, and folk in the mountains north of Assam with tails so inconveniently placed that they have to dig holes in the ground to sit down. Turner claims that the rajah introduced unicorns to the conversation, and perhaps he did. Whichever way round it happened in this case, in many encounters Europeans probably brought up the subject first, and a combination of pride, the desire to impress and the disquieting presence of European firearms provoked the desired response.

Nikolai Przhevalsky eventually twigged that Himalayan unicorns existed wherever he happened not to be, a phenomenon nicely illustrated by the rajah's phrase burra dûre!, a great way off! In his 1876 book *Mongolia, the Tangut Country and the Solitudes of Northern Tibet* Przhevalsky writes:

> A prevalent superstition is that the orongo [chiru] has only one horn growing from the centre of its head. In Kan-su and Koko-nor we were told that unicorns were rare, one or two in a thousand; but the Mongols in Tsaidam, who are perfectly well acquainted with the orongo, deny entirely the existence there of a one-horned antelope, though admitting that it might be found in south-western Tibet. Had we gone further we should probably have heard that it was only to be found in India, and so on till we arrived at the one-horned rhinoceros.

There is a neat summary of how myths stay alive and propagate themselves, even among people best placed to know the truth.

Przhevalsky gave up on unicorns before wasting too much time, something that cannot be said of all Himalayan expats. Twenty years after Samuel Turner published his account of his travels on the plateau, Major Latter, another military man of good repute, stationed in the hill country east of Nepal, announced that the unicorn had at last been discovered in Tibet. His story was taken seriously enough to be published in the respected *Quarterly Journal*:

In a Thibetan manuscript which I procured the other day from the hills, the unicorn is classed under the head of those animals whose hooves are divided; it is called the one-horned tso'po. Upon inquiring what kind of animal it was, to our astonishment the person who brought me the manuscript described exactly the unicorn of the ancients, saying that it was a native of the interior of Thibet, fierce, and extremely wild, seldom if ever caught alive. They go together in herds like our wild buffaloes, and are very frequently met with on the borders of the great desert about a month's journey from Lassa, in that part of the country inhabited by the wandering Tartars.

The *Quarterly* printed Latter's note in 1821, along with an editorial expressing hope that more discoveries would be forthcoming and assuring its readers that 'steps have been taken to obtain a complete specimen of the animal supposed to be the unicorn, which is said to exist in considerable numbers in Thibet.'

The hoped-for specimen never materialized. Which or how many of the numerous Tibetan large mammal species formed the basis of Latter's unicorn is impossible to tell, but the chiru is an obvious candidate given its history of generating legends about one-horned animals. The yak is probably also in the mix, because Latter mentions herds of buffalo. The major's informant says that the tso'po is 'fierce, and extremely wild, seldom if ever caught alive', a now familiar

description that could be pinned on the chiru, the yak, the kiang or a combination of all three. The tso'po connotes the herd animals of Tibet and the one-horned ass of Ctesias and Aelian. The legend appears to have survived more or less unchanged on the Himalayan plateau for a hundred generations, during which time European civilization stumbled from the glory of Plato and Aristotle to the grime and grind of the Industrial Revolution.

Of Latter history records only a little more. Seven years on the *Quarterly*'s editors, palpably disappointed, reported that the major was still hunting the beast but had nearly given up hope.

Accounts of the elusive animal continued to emerge from Himalaya well into the nineteenth century. The French missionaries Evariste Huc and Joseph Gabet made the arduous journey to Tibet along the southwestern route from China, eventually reaching the Forbidden City of Lhasa in January 1846. Huc wrote about the kiang's personality and the Tibetan unicorn's horn, and part of his account quoted in Chapters 1 and 2 bears repetition, since it agrees with those of Aelian and Major Latter:

A Thibetan manuscript . . . calls the unicorn the one-horned tsopo. A horn of this animal . . . was fifty centimetres in length and twelve centimetres in circumference from the root; it grew smaller and smaller and terminated in a point. It was almost straight, black, and somewhat flat at the sides. It had fifteen rings, but they were only prominent on one side.

Apart from the dropped apostrophe, tsopo is the name used by Latter. Huc later refers to the tsopo by its alternative name of tchirou, which can safely be read as chiru, the animal that gave rise to the legend in the first place. Two thousand years had passed and Victorians were only just beginning to rediscover the knowledge of Himalayan creatures gathered by the ancients.

In the 1800s Tibet held up a mirror to Europe's rationalist–romantic split personality. Only one other part of the world could compete for the attention of serious travellers, a place that was vast, mostly unexplored, full of wonders according to the ancients, and every bit as strategically important as Tibet.

Reports of unicorn activity had trickled out of Africa for hundreds of years, but the number of accounts rose through the late eighteenth and nineteenth centuries as explorers mapped the continent and engaged with local peoples. In 1783 the Swedish naturalist Anders Sparrman cited the testimony of many native South Africans that unicorns were common near the Cape of Good Hope. Sparrman never saw the animal himself, but claims to have seen single horns brought to him by his native informants (there are too many kinds of antelope in Africa to guess the owner of these horns). Mirroring Major Latter's account from Nepal, Baron Friedrich von Wurmb, a German officer with the East India Company, wrote in 1791 from the Cape of Good Hope that he expected soon to see the unicorn that

has just been discovered in the interior of Africa. A Boer saw a beast shaped like a horse and with one horn on its brow, ash-gray and with divided hoofs . . . A Hottentot has confirmed this report, and the people in these parts quite generally believe in the existence of the unicorn . . . Various respectable natives have given their servants orders to bring in one of these beasts alive if possible, or else to shoot one, so that we shall soon see the question settled.

Przhevalsky Syndrome again: von Wurmb was at the Cape of Good Hope while unicorns were being discovered in the African interior. Typical, too, is the fondly expressed hope that the question of the unicorn's existence would soon be settled, after which nothing more is heard of the matter.

Von Wurmb may or may not have believed that unicorns roamed the heart of the Dark Continent, but he was in no doubt that the Africans to whom he spoke did believe it. This willingness to heed the accounts of indigenous peoples, though not a new phenomenon, was more common in the nineteenth century than at any time previously. Romantic notions of noble savages who understood and lived in harmony with their environments – unlike Westerners: witness the industrial cities of northern England – played a key role in the growth and spread of the unicorn myth.

Sir Francis Galton – explorer, meteorologist, geneticist, eugenecist,

psychologist, statistician – was impressed by the testimony of the Africans he met:

> The Bushmen, without any leading questions or previous talk upon the subject, mentioned the unicorn. I cross-questioned them thoroughly, but they persisted in describing a one-horned animal, something like a gemsbok in shape and size, whose one horn was in the middle of its forehead and pointed forwards . . . It will be strange indeed if, after all, the creature has a real existence. There are recent travellers in the north of tropical Africa who have heard of it there, and believe in it, and there is surely room to find something new in the vast belt of *terra incognita* that lies in this continent.

As Galton points out, accounts of unicorns from northern Africa were not uncommon in the nineteenth century, no doubt echoing reports from the south, which began to emerge a little earlier. At the start of the century Dr Eduard Rüppell was told by the natives of Sudan about an animal the size and shape of a horse, with a red hide, divided hooves and a single horn in the middle of its forehead. Baron von Müller encountered tales about a creature from the same region resembling a donkey with a boar's tail and a single horn that it could move at will. In 1838 the German traveller Albrecht von Katte reported that he had been told by Ethiopian soldiers that unicorns dwelt in central Africa:

It is true that their reports are not entirely consistent, but neither are they contradictory. Those who assert that they have seen the animal give the same description of it that Pliny left us. They say, that is, that it has the hoofs of the horse and the same shape as a horse, that it is grey in colour and has a strong horn in the middle of its brow . . . They say also that it is very shy and therefore hard to approach. These people find great likeness between it and the unicorn shown on the English arms, but when I showed them a picture of the rhinoceros they said at once: 'That is not it; that is another animal.'

Katte goes on to say that 'the unicorn is really to be found in the high, inaccessible mountains of this country,' suggesting that his lowland informants encountered the beast in the flesh only rarely – never, in fact.

Philip Henry Gosse FRS (Fellow of the Royal Society) collected together a number of accounts of African unicorns for his 1861 book *The Romance of Natural History*.[63] Here is an example:

63 Gosse is quite open about his romantic inclinations, which would have been unthinkable a century earlier when Enlightenment rationalism held sway: 'There are more ways than one of studying natural history,' he writes in the preface. 'There is Dr. Dryasdust's way; which consists of mere accuracy of definition and differentiation; statistics as harsh and dry as the skins and bones in the museum where it is studied. There is the field-observer's way; the careful and conscientious accumulation and record of facts bearing on the life history of creatures; statistics as fresh and bright as the forest or meadow where

Mr. Freeman, the excellent missionary whose name is so inti-
mately connected with Madagascar, received the most particular
accounts of the creature from an intelligent native of a region
lying northward from Mozambique. According to this witness,
an animal called the Ndzoodzoo is by no means rare in
Makooa. It is about the size of a horse, extremely fleet and
strong. A single horn projects from its forehead from between
two and two and a-half feet in length. This is said to be flexible
when the animal is asleep, and can be curled up at pleasure, like
an elephant's proboscis; but it becomes stiff and hard under the
excitement of rage. It is extremely fierce, invariably attacking a
man whenever it discerns him. The device adopted by the
natives to escape from its fury is to climb a thick and tall tree
out of sight. If the enraged animal ceases to see his enemy, he
presently gallops away; but, if he catches sight of the fugitive in
a tree, he instantly commences an attack on the tree with his
frontal horn, boring and ripping until he brings it down, when

they are gathered in the dewy morning. And there is the poet's way; who looks
at nature through a glass peculiarly his own; the aesthetic aspect, which deals,
not with statistics, but with the emotions of the human mind, – surprise,
wonder, terror, revulsion, admiration, love, desire, and so forth, – which are
made energetic by the contemplation of the creatures around him . . . Now,
this book is an attempt to present natural history in this aesthetic fashion . . .
[I] have sought to paint a series of pictures, the reflections of scenes and aspects
in nature, which in my own mind awaken poetic interest, leaving them to do
their proper work.'

the wretched man is gored to death. If the tree is not bulky the perseverance of the creature usually succeeds in overturning it. His fury spends itself in goring and mangling the carcase, as he never attempts to devour it.

It is hard to resist comparison with another bad-tempered, short-sighted, non-arboreal vegetarian, even though the two African varieties of the rhinoceros are technically bi-horned.

The excellent Mr Freeman was clearly an honourable man who had earned the respect of his peers, but not all reporters were as trustworthy. The flowering of interest in unicorns in the nineteenth century encouraged exaggeration and invention, particularly when personal gain was at stake. It is within this context that we must judge the actions of the French Service de Missions, a nineteenth-century state-run research council, whose task was to dispense travel grants to encourage 'voyages directed towards physical and geo-graphical research or studies of languages, history and all that is of interest to our [French] civilization'.

A fine idea, but political upheavals both in France and within the Service rendered the organization less enlightened than it might have been. In the turbulent months following the revolution of 1848 Louis Ducoret, also known as Hadji Abd el-Hamid Bey, a bankrupt former army colonel who claimed to have converted to Islam while touring Egypt in the 1830s, applied to the Service for funds to undertake a five-year journey from Algiers across the Sahara to

Senegal, by boat to the Cape of Good Hope, then back overland to the west coast. Anyone familiar with Africa in the nineteenth century will recognize Ducoret's travel plans as ambitious, to say the least. On having his initial application turned down, in large part because of the intervention of the Paris Geographical Society, headed by none other than Georges Cuvier, Ducoret wrote an impassioned letter accusing members of the Society of being armchair geographers with neither the right nor expertise to judge the feasibility of his mission. In support of his argument he cited the arrogance of so-called intellectuals who refused to believe in the existence of unicorns, despite his observations of huge herds of the magnificent beasts grazing the grassy plains around Lake Chad. Roughly the size of a large ass, he continued, African unicorns have single horns extending from their foreheads, which under normal circumstances remain flaccid like an elephant's trunk, but which stiffen to form engorged spikes when their owners become agitated, 'rendering them most redoubtable'. Ducoret also fired a broadside at the establishment for failing to acknowledge his reports of an African tribe called the Ghylâne, 'a pagan and degenerate race whose vertebral column is extended to produce a tail of between four and six inches' (probably a descendant of myths about people with tails that originated in India). Ducoret went on like this for several more pages, comparing himself favourably with Columbus and Galileo along the way.

Fortunately for Ducoret if not for science or France's reputation, Africa was at the time being promoted by a number of influential

people as a land of opportunity, where state-sponsored colonization might bring the same economic and political advantage to France that annexation of North America and Australia had brought to Britain. Owing to this political climate, and in spite of further unsavoury revelations about his financial affairs, the Service awarded Ducoret the enormous sum of 4000 francs per year for five years to further his African studies. Ducoret accepted and spent the next eighteen months living in some splendour in Algiers, never straying beyond its walls. He corresponded regularly with the Service, however, lodging weather reports and applications for further funds. He milked 9000 francs from French taxpayers before the Service finally pulled the plug on his mission. Penniless but unrepentant the colonel returned home one year later, disembarking from the Algiers steamboat into the streets of Marseille on the back of a camel. Frustratingly, history has neglected to record what the ingenious Hadji Abd el-Hamid Bey did next to fund his flamboyant lifestyle.[64]

What should we make of the upsurge of interest in African unicorns in the nineteenth century, which stands in such contrast to the general attitude of scepticism that characterized the Enlightenment? Europe's outlook on the world had changed. Weary of the modern world, many Europeans turned their backs on rationalism and opened the door again to awe and wonder, and nothing promised to

64 See Heffernan (1994).

provoke more awe and wonder and fame and riches than the discovery of unicorns. Any hint of the creature, however vague, sharpened this focus, leading to a chain reaction of reports, follow-up investigations, clumsy questioning of natives, rediscoveries of old stories left behind by previous visitors, translocations of local legends from one place to another, lies, embellishment, gullibility, foolishness, wish-fulfilment and funding applications to the Service de Missions. The only way to stop the chain reaction was to find the animal or explore sufficiently to eliminate any lingering hope; the former never happened and the latter, even with the resources of European nation states, took quite some time, during which stories passed from person to person and place to place until they formed a body of the most colourful and questionable travel literature in history.

Unfortunately, literature on the origin and transmission of African folk-tales of this period is so scant that we are left speculating what Africans contributed to the myths. Some Africans would have been familiar with unicorns from *Physiologus*, first written down in Alexandria and translated into Ethiopic and many other languages more than 1000 years before Europeans undertook serious exploration of the continent. Christianity itself is very old in Africa, especially in Ethiopia, and Christians of that country were familiar with the biblical unicorn. Portuguese missionaries had extensive contact with both Christian and non-Christian Africans long before other Europeans arrived. These men of God took their Bibles with them as well as bestiaries descended from the Latin

Physiologus. Arab traders brought to the continent unicorn stories derived from the Syriac and Arabic *Physiologi*. No doubt Africans had unicorn myths of their own, not least because they were acquainted with real one-horned animals. Yes, flesh-and-blood non-rhinocerine mammalian quadrupeds with single horns in the middle of their foreheads. Himalaya had its unicorns, too, and they were not chiru. We must delay our meeting with these surpassingly strange creatures until a later chapter, but note that the two great centres of unicorn tales in the nineteenth century were also where one-horned animals roamed.

We have explored the edges of Africa. To guide us to as yet untrodden parts of the continent we return to that quirky work of romantic rationalism *The Romance of Natural History*, where Philip Gosse tells his soot-blackened, wonder-starved audience of his belief that

whatever discoveries of importance are yet to be made in African zoology, will be in the very central district; the region, that is, which lies south of Lake Tchad and Abyssinia . . . There is reason to suppose that lofty mountain chains exist here, and geographical discovery has not yet even approached these parts. Many forms of high interest, and some of them of vast dimensions, may yet be hidden there.

It is highly probable that an animal of ancient renown . . . resides in the region just indicated. I refer to one of the supporters of Britain's shield, the famed Unicorn. We may not, to

be sure, find him exactly what the heraldic artists delight to represent him . . . but there may be the original of the traditionary portrait of which this is the gradually corrupted copy.

No surprise then that the talented naturalist and British governor of Uganda set out in 1899 for the interior on what would turn out to be the last, and most zoologically profitable, hunt for the elusive unicorn.

CHAPTER 8

In darkest Africa

The Wambutti know a donkey and call it 'atti'. They say that they sometimes catch them in pits. What they find to eat is a wonder. They eat leaves.

This paragraph of typically direct prose can be found in the end-notes to volume two of *In Darkest Africa*, a very long book recounting the adventures of Sir Henry Morton Stanley, one of the most fêted explorers of the Victorian era. Stanley was the man who took up the *New York Herald*'s challenge to 'go and find Livingstone,' the Scottish explorer who, as far as the rest of the world was concerned, had got lost somewhere in Africa. Stanley trekked 700 miles before finding the ailing Livingstone near Lake Tanganyika in November 1871. His account of their meeting yielded one of the most famous (and famously British) pieces of dialogue in the history of exploration:

I would have run to him, only I was a coward in the presence of such a mob – would have embraced him, but that I did not know how he would receive me; so I did what moral cowardice and false pride suggested was the best thing – walked deliberately to him, took off my hat, and said: 'Dr. Livingstone, I presume?'

'Yes,' said he, with a kind and cordial smile, lifting his cap slightly.

Stanley met and studied the Wambutti (Mbuti) pygmies of the Congo in 1888. Mbuti do indeed eat the leaves of rainforest plants on occasion, but under normal circumstances they are typical hunter-gatherers, trapping and shooting game, including the supposedly donkey-like atti, and collecting the more nutritious vegetable offerings of the forest.

Brief though Stanley's reference to the atti was, it did not escape the attention of Harry Hamilton Johnston, diplomat, explorer and tireless promoter of Britain's colonial interests in Africa. In 1883 Johnston penetrated the Congo Basin, where he met and befriended Stanley, who was then helping to set up the Congo Free State on behalf of the Belgian King Leopold II. A year later Johnston was appointed by the Royal Society to lead a scientific mission to the lands surrounding Mount Kilimanjaro. Few expeditions during the partition of Africa were apolitical, and Johnston's reputation as a sensitive negotiator with native Africans was as important as his

scientific skills. He duly struck agreements with the indigenous tribes of the region, under which they accepted British protection, essentially from the attentions of other predatory European powers. Johnston's treaties later formed the basis of the British East Africa Protectorate, which brought Kenya and Uganda into Britain's expanding sphere of influence. In 1885 Johnston joined the Foreign Office, and over the next seventeen years held administrative and diplomatic posts in Cameroon, the Niger Delta, Mozambique, Tunisia and Uganda. By the end of his career he had added 400,000 square miles of Africa to the colonial holdings of the British empire. For this he was awarded a pension of £500 per year, about which he was far from happy.

As a boy Johnston had shown a keen interest in science, natural history, linguistics and art. In 1875 he entered King's College, London, to study modern languages. While there he worked on gaining the qualifications needed for a scholarship in painting to the Royal Academy. In spare moments he studied natural history at Regent's Park Zoological Gardens and anatomy in the museum of the Royal College of Surgeons, gaining expertise in both subjects. Along the way he made the acquaintance of some notable London academics with whom he corresponded for the rest of his life. He would later seek guidance on scientific matters from his more sedentary colleagues, and, like many Victorian naturalist-explorers, reciprocated by sending home specimens of exotic plants and animals, including on one occasion 'four parcels consisting of one hippopotamus' head and several bucks'

heads . . . and the skull and tusks of one elephant'. Johnston's letters show that he was frequently irritated by the time it took his packages to get from Africa to England, but he had less cause for complaint than the post-room workers at the Zoological Society of London.

Johnston knew that rumours about African unicorns had been circulating in Europe for centuries and was fully aware that his eminent predecessors and contemporaries believed that the unexplored heart of Africa was where the unicorn might one day be found. As a child in the 1860s he had been affected by a book based on the mostly unreliable tales collected by early Dutch and Portuguese explorers. He writes in his autobiography:

The publication of this book was more or less incited by . . . discoveries of the gorilla and other strange creatures on the west coast of Africa, and its purport was to show that there were in all probability other wonderful things to be discovered in the Central African forests. Among these suggested wonders . . . was the unicorn. Passages from the works of the aforesaid Dutch and Portuguese writers were quoted to show that a strange horse-like animal of striking markings in black and white existed in the very depths of these equatorial forests. The accounts agreed in saying that the body of the animal was horse-like, but details as to its horn or horns were very vague. The compiler of the book, however, believed that these stories pointed to the existence of a horned horse . . .

Alex Johnston, writing thirty years later, gives a more forthright account of his brother's reasoning: 'Harry . . . had for years been on the track of the persistent "unicorn" legend, and had guessed that, just as the once fabled existence of the Pygmies had been proved to be truth, so the unicorn might really exist in the shape of some horned, horse-like animal in the heart of Africa.'

Harry could not help but connect his childhood memories with the writings of Henry Morton Stanley: 'Somehow these stories – which may have had a slight substratum of truth – lingered in memory, and were revived at the time Stanley published . . . "In Darkest Africa". A note in the appendix of [Stanley's] book states that the Congo dwarfs knew an animal of ass-like appearance which existed in their forests, and which they caught in pitfalls.'

To someone versed in natural history, Stanley's ass was an intriguing puzzle regardless of whether it had horns: 'The occurrence of anything like a horse or ass – animals so partial to treeless, grassy plains – in the depths of the mightiest forest of the world seemed to me so strange that I determined to make further enquiries on the subject whenever fate should lead me in the direction of the great Congo forest.'

A forest-dwelling horse is something of a contradiction nowadays, but Johnston knew that horse-like animals had once been common denizens of woodlands. If descendants of early horses were to survive anywhere in the world, Johnston reasoned, the vast rainforests of central Africa would be the most likely place. Perhaps the atti was a relic

of a bygone evolutionary world, a true living fossil. Whatever it turned out to be – a woodland horse, a survivor from before the age of humanity, or, just perhaps, a unicorn – Johnston knew that tracking it down would stamp his name in the annals of African exploration.

In March 1900, a few months after taking up the post of special commissioner to Uganda, Johnston received word from Belgian officials at Fort Mbeni on the Congo Free State frontier that a German showman and his entourage had turned up unannounced asking for permission to enter the forest and make contact with the Mbuti pygmies. The impresario's mission was to persuade some of the legendary Congo dwarfs to accompany him to Europe, where he would exhibit them at the 1900 Paris Exhibition. Whatever financial reward the German foresaw it was enough to impel him to the farthest outpost of the British and Belgian empires, risking along the way ambush, murder, predatory animals and the usual catalogue of incurable diseases to which itinerant Europeans had been succumbing in large numbers for centuries.

Not surprisingly Lieutenant Meura, the Belgian soldier in charge of Fort Mbeni, was unsure about official procedures in respect of the relocation of indigenous peoples from Belgian state land to France, so he decided to consult his superior, the governor-general of the Congo Free State, who at the time was on the other side of Africa. It was late 1899, the Paris Exhibition was due to start in a few months, and there was little chance that Meura and the governor-general would

resolve the situation quickly by exchange of letters. Given the tight time frame, Meura's insistence on following protocol amounted to a refusal of permission. The impresario seemed at first to acquiesce to his administrative fate, but shortly afterwards he and his men disappeared from Mbeni. Their tracks led into the forest.

A few weeks later Johnston received word from Meura that the German had engaged twenty to thirty pygmies and was trying to ferry them to the Nile or to the coast through northern Uganda. Uganda was Johnston's turf, so he sent word to his military officials to apprehend the miscreant at the first opportunity. No one is sure how many pygmies began the journey to France, but by the time they were taken into protective custody by the British only seven remained alive. The German was tried for his offence and given a heavy fine, since 'the imprisonment of Europeans was not, at that time, a convenient thing.'

Much more convenient for Johnston was to have on hand seven Congo pygmies. A passionate linguist, Johnston could not pass up the opportunity to study a race that may be the source of ancient Egyptian references to 'the people of the trees', and to compare their language with others in the region.

As senior administrator it fell to Johnston to organize the pygmies' repatriation. Who should he entrust with such a mission? He could have summoned up a British military force of almost any composition, but instead he decided to undertake the task himself. If escorting pygmies into the heart of the Congo rainforest seems an

incongruous job for one of the Crown's highest officials – he would be away from his desk for some time and difficult to contact – his choice of companions may shed a little light: his brother Alex and one W. G. Doggett, taxidermist, son of a taxidermist, and Johnston's chief preserver of natural history specimens. The young Doggett would not be much use in a fight, but he might know how to get a horned horse back to the Natural History Museum in good condition. Just in case Johnston got bored with collecting he instructed his staff to pack his painting equipment.

Johnston was unable to leave for the Congo straight away – there were provisions to organize, porters to employ and administrative loose ends to deal with – which left the question of what to do with seven frightened pygmies. The solution was simple for someone of Johnston's basic humanity and anthropological interests: he put them up at his house. Whose idea it was that they should decamp in his back garden history does not record, but one suspects that the choice was theirs. Here at least they had constant company:

. . . remarkable birds of prey, tethered to stumps, grey parrots in semi-liberty, pythons, puff-adders and other snakes in large wire cages. A young elephant allowed to roam where he liked, and with his companion, a young zebra, well behaved and not destructive; tame bush-buck; a Situtunga or water-loving Tragelaph; a baby hippopotamus . . .

When Johnston first welcomed the pygmies to his home he could communicate with them only in signs, but both parties could speak a spattering of the Bantu trade language of northern Congoland and the pygmies quickly picked up Swahili. Johnston worked out that his guests' native language was a variation of Mbuba spoken by the taller inhabitants of the Congo forest, but otherwise it seemed to be an unclassified and unstudied dialect. The pygmies' and Johnston's combined facility for languages was such that within weeks everyone was communicating freely.

Shortly before leaving for the forest one of the pygmies died. Johnston had been particularly intrigued by this individual because 'he was the most ape-like among my seven guests.'[65] Sensing a scientific opportunity, Johnston gathered the remaining pygmies together 'to ask their opinions and wishes', and to explain to them 'how interesting to us was the study of their people; how in the principal town of our Empire, we had a great house [the Natural History Museum] in which we preserved specimens of beasts, birds, reptiles and fishes from all parts of the world, and how we also tried to illustrate the different types of mankind. Would they have any objection,' he continues, 'to the skeleton of their dead brother being sent on to

65 Such was the nature of the times. But Johnston was not a racist in the sense that we use this term today. He went as far as to advertise his cherished black, white and yellow interracial policy – races working together for the greater good – by requiring his under-secretaries to wear yellow waistcoats with their otherwise black and white evening dress.

this great house, where the British people could see him, and compare him with the skeletons of their own race?'

The pygmies held a tribal council and decided that they approved of the honour that Johnston proposed to confer on their dead friend. Alex records: 'my brother got permission . . . to bury the body in an ant-hill, so that in a very short time the skeleton of the ape-like man was ready to be sent to the South Kensington Museum, where it is now exhibited.' Exposing the corpse to ants was an efficient way of cleaning the skeleton, although the technique had a dark history:

> This method of removing flesh from bodies did not seem so expeditious when it was practised on live subjects in Uganda in the days before the British Protectorate, when an escaped slave or wife on recapture might be pegged down across the regular roads made by the marching soldier ants. Casual attacks from these terrible insects when one is on the march give one a faint idea as to what it must have been like to be at their mercy [when] tactless missionaries and British officials refused to let the natives alone.

With the skeleton safely packed and on its way to London, Johnston's party was ready to leave Uganda. Harry, Alex, Mr Doggett, six Mbuti pygmies and, in Alex's words, 'some big ex-cannibal neighbours of the Pygmies, their teeth filed to sharp points and their faces horribly scarred', set off westwards towards the possible home of the unicorn.

Having snaked its way across the western part of Uganda Johnston's caravan stopped in Toro, where Harry took time 'to settle the affairs of that western kingdom of the Protectorate as he had those of the bigger kingdom of Uganda' (obviously a minor diplomatic task), and to make a headquarters for the onward journey. He christened the place Fort Portal after Sir Gerald Portal, but to Alex the fort was 'the portal to the wonderland of the Ruwenzori [mountains], looming in the clouds above, and also to the mysterious Congo Forest beyond'.

From Fort Portal Johnston's party descended to a short-grass plain dotted with euphorbias, acacia trees, antelopes and elephants. Harry settled down to paint a study of waterbuck, which was later exhibited at the Academy in London, while Alex and Mr Doggett wandered off in search of smaller wildlife to collect. Alex found more than he bargained for when he came face to face with a lion, but so did the lion: one look at the strange creature dressed in sun helmet, blue goggles and wielding a butterfly net and the king of the beasts crashed off into the undergrowth.

Much as Harry wanted to stay in this paradise of exotic wildlife the pygmies were keen to get home, so the party broke camp and marched up the Semliki River to a crossing station, from where they were ferried across in canoes to the Belgian fort of Mbeni. Here Johnston and his companions were greeted by Lieutenant Meura and his Swedish deputy Mr Eriksson. 'We settled up the pygmy question,' Johnston writes, 'and the pygmies, it was arranged, should

guide me to their home in the Forest, so that I could see them definitely repatriated.' A column of soldiers under the command of Fort Mbeni would have sufficed, but Johnston was determined to continue his 'fascinating quest for new languages, and [to see] the marvellous botany of Stanley's great Congo Forest'. More than anything he wanted to find Stanley's forest horse. Meura and Eriksson had never seen the animal, but they had heard stories from their pygmy contacts in the forest. According to Harry they described it 'vaguely as being a species of zebra, or possibly something more wonderful, a horse with three toes; a still surviving Hipparion. They advised me to enlist the pygmies as guides, and told me that the direction of their home in the Forest would bring me into the region [where the animals lived].'

Zebras are members of the horse family, and like all living horses they have only one toe on each foot in contact with the ground. Some ancestral horses walked on three toes, the best known in Johnston's time being *Hipparion*. If a relic population of *Hipparion* survived in the forests of the Congo its discovery would be a sensation.

Meura supplied Harry with some native soldiers for protection on the onward journey. Like the rest of the local workforce at Mbeni they were from plains-dwelling tribes. The thought of striking into the forest, a place that in all other circumstances they avoided, clearly made them nervous. But Harry would not be deterred. He reassured the spooked soldiers, gathered together his displaced pyg-

mies and excited British natural historians, and set off towards the forest.

Crossing the border from grassy plain to woodland, Johnston and his companions were enveloped in deep shade. Immense trees creaked in the semi-darkness. A tree hyrax screamed in alarm. In the distance parrots squawked and monkeys howled.

Riding horses through the Ituri Forest was impossible: their hooves sank into the boggy ground and lianas tangled around their necks. The prospect of going on worried even the intrepid Alex:

The many layers of dense foliage overhead, completely obscuring the sky, were bombarded by perpetual and torrential thunderstorms with a sound like musketry punctuated by terrific crashes of heavy guns. Even when this inferno ceased, the atmosphere, like the ground, was as full of water as a sponge, this being one of the wettest spots on the globe not actually submerged by ocean. At times indeed the illusion was strong in this ghastly gloom, as we staggered, half blinded and choked through the reek of it, that we were being drowned in a thicket of seaweed, in the stagnant zone beneath a storm-tossed sea.

Harry could see why Stanley had enthused about the botany of the forest. Strange ferns, fungi and delicate orchids clung to trunks and branches. Palms sprouted wherever a little light reached the ground.

Grassy glades sprang up where trees had fallen. Lush, slippery moss covered the enormous buttressed roots that snaked across the forest floor.

Harry and Mr Doggett were desperate to see the animals of the forest, but the soldiers were so scared that they chanted and sounded bugles to keep up their courage. Harry could hear exotic creatures calling in the distance and the occasional crash in the undergrowth, but apart from butterflies and a few spiders all the animals fled before the clamour of his party.

Any break from the suffocating heat and darkness was a blessed relief to everyone except the pygmies, who seemed completely at home so long as there were trees nearby. Doggett, Harry, Alex and the soldiers instinctively headed for glades, streams and village clearings. By the bank of one stream the pygmies suddenly huddled together and pointed urgently at the ground. It was the footprint of an atti. His strength and patience sapped by the heat and humidity, Johnston became uncharacteristically angry. The print had been made by an animal with two toes on each foot. Extant horses have one toe per foot. The ancient – extinct? – horse known as *Hipparion* had three toes. The footprint was big enough to be that of an eland or some other large cloven-hoofed beast, but it could not be the animal that Johnston was looking for. He told the pygmies firmly that he did not want to see any two-toed animals and ordered them back into the sweltering gloom to find him a horse.

The pygmies led Johnston to a village where some Congo state soldiers sported waist-belts made from the skin of an atti. Johnston immediately bought the belts to send back to London for analysis. The strips were so thin that he could not identify the creature from which they had come, but their appearance convinced him that the atti was worth pursuing: the skin was finely striped. Johnston could not think of any two-toed animal with such camouflage, but one single-toed creature sprang immediately to mind: the zebra. Perhaps the atti was a forest-dwelling form of an animal hitherto known only from the open plains. At least Johnston could feel more confident that the atti was not a two-toed beast. All options were still open, and any one would represent an exciting discovery: the atti could be a new species of zebra which lived in an atypical environment, a relic population of the ancient horse *Hipparion* (no one knows whether these animals were striped), or even a patterned horse with a horn.

With the waist-belts packed away in his bag, Johnston fell in behind the pygmies as they headed back into the forest. Alex writes:

At length we reached a collection of beehive huts made of the leaves of wild plantains, about the height of an ordinary dining-room table. It was the Pygmy village. Our little friends were transported with delight to regain what was to us an almost uninhabitable abode. They stilled the fears of their kinsfolk by singing the praises of the white man, and danced for us in a

clearing by moonlight, looking more than ever like elves and gnomes.[66]

To go further into the forest without the pygmies would be suicide. Johnston could pay or entreat his little friends to act as guides, but he knew that they wanted to be with their families. And by this time everyone in the party except the pygmies and Harry had fallen ill, mostly with malaria. Johnston had previously suffered attacks of blackwater fever, one of the most dangerous forms of malaria, and the state of his companions suggested that it would be only a matter of time before he succumbed. The soldiers were also behaving strangely, seeming 'to be constantly menacing an attack'. They were, after all, in the forest against their will. As children they had been told about the malevolence of the trees by their elders, and sure enough they had now fallen sick. Harry's first responsibility was to protect his brother and Mr Doggett, and another attack of blackwater fever would probably see him out. He was deeply disappointed, but the time had come to leave the pygmies to their forest.

Back in Uganda in 1901, Johnston received a package from Mbeni. Its contents had been brought to the fort by the pygmies and given to Lieutenant Meura. Meura died of blackwater fever shortly afterwards,

66 One of Harry's many anthropological theories held that 'Europe in bygone ages was inhabited by a Pygmy race, and that the bigger people who superseded them wove about their memory and passed on to us stories of "Little People" and pixies who played thievish pranks by night and disappeared into trees.'

so his assistant Mr Eriksson forwarded the parcel. Johnston ripped it open to find two skulls and a complete skin. From the stripes he knew immediately that he had an atti. The hide was extraordinary:

The cheeks and the jaws are yellowish white, contrasting abruptly with the dark-colored[67] neck. The forehead is a deep red chestnut; the large broad ears are of the same tint, fringed, however, with jet black . . . The muzzle is sepia colored, but there is a rim or mustache of reddish-yellow hair round the upper lip. The neck, shoulders, barrel, and back range in tone from sepia and jet black to rich vinous red. The belly is blackish, except just under the knees. The tail is bright chestnut red, with a small black tuft. The hind quarters, hind and fore legs are either snowy white or pale cream color, touched here and there with orange. They are boldly marked . . . with purple black stripes and splodges.

Johnston had never seen such an extravagantly coloured mammal. It looked like a bird of paradise. The hooves were missing from the skin, having dropped off the bones of the feet somewhere between the pygmies' village and Mbeni. But even without the hooves Johnston could see that the atti was not a zebra. It was not a horse of any kind. The pygmies had been right. The cloven footprints in the riverbank had belonged to an atti after all. But what sort of animal was it? Johnston

67 Published in an American magazine.

was unsure. 'I knew enough anatomy to realize when I examined the skulls and skin, that this beast was a near relation of the giraffe. What decided me were the bi-lobed lower canines. Many years before, I remembered Professor Garrod pointing out to me this special feature in the giraffe, not to be met with among other ruminants.' Turning the skull over in his hands, Johnston thought that the atti might be *Helladotherium*, a giraffe-like animal known only from fossils found in Greece, Turkey and India. But that was as far as he could go.

E. Ray Lankester, director of the Natural History Departments of the British Museum, received Johnston's parcel in July 1901. He, too, saw immediately that the disarticulated remains did not belong to a horse. He writes in his 1901 memoir on the creature: 'The absence of horns and the great length of the ears account for the comparison of the animal to a donkey or a zebra frequently made by natives when describing it.' (In fact males do have horns: Lankester was working with the remains of females.) Lankester could also see that the atti's closest living relative was the giraffe, as Johnston had surmised. But Johnston had erred in his final assessment. Though the skulls had affinities with the extinct giraffe *Helladotherium*, they were different in subtle but important ways. The atti was like no animal seen before, living or fossil, an extant short-necked giraffe, not belonging to any known group of giraffes, without a fossil record and without a name. The atti's species designation (the second in Latin binomials such as *Homo sapiens*) would be *johnstoni*, acknowledging its European discoverer. Lankester then had to decide on the generic

name. Atti was a possibility, but the pygmies had another name for the creature which Lankester favoured: o'api, the apostrophe indicating a gasping sound for which there is no English equivalent. The tribes living around the edges of the Congo forest have a problem with this consonant too, so they harden it to a k and pronounce the name okapi. Today, so do we (Fig. 8.1). The okapi is neither a living

8.1 Okapi

Helladotherium nor a unicorn, but it is widely acknowledged as the outstanding zoological discovery of the twentieth century.

Even before the okapi's remains reached London the press found out that an astonishing new creature had been discovered in the heart of the Congo rainforest. The story made front-page headlines around the world. People in Europe and the United States clamoured for information about the animal. Some of Johnston's paintings appeared in magazines and the skin held by Lankester was displayed in the Natural History Museum in London, but only one type of display would satisfy demand: the public wanted to see a living okapi.

The race began to bring okapis to zoological gardens in Europe and North America. In 1902 Lieutenant Anzelius, an army officer working for the Belgian government, brought back six skins and the dubious honour of being the first European to shoot an okapi. His commanding officer captured the first live specimen in 1903, a young animal which subsequently escaped. Over the next few years so many museums sent expeditions to secure okapi skins and skeletons for their collections that the Belgian government imposed a ban on hunting without a permit, a practical administrative move that was important in ensuring the species' long-term survival.

The Congo Expedition, backed by the American Museum of Natural History and the New York Zoological Society and led by the mammal expert Herbert Lang, was granted the necessary permits and

left from the USA in 1909 on a five-year collecting tour. Top of Lang's hit list was the okapi, closely followed by the white rhinoceros. After travelling up the Congo River for over 1000 miles and trekking inland for three weeks, Lang's party stumbled across villagers drying okapi meat beside a fire. Lang soon discovered that the okapi was much valued by indigenous people. So prized was its skin among the Bantu that only the chieftain and his family were allowed to sit on it. One limb of okapi hide could buy a wife, and wearing the skin was believed to endow its owner with the cunning of an okapi in evading capture, which is probably why the native soldiers met by Harry Johnston a decade earlier had fashioned okapi skin into bandoliers.

Lang stayed and worked in the village for some time.[68] With the aid of a local chief's son he captured an okapi calf, fed it on condensed milk until his supply ran out, then tried a mixture of rice and water, but the calf gradually weakened and died. For many years this pattern would be repeated. Even if the animals survived capture,

68 Reportedly, natives would wait for hours to shake the hand of the white man. Some would stroke Lang's arms and say 'Nyama mingi! Nyama nzuri!' Lang thought he was popular because of his curiosity value, until he had the phrases translated: 'Lots of meat! Very good meat!' The natives added humorously that they would spare the white man because they would only have to send the meat to their chiefs. White men were reportedly considered a delicacy because they ate a lot of salt and so seasoned themselves. Cannibalism was abolished three years before Lang arrived, but how rigidly the ban was observed no one was sure. Cannibalism probably did happen in the region, but the practice was no doubt more common in the minds of Europeans than in reality.

getting them from the middle of Africa to Europe involved several days on rough jungle roads to reach the Congo River, a three-week boat ride to Kinshasa, several weeks at sea, and ninety days' quarantine. It was 1919 before the first live okapi arrived at Antwerp Zoo. She lasted seven weeks. Another female called Tele arrived at Antwerp in 1928. She survived until 1943, but starved to death during the Second World War. And so it went on. Some translocations were successful, however. The captive population in Europe descends from about two dozen individuals, and that in North America from about the same number. Most okapis held in captivity today were born there. These days we tend to think that okapis are better off where they belong.

The okapi will always carry Harry Johnston's name, but of course he was not the first to discover it. Stanley probably saw the okapi before Johnston did. Early Dutch and Portuguese explorers whom Johnston read as a child may have seen okapis before Stanley, though most likely they simply reported stories about them. Bantu agriculturalists knew about the okapi long before any European reached the rainforests of the Congo, and the Mbuti have been eating okapi for thousands of years. Counting from significant times in our own cultural history often obscures histories belonging to others.

There is an older story of the okapi, parts of which scholars have uncovered, which centres on Africa's most famous river. The major source of the Nile was discovered by Stanley in the 1880s. The White

Nile rises in the mountain ranges of Uganda, which Harry Johnston skirted before descending to the forests of the Congo. Central Africans have always known about the source of this river, though only recently have they learned about its destination. People from other cultures long wondered where the water in the Nile comes from and why the river floods in the summer rather than the winter. The ancient Greeks and Romans thought up a number of theories to explain this untemperate behaviour. In the fifth century BC Mediterranean scholars proposed that the Nile has its source in rain or snow that falls on the mysterious lands south of Egypt, and in the second century AD Ptolemy wrote about the 'Mountains of the Moon from which the lakes of the Nile receive snow water'. One theory holds that Ptolemy meant the Central African Lake District in Uganda, where the Nile does originate. If the ancients knew of the existence of Uganda, how did the news reach them?

Contact between Old World civilizations and Central Africa might have been made by the time of the Persian king Xerxes, who ruled between 486 and 465 BC, fifty years before Ctesias arrived at the Persian court. Xerxes oversaw the building of a lavish audience hall at Persepolis, the walls of which were adorned with exquisite friezes. The relief carvings show twenty-three groups of delegates from areas of the world known by, or subject to the rule of, the Persians, each offering tributes to the king. The twenty-third panel shows three Africans accompanied by a Persian usher, who is a head taller than his charges. Each African bears a gift: the first cradles a pot

(contents unknown), the second carries an elephant's tusk, and the third leads an animal by a bridle. This creature would appear to be an okapi. Or at least it looks like an okapi. Another theory holds that the twenty-third delegation comprises Nubians and a giraffe. The animal looks nothing like a giraffe, but then giraffes are difficult to represent in proportion unless a very tall surface is available, and the scene at Persepolis is long but not very high. The frieze is not so cramped that the processing Africans could not have been made taller, however. An okapi may have left Africa twenty-four centuries earlier than our history books record.

We do not know how widespread okapi were in the ancient world, but judging from the animal's current distribution in rainforest habitats it seems unlikely that the Persepolis okapi, if that is what it is, came from anywhere other than Central Africa. It is possible that Persian explorers travelled up the Nile before the famed expedition of the first century AD sent by Emperor Nero. Perhaps they skirted the Ruwenzori south of Lake Albert and descended into the forests of the Congo. And perhaps they brought back some little people and a multicoloured atti to show how great was their king.[69]

In the aftermath of Harry Johnston's Congo quest all hope of finding a unicorn evaporated. The world of the early twentieth century was too well known. Evariste Huc, Major Latter, Nikolai Przhevalsky

69 Sprague de Camp (1963).

and Sven Hedin had scoured the wilds of Central Asia and found only stories. The grassy plains around Lake Chad had been explored and Ducoret's herds of grazing unicorns had mysteriously vanished. And in spite of Johnston's hopes, Stanley's forest ass turned out to be a short-necked giraffe. Baron Cuvier had said it all in the early nineteenth century: the sutures between the skull bones of an animal do not give rise to horns. Unicorns cannot exist. By the second quarter of the twentieth century this fact of biology was universally accepted, just in time for everyone to be proved wrong.

CHAPTER 9

The scientist's unicorn

In the 1820s Georges Cuvier promoted the theory that the horn cores of animals like cows and goats grow from their owners' skulls. Cuvier's view became orthodoxy for lack of any obvious alternative, while his unrivalled reputation as a zoologist ensured that it stayed that way. But W. Franklin Dove, a biologist at the University of Maine in the 1930s, showed that his eminent predecessor had been wrong. 'Cuvier, like all his contemporaries,' Dove wrote in 1936, 'was mistaken in his idea of horn structure. [I have] reported recently . . . that the bony horn cores of ruminants (*Bos taurus* and *Capra domestica*[70]) are not outgrowths of the skull (frontal) bones, as comparative anatomists have generally considered them to be, but are rather the products of separate ossification

70 Cow and goat.

centres . . . in tissues above the frontal bones.' In other words, Dove showed that horns grow not from the skull but from separate centres of bone formation floating in an animal's flesh. From these horn buds sprout bony cores which only later fuse to the skeleton underneath.

It was because of his ideas about horn growth that Cuvier thought that unicorns could not exist. To be centrally placed on the forehead a unicorn's horn would have to grow from the junction between the frontal bones of the skull, and since Cuvier had never seen a horn growing from the junction between two of an animal's bones he concluded that such a thing could not happen. He was correct in that horn cores do not grow from the edges of skull bones, but Dove showed that they do not grow from anywhere else on the skull either.

Dove also knew of some obscure references to animal husbandry techniques which suggested that the horns of domestic animals could be altered in various ways. 'Le Vaillant, 1796, in his "*Travels in Africa*,"' Dove writes, 'describes a process of manipulating the horns of oxen. "As the horns of the young ox sprout they are trained over the forehead until the points meet. They are then manipulated so as to make them coalesce, and so shoot upwards from the middle of the forehead, like the horn of the fabled unicorn."'

Le Vaillant was not the only European to have come across accounts of such practices. Writing in 1868, J. G. Wood, a man whose qualifications were so lengthy that he abbreviated them to

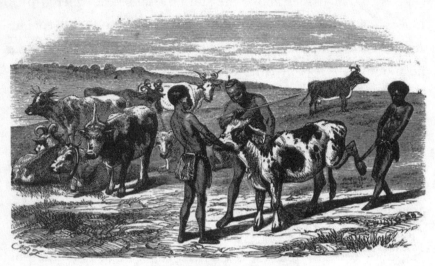

KAFFIR CATTLE. TRAINING THE HORNS.

9.1 Engraving of cattle with manipulated horns

'MA, FLS, etc., etc.', explains more about the technique and provides several engravings of the sculptured beasts (Fig. 9.1). Through the fog of Wood's easy racism the environmental and cultural context in which cattle ornamentation flourished can be made out:

The love that a kaffir[71] has for his cattle induces him to orna-

71 Now an offensive word in South Africa – so offensive as to be actionable – but originally used to describe black southern African Bantu-speaking peoples, or sometimes black Africans in general. In this passage Wood is referring to people living on the eastern coast of modern-day South Africa and Mozambique.

ment them in various ways, some of which must entail no little suffering upon them. To this, however, he is quite indifferent, often causing frightful tortures to the animals which he loves, not from the least desire of hurting them, but from the utter unconcern as to inflicting pain which is characteristic of the savage, in whatever part of the earth he may be. He trims the ears of the cows into all kinds of odd shapes, one of the favourite patterns being that of a leaf with deeply serrated edges. He gathers up bunches of the skin, generally upon the head, ties string tightly round them, and so forms a series of projecting knots of various sizes and shapes. He cuts strips of hide from various parts of the body, especially the head and face, and lets them hang down as lappets. He cuts the dewlap and makes fringes of it, and all without the least notion that he is causing the poor animal to suffer tortures.

But in some parts of the country, he lavishes his powers on the horns. Among us the horn does not seem capable of much modification, but a Kaffir, skilful in his art, can never be content to leave the horns as they are. He will cause one to project forward another backward, and he will train one to grow upright, and the other pointing to the ground. Sometimes he observes a kind of symmetry, and has both horns bent with their points nearly touching the shoulders, or trains them so that their tips meet above, and they form an arch over the head.

Le Vaillant expresses his curiosity about these fancy-horned creatures, so different from the cattle of his native country:

I had not yet taken a near view of the horned cattle which [the herdsmen] brought with them, because at the break of day they strayed to the thickets and pastures, and were not brought back by their keepers until the evening. One day, however, having repaired to their kraal very early, I was much surprised when I first beheld one of these animals. I scarcely knew them to be oxen and cows, not only from account of their being much smaller than ours, since I observed in them the same form and the same fundamental character, in which I could not be deceived, but on account of the multiplicity of their horns, and the variety of their different twistings.

A knowledgeable man, Le Vaillant could see that these animals were cattle of some sort, but he was nearly fooled into thinking that they were works of nature:

Being at this time persuaded that these concretions [horns], of which I had no idea, were a peculiar present of nature, I considered the Kaffir oxen as a variety of the species, but I was undeceived by my guide, who informed me that this singularity was only the effect of their invention and taste; and that, by means of a process with which they were well acquainted, they

could not only multiply these horns, but also give them any form that their imaginations might suggest.

Intrigued, Le Vaillant was keen to learn more about the mysterious practice of horn manipulation. For several days he was tutored in the art by his hosts:

> They take the animal at as tender an age as possible, and when the horns begin to appear they make a small vertical incision in them with a saw, or any other instrument that may be substituted for it, and divide them into two parts. This division makes the horns, yet tender, separate of themselves, so that in time the animal has four very distinct ones.
>
> If they wish to have six, or even more, similar notches made with the saw produce as many as may be required. But if they are desirous of forcing one of these divisions to form, for example, a complete circle, they cut away from the point, *which must not be hurt*, a small part of its thickness, and this amputation, often renewed, and with much patience, makes the horn bend in a contrary direction, and, the point meeting the root, it exhibits the appearance of a perfect circle. As it is certain that incision always causes a greater or less degree of bending, it may be readily conceived that every variation that caprice can imagine may be produced by this simple method.

A simple method in principle, but one unknown to Le Vaillant's Europe. This could not pass without comment:

> In short, one must be born a Kaffir, and have his taste and patience, to submit to that minute care and unwearied attention required for this operation, which in Kaffir-land can only be useless, but in other climates would be hurtful. For the horn, thus disfigured, would become weak, whereas, when preserved strong and entire, it keeps at a distance the famished bears and wolves of Europe.

Needless to say, African herbivores would be a lot less skittish if they had only wolves and bears to worry about.

Franklin Dove was fascinated by such tales, and owing to his specialist knowledge he knew that the sort of horn sculpturing reported by Le Vaillant and Wood was at least theoretically possible. Clearly a unicorned animal could be produced by bending an animal's horns inwards as they grew and twisting them together, or, presumably, by removing one horn and manipulating the other. But Dove knew about another type of unicorn which, though better known in some ways owing to its connections with the British royal family, was much more mysterious. W. S. Berridge in his 1921 book *Marvels of the Animal World* describes the creature in revealing detail:

Few domestic sheep are more remarkable, or have given rise to more controversy, than the Indian one-horned or unicorn sheep, of which the first living specimens ever seen in this country formed part of a large collection of Nepalese animals presented to King George V, when Prince of Wales, that were exhibited at the London Zoological Gardens in 1906. Although receiving the name of unicorn sheep, these animals really possess a pair of horns, for if we examine one of their skulls and remove the horn sheath from its bony support, it will be noticed that the latter is composed of two quite separate structures. The sheath itself, however, is united externally along its inner margin for the greater part of its length, but, diverging at its extremity, finally forms two distinct points; while, moreover, a thin horny partition divides the interior of the sheath into two portions. The horns of these sheep take a bold backwards sweep from their bases and, in some cases, their curvature is so pronounced that it is necessary to saw off the tips in order to prevent them from piercing the backs of the animals' necks.

Though Berridge knew that two horn cores were covered by a single horn sheath, the marriage was so artful that he was unsure whether unicorned sheep were the work of nature or cunning:

There appears to be a certain amount of mystery regarding the origin of these creatures, and some doubt as to whether their

peculiar horn formation is not the outcome of artificial manipulation. Some interesting correspondence was published in the *Field* concerning this question, and in the issue of that paper dated April 27, 1911, the following extract from a letter sent to the late Mr R. Lydeker by Colonel J. Manners-Smith, British resident at the court of Nepal was published:

'The enquiries which have been kindly made for me by his Excellency the Prime Minister of Nepal . . . have resulted in a clearing up of the mystery attaining to these curiosities. There is no special breed of one-horned sheep in Nepal, nor are the specimens which have been brought here for sale natural freaks. By certain maltreatment, which is described below, ordinary two-horned sheep are converted into a one-horned variety. The process adopted is branding with a red hot iron the lambs when about two or three months old on their horns when they are beginning to sprout. The wounds are treated with a mixture of oil and soot, and when they heal, instead of growing at their usual places and spreading, come out as one from the middle of the skull. The breed which appears to be used for the purpose of manipulating and converting into "unicorns" seems to be exclusively the barwal, a Tibetan breed of heavy-horned sheep.'[72]

72 The barwal, bharal or Tibetan blue sheep also lives in Nepal, predominantly along the country's northeastern border.

The use of hot irons, oil and soot suggests a method of cauterizing wounds and protecting them from infection rather than manipulating horn growth. In extremis soldiers use heated metal or flamed gunpowder to cauterize wounds, while oil, a substance free of harmful microbes, thickened with soot, a powder produced and sterilized by fire, would form an effective barrier against most types of bacteria. Dove knew that branding horns in such a cavalier way would not produce a unicorn:

> Scientific scrutiny . . . has tended to pick flaws in descriptions of this process. As Berridge goes on to say, '. . . the majority of naturalists are inclined to doubt whether a true understanding has even yet been arrived at concerning these sheep, for it has been pointed out that the mere fact of searing the budding horns would not result in those appendages sprouting out of the summit of the skull instead of towards the side.'

To those inclined to think that the horns had been twisted together and the deceit hidden beneath the animal's fleece, Berridge gives an emphatic response:

> It is true that the horns of a young animal might be induced to grow together by binding them up, but in that case we would expect the bony supports to be bent aside at their bases as a result of the unnatural strain put upon them, whereas, on the

contrary, those of the unicorn sheep arise in quite a straight manner from the skull.

That is the important point: the horn cores were located in the centre of the skull. Berridge's Nepalese sheep were proper unicorns. As we have seen, tales about one-horned animals were common on and around the Himalayan plateau, so perhaps shepherds perfected the practice of horn manipulation over the centuries and in the process brought one of their most ancient myths to life. Franklin Dove thought he knew how they had done it.

In March 1933 Dove set about creating a unicorn. He acquired a day-old Ayrshire bull and performed a delicate operation on its forehead. He cut out the calf's horn buds while leaving them attached to strips of skin, ensuring that they stayed alive. He then planted the buds one on top of the other into a pre-prepared area in the centre of the calf's forehead, above and in contact with the suture between the frontal bones of the skull.

Dove included a photograph of the calf in his 1936 article. It would be difficult to find better support for the argument that experiments like this have no place in science any more. The picture shows a day-old calf propped up unsteadily on its two front legs with a square of white card held behind its head. The top of its head has been shaved, and the scars of its operation are clearly visible. The animal looks stunned and bedraggled. But in operative terms the experiment was a complete success (Fig. 9.2):

The animal, now two and a half years old, bears upon the forehead the stamp of the once fabulous unicorn. The two buds have coalesced and have formed one exceptionally large and long horn molded into the skull bones of the forehead for support. Cuvier's argument that the separation of the frontal bones at the point of origin of the horns precludes the existence of the unicorn is shown to be unfounded, since the horn spike grows not *from* the skull but *upon* the skull, first as an epiphysis, later to fuse to the frontal bones over the suture as a horn spike solidly attached to the skull. A single united sheath covers the horn spike. The horn curves slightly upward toward the tip and gracefully extends the curve of the back and neck when the animal stands at attention.

Intriguingly, the bull's horn was white at the base and black at the tip. Had Dove chosen a cow rather than a bull for his experiment the end of its horn would have been red, because horn-colour is linked to gender in this particular breed. White at the base, black in the middle and red at the tip: the same pattern of colours attributed to the one-horned ass's horn by Ctesias of Cnidus. A coincidence no doubt, but one that gives us pause to reconsider Ctesias' supposedly outlandish claims.

In Book 11 of his *Natural History*, Pliny pushes the practice of horn manipulation back 2000 years. He says that the horns of oxen are so pliable when heated with boiling wax that they can be bent any

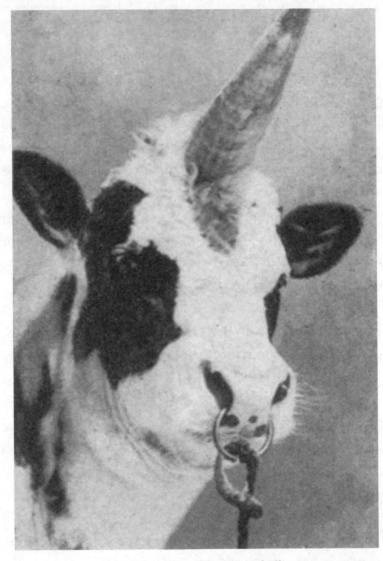

9.2 Franklin Dove's unicorn bull

which way, even while still attached to a living animal. He goes on to say that horns may be slit at birth and twisted in opposite directions. Dove believed that this showed ancient knowledge of the surgical technique that he had used:

> Pliny says: "atque incisa nascentium in diversas partes torquean-tur, ut singulis capitibus quaterna fiant." While this reference has to do with the artificial production not of unicorns but of multi-horned animals . . . the words 'incisa' (to cut) and 'torqueantur' (to twist awry or to writhe) clearly denotes the modern method of skin transplantation by means of pedicled flaps, i.e., strips of skin so cut that that they remain attached at one end of the strip (containing, in this case, the horn bud) may be twisted or shifted to another part of the animal [sic] body as a transplantation. This reference indicates that the men of Roman times had the secret of horn bud transplantation.

Dove is probably overstretching. Pliny seems to be describing the cutting of an ox's horn buds into several sections, which are then twisted apart so that each grows into a separate horn. There is little in Pliny's description to suggest transplantation as Dove under-stood the technique. Nevertheless, it would take only one more step – moving the sections further apart than can be achieved by twisting – for Pliny's and Dove's techniques to merge. Ancient herdsmen who understood how to divide the horn buds of

new-born calves to produce multi-horned cattle probably also knew how to move the same organs around an ox's head, just as Nepalese shepherds knew how to rearrange the horn buds of their local sheep.

So the tradition of horn manipulation dates back to the time of Christ, and probably originated much earlier. Odell Shepard believed that many reports and sightings of one-horned animals down the centuries could be explained by this ancient tradition, and also that elements of unicorn mythology might be rooted in the practice. In pondering the unicorned sheep of Nepal, Shepard wondered 'why a sheep with one horn is thought to be worth more than a sheep with the normal equipment, and also why such a sheep was thought a suitable gift for the Prince of Wales'. He speculates:

Some light is thrown upon this question by the fact that the tribe of Dinkas, who live [in Sudan] just south of the White Nile, not only manipulate the horns of their cattle as the Kaffirs do but use this practice as a means of marking the leaders of their herds. One can readily believe that the practice is one of great antiquity and that it was used as the Dinkas used it in many parts of the world during the pastoral ages. In the minds of primitive men living a pastoral life the leader of a flock or herd is a valuable possession and he is also a natural emblem of sovereignty and supreme power.

If artificial unicorns were once thought of as leaders, some otherwise confusing ancient references to one-horned animals being offered as gifts or sacrifices to earthly and heavenly leaders would make more sense. Shepard explains:

> The one-horned ram's head sent to Pericles [leader of Athens between 443 and 430 BC] by his farm hands may have been that of the leader of their flock, and so a perfect symbol of that leadership in Athens which, according to Plutarch's interpretation, they wished to prophesy for their master . . . [And] the mysterious one-horned ox mentioned three times over in the *Talmud* as Adam's sacrifice to Jehovah may have been the most precious thing that Adam possessed, the leader of his herd of cattle.

On the other hand, if one-hornedness once widely symbolized leadership, we might expect to find many allusions to the condition in ancient literature, but the writings of the Greeks, Hebrews, Egyptians, Mesopotamians and Chinese offer little support for the idea.[73] However, an association between unicornity and leadership might explain an obscure reference to Kaffir society by Samuel Purchas in 1625, in which he reproduces an account by the itinerant Portuguese Dominican Friar Sanctos in the late 1500s:

73 See Godbey (1939) and Schaper (1994).

The Cafres are blacke as Pitch, curled, and weare their head full
of hornes made of the same haire, which stand vp like a
Distaffe, wearing slender pieces of wood within their lockes to
vphold them without bending: without, they tye them with a
ribband made of the barke of an herbe, which whiles it is fresh
sticketh like glue, and dried is like a sticke: with this they binde
their haire in bundles from the bottome to the top; of each
bundle making a horne, holding herein great pride and gal-
lantrie; striuing to excell each others; and mocking them which
want them, saying, they are like women. For, as the male wilde
beasts haue hornes which the females want; so doe these sauage
beasts also. The Quiteue [king] hath herein a fashion which
none may imitate, of foure hornes, one of a spanne long on the
mould of the head, like an Vnicorne, and three of halfe a
spanne, one on the necke, at each eare another, all vpright to the
top. For their hornes sakes they haue no hats, nor headcouer-
ings amongst them.

According to Sanctos at any rate, the king of the Kaffirs adopted a
unicorn hairdo that marked him out as the leader of his people. If this
fashion was a badge of chiefdom, no wonder ordinary tribesmen
made unicorns the leaders of their herds. Or perhaps the king adopted
a hairstyle that aped the badge of leadership traditionally worn by his
people's cattle: animal husbandry is very ancient in this part of the
world, so it is quite possible that unicorned cows came first.

Why should one-hornedness denote leadership? The horns of cattle were once manipulated to produce individuals with many horns, others with strangely shaped ones, others whose horns pointed in different directions. Many forms were available, yet unicornity marked the dominant individual. How did pastoralists know that calves whose horns had been united to form a single spike at birth would turn out to be leaders?

Altering the body of an animal, particularly the structures it uses for displaying and fighting, may induce profound behavioural changes. Having observed his one-horned bull grow and develop over a period of two years, Franklin Dove came to some intriguing conclusions about its personality:

> [H]e is conscious of peculiar power. Although he is an animal with the hereditary potentiality for two horns, he recognizes the power of a single horn which he uses as a prow to pass under fences and barriers in his path, or as a forward thrusting bayonet in his attacks . . .
>
> According to our literature, an aristocratic nature is inherent in every unicorn. He is always the leader. Quite rightly so, and for reasons quite acceptable to behavioristic interpretation. Any animal fronted with a single horn would learn the advantages of a single well-placed weapon and would, through experience, gain ascendance and leadership over the rest of the herd. To take a modern parallel, it is common knowledge

among Argentinian gauchos that the mulley [hornless] animal is generally able to dominate the horned animal. The animal lacking horns usually has a well developed frontal eminence which with the straight body weight behind it produces a more telling impact than does the side cut and slash of the horned animal. Should there be joined in one animal the mulley's potential impact with a powerfully blunt horn centrally posited, the animal would undoubtedly come to be invincible. Thus in true modern fashion we invert cause and effect. We can not say that the ancients made unicorns of the leaders of their herds, especially in view of the fact that such a transplantation as we have described must be effected shortly after birth when qualities of leadership are not yet discernible. But we say rather that the presence of a single horn upon the forehead of any single beast in the herd or flock gave it the incentive for leadership through a power which it learned only through experience.

As Dove points out, strange as it may seem, hornless cattle often dominate their horned neighbours. Mulleys butt their rivals, or threaten to do so, with their full body weight, rather than displaying, locking horns, head-bucking and side-slashing in the traditional shows of bluster and strength that usually decide who is who in a dominance hierarchy. Dove was convinced that his unicorn was conscious of a similar 'peculiar power'. The animal used its horn as a

bayonet in thrusting attacks and as a prow to move fences out of its way. Needless to say, ranchers rarely have to deal with cattle who know how to get from where they are to where they want to be by levering fence-posts out of the ground.

Dove's claim about the behaviour of his one-horned bull is thus quite plausible. The horns of a normal cow or bull can be swivelled around violently, the point of one horn can be thrust at an adversary in a sideswipe, or both points can be deployed by the animal lowering its head to the ground and bucking its neck upwards.[74] All these methods can injure an opponent, and head-bucking can be devastating if the aggressor manages to catch its victim in the belly, which is why cattle deploy their heads forward and swivel their bodies out of the way. But a bull facing Dove's creation would be tangling with an adversary whose unwieldy cranial ornaments have been replaced by a human being's idea of a weapon of war. Instead of lowering its head to the ground, the unicorned animal can stand erect and aim its horn right between its opponent's eyes. The threat that such a beast would pose to its fellows might be enough to settle disputes before they begin, for a truly dominant individual rarely has to lower itself to violence. The one-horned animal receives deference from its

74 The last mentioned methods explain why the human bull runners of Spain are often seen flying through the air if they are caught. It is also why the second best way to avoid being gored is to lie flat on the ground. The best way is to leave the poor animals alone.

fellows, while the herdsman describes the leader of his herd in terms destined to echo down the ages: powerful, gentle, noble, aristocratic. Perhaps that is why Africans made one-horned cattle to be the leaders of their herds, why the king of the Kaffirs had a unicorn hairstyle, and why loyalists sent a one-horned ram to Pericles. Perhaps unicorns once made perfect sense and then we simply forgot.

CHAPTER 10

Ancestral unicorns

We have reached 1936. Up ahead is the unicorn of New Age mystics and advertising executives. We must turn back.

Like most histories of the unicorn, this one has made it seem that the beast sprang into existence in the middle of the first millennium BC. Many of the threads of Western history appear around Ctesias' time, because the ancient Greeks left to posterity a wealth of records written in a language that their descendants had little trouble understanding. Most pre-Greek peoples were not so obliging. Many left no written records at all. Others left writings that have only recently been deciphered, or that have yet to be, or that can never be. Some hid their existence from historians until the eighteenth century, or the nineteenth, or, in the case of the huge Indus Valley Civilization of India and Pakistan, 1924. We are only beginning to recover the thoughts of these people, yet already we know that the unicorn idea was abroad long before Ctesias' time. Similarities between the uni-

corn as we know it and characters in ancient folk-tales and artwork are sometimes striking, though it is rarely possible to tell whether the similarities are genetic or the product of wishful thinking. The source material – fragmentary, disconnected and always ambiguous – provides little evidence and ample room for speculation, with the result that theories about the prehistory of the unicorn vary from the plausible to the highly imaginative. The last few pages of this book will be given over to some ideas from the sober end of the spectrum.

Fig. 10.1 shows images of some apparently one-horned animals made by the ancient inhabitants of Persia (Iran and environs; 10.1a), Mesopotamia (modern Iraq, along with parts of Syria, Turkey and Iran; 10.1b) and the Indus Valley (10.1c).[75] They illustrate a venerable controversy: are we looking at unicorns, or bicorns in profile? Opinion on this matter has swung from one extreme to the other. Early interpreters of Persian wall carvings came to the conclusion that unicorns were meant,[76] whereas their successors argued in

75 Ancient Mesopotamia hosted a succession of civilizations from *c.* 5500 until the Persians overran the region in the middle of the sixth century BC. The Indus Civilization is as ancient, but the so-called Mature Indus Civilzation flourished 2600–1900 BC. Persian images from the palace complex of Persepolis were made from the sixth century BC onwards.

76 Since Ctesias spent many years in Persia it was natural to infer that his account of the one-horned ass had been influenced by these images. In retrospect it is clear that if Ctesias had been influenced by the bas reliefs of Persepolis he did a good job of concealing the fact.

10.1a 'Unicorn' from ancient Persia

10.1b 'Unicorn' from Mesopotamia

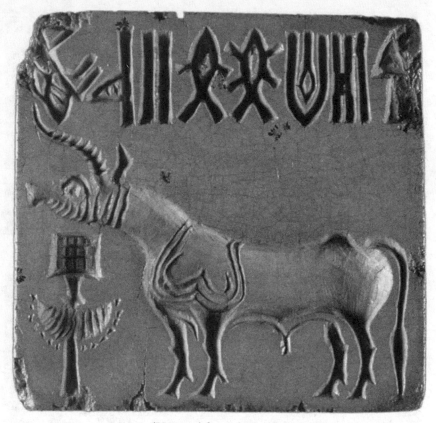

10.1c 'Unicorn' from the Indus Valley

favour of the ancient artistic convention of representing animals side on with one horn hidden, but understood to be, behind the other. In 1930 the ever sensible Odell Shepard pointed out the middle ground: the ancients usually did represent horned animals in profile, but when they wanted to show both of an animal's horns

they were quite capable of doing so. Moreover, the intentions of artists are far less to the point than the impact of their work on other people: if scholars of the nineteenth and twentieth centuries disagreed about the interpretation of side-on animals, what should we expect of the people who came in awe and fear to the mighty power centres of Mesopotamia and Persia in ancient times? What did they tell their compatriots back home about the monsters adorning the walls of Persepolis? All sorts of things, probably. And whatever was thought about wall carvings and paintings, travellers who saw statuettes like the one in Fig. 10.2 from early first millennium BC Iran would have been left in no doubt that unicorns existed, if only in someone else's head.

We do not even need to invoke travellers' tales to imagine how the unicorn idea might have spread, because pictures of one-horned animals were passed around the ancient world. The image in Fig. 10.1c, known as a sealing, was made by impressing an intricately carved seal into clay. Sealings were often attached to merchandise, recording information about sellers, handlers, administrators and anyone else involved in the business of trade. Seals were used by Mesopotamians, Indians, Egyptians, Cypriots, Hittites (from Anatolia, modern Turkey), Elamites (from Iran) and a number of peoples from Central Asia. Mesopotamian and Indus Valley sealings in particular travelled widely around the ancient world, and as such it is not hard to imagine tales being spun about the strangely endowed animals that supposedly lived in the dimly perceived lands

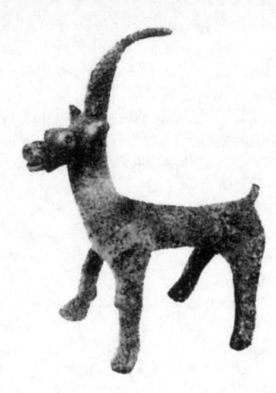

10.2 Statuette of one-horned goat, Iran, *c.* ninth century BC

from which goods and their accompanying labels were thought to have come.

Seals and sealings from ancient Pakistan and northern India are particularly interesting. Rhinoceroses feature on Indus Valley seals, but they are rare compared with another type of unicorn. The one-horned cow-like animal in Fig. 10.1c is the most common of all the stylized beasts found on seals from the Indus

Valley. In 1981 Shereen Ratnagar published the findings of her research on the Indus people and their artifacts. Of the seals and sealings available to her at the time, 92 per cent showed single animals as the dominant background motif, and of these 60 per cent were of the bovine unicorn. If frequency of representation is anything to go by, the Indus Valley people were much more interested in imaginary unicorns than they were in the real ones wandering around their environment. (Or were they imaginary? They look like Franklin Dove's unicorn.) We also know that these Indian unicorns were seen by the people of other ancient cultures, because Indus Valley seals and sealings have been found at a number of sites in the Gulf region, Iraq and Iran.[77] Ratnagar thinks that the unicorn symbol may have belonged to a dominant or ruling clan, one that perhaps expanded in influence at the expense of other clans over time, hence the eventual dominance of the unicorn symbol itself. A sealing with a unicorn on it might have proclaimed that the item to which it was attached

[77] The Indus Valley Civilization in its so-called Mature Harapan phase (2600–1900 BC) also founded settlements outside the Indus Valley and had extensive maritime links with Mesopotamia, Persia, Bahrain and the Oman Peninsula. There is also evidence that people from the Indus Valley lived in Mesopotamia and the Gulf region. Curiously, no item with Mesopotamian writing on it has ever turned up in the Indus Valley. Farmer et al. (2004) suggest that the Indian priesthood might have opposed and excluded non-indigenous writing.

belonged to, or was under the control of, a powerful elite.[78] More generally, wherever seals were used, they were probably associated with high-status individuals and institutions – or at any rate it is difficult to imagine a beggar authorizing a consignment of goods or approving a legal document. And there can be little doubt about the power symbolism, intended or imagined, of mythological animals carved into the palace walls of a Persian ruler who styled himself the King of Kings. The idea of one-horned animals, or at least of apparently one-horned animals, was around long before Ctesias' time, and in some cultures images of unicorns were important, prominently represented in everyday life, and probably bound up with notions of power. That some ambiguously horned unicorns from ancient Iran and Iraq seem to have had associations with nobility is also fuel for the imagination.

Ancient images of one-horned animals are thought-provoking, but do they really have any connection with the unicorn of our imagination? If a connection does exist it must be indirect, because

78 We might understand a lot more about these enigmatic items and the people who made them if we could decipher the letter-like symbols that abound on Indus Valley seals. Unfortunately the script has not yet been deciphered, in spite of more than a hundred published claims to the contrary. Recent research suggests that the script may not record a language at all, but rather comprises religious, political or social symbols of some kind (Farmer et al. 2004).

none of the ancient unicorns we have encountered so far bears much resemblance to the beast as we know it. But let us seed the visual milieu with some ancient thoughts that have come down to us in a different medium – words.

In Chapter 4 the unicorn of the Western lineage of *Physiologus* was found cavorting with a mysterious maiden. We noted in passing that an earthier version of what appears to be the same relationship was once popular among people of the Near East. Our best guess at an explanation of the similarities between these stories was that both were derived from a more ancient source. Find the common ancestor of these tales and we may be closer to uncovering one root of the unicorn legend.

Intriguingly the Indian saga known as *Mahabharata* contains a story that is similar to the maiden–unicorn tales of Latin and semitic texts. A genetic link between these three traditions would suggest that maiden–unicorn tales mutated and spread around the world until the lineage had a geographic range extending from India to the New World, having first taken in North Africa, where *Physiologus* was composed, and Europe, where the *Physiologus* unicorn was given form by medieval artists.

The *Mahabharata* is a long and rambling saga – about 200,000 lines, ten times the length of Homer's *Odyssey* and *Iliad* combined – which tells the story of two closely related families of princes, known as the Kauravas and the Pandavas. The corpus was probably written down in the form we have received it between 300 BC and AD 300,

though it harks back to a much earlier era. Family intrigue is the *Mahabharata*'s main theme, but the narrative makes frequent detours, introducing folk-tales, hymns of praise to Vishnu and Shiva, and discussions of wider philosophical and religious matters. One of *Mahabharata*'s folk-tales concerns a hermit called Risyasringa, also known as Gazelle Horn. He lives deep in the forest with his father, an ascetic named Vibhandaka. Risyasringa is outwardly human, but he has a special endowment, a single horn on his head. Owing to familial connections with the gods he also has the power to bring on the rains. The backdrop to Gazelle Horn's tale is a drought in the land of Anga.[79] The drought is King Lomapada's fault: he crossed a Brahmin priest and incurred the displeasure of the gods. In desperation Lomapada consults his soothsayer, who divines that the only way to save the land and its people is to capture the rain-maker Gazelle Horn. Lomapada, who as a king must have had significant resources of money and manpower, has no idea how to capture a young man living in a forest with his aged father. This incongruity tells us that we have yet to reach the important part of the story.

79 The four early civilizations of the Old World – Shang China, Mesopotamia, the Indus Valley and Egypt – were built on the floodplains of huge river systems, so droughts and catastrophic floods were among the apocalyptic fears of people living in these regions. These fears are reflected in many ancient myths. Predictable floods that brought water and fresh silt to the land each year, on the other hand, were welcomed and often venerated.

Lomapada's daughter, Nalini, has an ingenious if circuitous solution to her father's problem. She builds a floating hut out of leaves and sails down the river that runs through the forest where Gazelle Horn lives. On arriving at his home, Nalini dresses in her best clothes, lets down her hair, and generally makes herself attractive. Then she goes ashore in search of her quarry. Suddenly the pair come face to face. Gazelle Horn, who knows little of the world outside the forest, is smitten with the strange and exotic creature standing before him. The young pair spend some time together – Gazelle Horn shows Nalini his hut – after which she retires to her boat so that he can wander off and develop the plot.

That evening Gazelle Horn's father notices that his son is behaving strangely and warns him to beware of evil and corrupting influences. The next day Gazelle Horn sees Nalini and promptly forgets his father's advice. He climbs aboard the leafy boat, where Nalini beffudles his brain by plying him with wine, a potent symbol of the agricultural, civilized outside world to which Nalini is leading her forest-dwelling primal force of nature. With Gazelle Horn now fully under her spell, Nalini sails her boat out of the forest and back to the palace of the king. On the pair's arrival the rain duly begins to fall and Anga is saved. No doubt plants grow and the kingdom bursts with life again, just as one would expect of a land under the influence of a rain-maker with an obvious fertility symbol stuck on his head. Finally the loose ends of the story are tied up: Vibhandaka is brought to the palace to witness the

marriage of his son to Nalini. The betrothed go on to have lots of children, which may have been unicorns like their father, though the version of *Mahabharata* that we have received leaves this to the imagination.

While we should be suspicious of any connection between the modern unicorn and the contents of ancient folk-tales – thousands of such stories have survived so the occasional chance similarity is to be expected – only a grave sceptic would dismiss the multiple parallels between the tale of the virgin and the unicorn and that of Nalini and Gazelle Horn. In both we have an innocent one-horned creature – a force of nature, living at one with nature – who cannot be captured by conventional means. The only way to ensnare him is with the aid of a human female. The girl and the unicorn meet in the woods, she intoxicates him in one or more ways, captures his heart and loyalty, leads him to the palace of the king, and harnesses his supernatural powers for the salvation of the people. We do not know whether the story of Gazelle Horn influenced Christian allegorizers, but it is difficult to avoid the suspicion that it or one of its relatives did. We do know that many pagan ideas were either absorbed by Christianity or actively turned to its purposes as the religion developed in the centuries following Christ's death, the premier illustration of which is the mish-mash of pagan natural history stories overlain with Christian interpretation known as *Physiologus*. We thus have some grounds for inferring a genetic linkage, though not necessarily a direct one, between Gazelle Horn and the unicorn, the *Mahabharata* and

Physiologus, and thereby the fertility myths of Hinduism and the allegorical excrescences of Christianity. When we recall that Ctesias of Cnidus based his account of the one-horned ass on folk-tales from northern India and Himalaya, the suspicion grows ever stronger that mythologies from the East had a profound influence on the Western legend of the unicorn.

Gazelle Horn is a likely ancestor of the *Physiologus* unicorn, but he is not the only candidate. Here is what appears to be another version of the tale:

> [N]oble Enkidu was created . . . His body was rough, he had long hair like a woman's . . . His body was covered with matted hair . . . He was innocent of mankind; he knew nothing of the cultivated land.
>
> Enkidu ate grass in the hills with the gazelle and lurked with wild beasts at the water holes; he had joy of the water with the herds of wild game. But there was a trapper who met him one day face to face at the drinking hole. . . . On three days he met with [Enkidu] face to face, and the trapper was frozen with fear . . . With awe in his heart [the trapper] spoke to his father: 'father, there is a man, unlike any other, who comes down from the hills. He is the strongest in the world, he is like an immortal from heaven. He ranges over the hills with wild beasts and eats grass . . . I am afraid and dare not go near him. He fills in the pits which I dig and tears up my traps set for the game;

helps the beasts the beasts to escape and now they slip through my fingers.

His father opened his mouth and said to the trapper, 'My son, in Uruk lives Gilgamesh; no one has ever prevailed against him, he is strong as a star from heaven. Go to Uruk, find Gilgamesh, extol the strength of this wild man. Ask him to give you a harlot, a wanton from the temple of love; return with her, and let the woman's power overpower this man. When next he comes down to drink at the wells she will be there, stripped naked; and when he sees her beckoning he will embrace her, and then the wild beasts will reject him.'

[The trapper duly goes to Uruk and speaks to Gilgamesh, who offers precisely the same advice as the trapper's father gave.]

Now the trapper returned, taking the harlot with him. After a three days' journey they came to the drinking hole, and there they sat down; the harlot and the trapper sat facing one another and waited for the game to come . . . [O]n the third day the herds came; they came down to drink and Enkidu was with them . . . The trapper spoke to [the harlot]: 'There he is. Now, woman, make your breasts bare, have no shame, do not delay but welcome his love. Let him see you naked, let him possess your body. When he comes near uncover yourself and lie with him; teach him, the savage man, your woman's art, for when he murmurs love to you the wild beasts that shared his life in the hills will reject him.'

She was not ashamed to take him, she made herself naked and welcomed his eagerness; as he lay on her murmuring love she taught him the woman's art. For six days and seven nights they lay together, for Enkidu had forgotten his home in the hills; but when he was satisfied he went back to the wild beasts. Then, when the gazelle saw him, they bolted away; when the wild creatures saw him they fled. Enkidu would have followed . . . [but he] was grown weak, for wisdom was in him, and the thoughts of a man were in his heart. So he returned and sat down at the woman's feet, and listened intently to what she said. 'You are wise Enkidu, and now you have become like a God . . . Come with me. I will take you to strong-walled Uruk . . .: there Gilgamesh lives, who is very strong, and like a wild bull he lords it over men.[80]

Though not as rambling as *Mahabharata,* the Gilgamesh saga from which this extract is taken is a highly complex work.[81] To cut a long epic short, the once wild Enkidu duly meets Gilgamesh, and, after

80 Sandars (2006).

81 The most complete text is from the library of the Assyrian king Ashurbanipal at Nineveh (northern Mesopotamia on the Tigris River), which means it can be no older than the seventh century BC. The central motifs of the tale, however, are thought to have been based on myths that were current among the much earlier Sumerians of southern Mesopotamia (where the Tigris and Euphrates rivers flow into the Persian Gulf). The Sumerian city of Uruk mentioned in the epic is where the earliest writing on clay tablets has been

a few initial difficulties, the two become firm friends. They embark on adventures of the sort that ancient mythological heroes always seem to have: journeys to heuristic places, visits to the underworld, fights with monsters and gods, triumphant returns to civilization and fruitless searches for everlasting life.

The story of Enkidu's capture is obviously similar to the tales of the unicorn and the maiden and of Gazelle Horn and Nalini, and is perhaps closest of all to the Near Eastern story of the seductress and the dajja. It is disappointing to find that Enkidu does not have a horn on his head, or even two, but given the many similarities between Enkidu's experiences and those of the other unicorns we have encountered perhaps we should pause to think whether chasing down the unicorn by its one horn and four legs is sensible. In the tales of Enkidu and Gazelle Horn we have the myth of the wild spirit who lives in harmony with nature, cares in some way for the animals around him and is lured into the world of human affairs by

unearthed, dated to *c.* 3400 BC. The script on these tablets is fully developed, so the writing system must have been invented somewhat and perhaps much earlier. For comparison, Egyptian hieroglyphics emerge at the end of the fourth millennium, Chinese pictographs in the middle of the second, Greek at the beginning of the first, and Latin around 800 BC. Fragments of the *Epic of Gilgamesh* have been found written in other languages, and by the middle of the second millennium Babylonian had become the diplomatic language of Egypt and the whole of southwest Asia, including what was to become the Holy Land. Babylonian texts excavated in Upper Egypt suggest that Mesopotamian literature travelled widely around the ancient world at this time.

a woman. This motif turns up in many forms in the myths of Asia, and one well researched theory holds that it originated in legends about the orang-utan.[82] It is difficult to imagine a creature less like the unicorn than the old man of the forest, though notions of gentleness, wildness, strength, solitude and a certain aura of nobility could no doubt be pinned on the orang if one tried. That is the problem with chasing the unicorn. While it would be nice to imagine some original, single source as we travel backwards in time, in reality the beast dissolves into the globe-encircling milieu of human imaginings, and as it does so it becomes increasingly difficult to distinguish other people's imaginings from one's own. These are perhaps disappointing realizations, but at least we have had the pleasure of following the unicorn and the maiden far enough into the past to witness their returning to the only place from which they could have come.

We have been tracking the iconic unicorn of the Western lineage of *Physiologus*. There is a parallel motif in the Eastern lineage that developed free from the influence of maidens, forest glades and kings' palaces. The most familiar setting comes from the Greek *Physiologus*:

An animal exists which is called Monoceros. In the regions where he lives there is a great lake, and there the animals gather to drink. But before they arive the serpent goes and spews his

82 See Williams (1925–6) and Jacobsen (1976).

poison into the water. Now when the animals notice the poison they dare not drink but wait for the Monoceros. It comes and straightaway goes into the water, makes the sign of the cross with its horn and thus annuls the power of the poison. And when it starts to drink the water all the animals do likewise.[83]

Inevitably this tale became mixed up with the unicorn's alexipharmic reputation and in turn with legends about the rhinoceros, but the kernel of the idea may have originated in one or another of the religious traditions of the ancient Near East.

Enkidu's near namesake Enki[84] was a god of the crowded

83 From a fourteenth-century Greek *Physiologus* (Gotfredsen 1999). The motif is absent from Western versions of *Physiologus* and later bestiaries, which is why we did not pursue the matter in Chapter 4. Though largely forgotten in medieval times, the water-purifying unicorn was given a limited lease of life when Greek studies became popular as part of the developing humanistic outlook of Italian culture in the fifteenth century. Knowledge of Greek was largely the preserve of intellectuals at this time, which explains why the motif rarely appears in art of the fifteenth and sixteenth centuries. The absence of the sanitizing unicorn from the Western lineage of *Physiologus* is puzzling, because one would have thought that an animal renowned as a leader, protector and purifier would have done a much better job of reflecting the life of Jesus than did the *Physiologus* unicorn that fell under the spell of a woman. Either the Eastern tale was one of the few that did not make it to Alexandria, or Christian allegorizers knew about the story but for some reason preferred that of the unicorn and the maiden.

84 Enki is known as Ea in the later Akkadian language of ancient Mesopotamia.

Mesopotamian pantheon. His name, En-ki, means Lord-Earth or Lord of the Earth, though in light of the precarious agricultural context from which Mesopotamian civilization emerged a more appropriate reading is Productive Manager of the Soil. Like other Mesopotamian gods, Enki was distinguished from non-divine characters in artwork by his hat of horns, a stylistic convention that became popular in the early third millennium BC. Enki did not have a horn on his forehead, but he was associated with animals that appear to be one-horned owing to their representation in profile in Mesopotamian art. Combine these animalistic associations with some key aspects of Enki's divine character and one begins to wonder whether another Mesopotamian character besides Enkidu lurked in the milieu from which the Christian unicorn emerged.

Enki was the cleverest and craftiest of the gods, the son of the highest god (An or Anu) and the god of fresh water. Enki controlled springs, rivers, lakes, mists and marshes, as well as the vast reservoir of sweet water that was thought to exist, metaphorically and literally, underground. Enki gained control of these aquifers via a complicated historical relationship with a primal entity known as Abzu. Abzu was also the name given to the underground water itself, and to the tanks of holy water situated in the courtyards of Mesopotamian temples. Almost anything to do with sweet water could be, and usually was, connected with Enki, even the breaking waters that heralded the birth of humans and other mammals. Since water is intimately

235

associated with growth and fecundity (water irrigates the soil, makes plants grow, brings fresh silt down from the mountains, breaks droughts), and since water and semen were considered to be the same thing in ancient Mesopotamia (a single word sufficed for both), Enki was associated with fertility. Most important, Enki's power over water gave him the power to cleanse. In the words of Thorkild Jacobsen, one of the finest Mesopotamian literary scholars of the twentieth century, Enki was 'the god of ritual lustration and purification from polluting evil'.

Gods of purification who rid the world of evil were not uncommon in the ancient world, nor are they today, so we should not read too much into parallels between Enki's and the unicorn's powers of lustration. But add to the mix the creatures with which Enki was associated and connections with the unicorn of the Greek *Physiologus* begin to tempt. Fig. 10.3 shows one of these beasts. Here we see Enki, the fish-filled Tigris and Euphrates rivers emerging from his shoulders, with his foot resting on an apparently one-horned ibex. Jacobsen and others have interpreted this animal as emblematic of the subterranean abzu, the underground waters that Enki controlled. These characters come together in the name of the boat in which Enki cruised around the Mesopotamian imagination, the Ibex of the Abzu. Intriguingly, another of Enki's animalistic referents is the goat-fish – half goat at the front, half fish at the back – which is invariably shown as unicorned in two-dimensional representations. Images and figurines of this creature were widely used in ancient

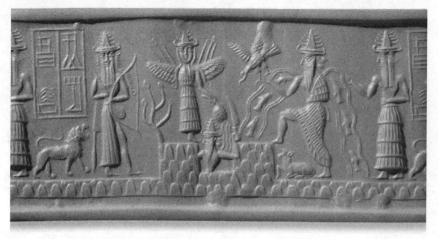

10.3 The Mesopotamian god Enki

Mesopotamia to ward off evil.[85] Enki, then, is a deity, the son of the Great Deity, associated with water and purification, and symbolically attached to a pair of apparently one-horned goats. Just for good measure, though the parallel is not to be taken too seriously, the fish and the goat-like one-horned quadruped – both ends of the goat-fish – were destined to become symbols of Christ.[86]

None of which is to suggest that the Christian unicorn is linearly

85 The last of Enki's animals is the turtle, an obvious reflection of his watery responsibilities.

86 As a symbol of Christ, the fish is older than the unicorn and even the cross. One theory holds that the fish symbol was used because fish in Greek is *icthus*, which can be read as an acronym of *Iesous Christos Theou Huios Soter* (Jesus Christ, Son of God, Saviour). Fish were later employed as symbols of the Trinity (three fish) and the Eucharist (typically a fish and a chalice).

descended from Enki, any more than previous speculations were to suggest that it is linearly descended from Enkidu, Gazelle Horn, the orang-utan, or the walls of Persepolis. What is suggested is that Alexandria, the story capital of the ancient world in the centuries after Christ's death, must have been a very stimulating place, particularly for a group of people who had taken it upon themselves to divine the Christian meaning in stones, stars, blades of grass and every single word of a collection of Israelite legends composed centuries before Christ's birth. Quite what early Christians made of garbled stories handed down from the time of the Hebrews' exile in Mesopotamia blended with the accumulated wisdom of the Alexandrian libraries and the multicultural chatter of the marketplace is anyone's guess. That the same folk who were responsible for the Christian Bible were also capable of *Physiologus* illustrates the range of possibilities.

Enki and his animals may be connected with the unicorn of the Greek *Physiologus*, but the civilization that consigned ancient Mesopotamia to the realm of archaeology hosts perhaps an even closer relative. Around 600 BC, Zarathustra (called Zoroaster by the Greeks) enters history. He was a priest-prophet thought to have been active among the semi-nomadic peoples of Bactria in eastern Iran. Rebelling against the existing pantheon of Iranian gods, Zarathustra taught that there was only one god, Ahura Mazda, the Wise Lord. Ahura Mazda was connected to another entity known as the Holy Ghost or Son, whose brief seems to have been to maintain the right

order in heaven and on earth and to officiate at the last judgement, when the dead would enter heaven or descend into hell – it is difficult to avoid the conclusion that Zarathustra's ideas were familiar to people who lived far to the west of Bactria. Zarathustra's doctrines, usually referred to as Zoroastrianism, became the state religion of Persia at the time that Cyrus the Great and his successors were attempting to take over the world, which is to say that Zoroastrian ideas spread rapidly across the lands that coalesced into the vast Persian empire of the sixth to the fourth centuries BC.

At Zoroastrianism's heart lies a conception of the universe divided into good and evil. Figurehead of light and good was Ahura Mazda, while heading up the forces of darkness and evil was Ahriman, the equivalent of the Christian devil. The intense dualism of Zoroastrianism fostered a division of the world's inhabitants into servants of good and evil, the pure and the impure, whose natural duties were to advance the symbolic cause of their own kind while hindering that of the opposition. Animals tended to fall into one or the other camp on the basis of their usefulness or threat to people, so the horse and the bull belonged to Ahura Mazda's army, whereas the lion and the snake belonged to Ahriman's. Mythical creatures were dichotomized in the same way: the martichore was bad and the unicorn good.

In the collection of sacred Persian writings known as the *Avesta*, in which ancient mythological ideas and those of Zarathustra come together, the unicorn is praised as a force of nature: 'We worship the

Good Mind and the spirits of the Saints and that sacred beast the Unicorn which stands in Vouru-Kasha, and we sacrifice to that sea of Vouru-Kasha where he stands.' The text goes on to say that rain falling on the remains of Ahriman's creatures becomes polluted. This tainted water eventually reaches the unicorn standing in the sea, however, who renders it pure again. Had the unicorn not always performed this cleansing task the sea would have perished long ago, destroyed by its accumulated load of polluting evil:

It is said of the three-legged ass that it stands in the middle of the wild sea, and it has three feet, six eyes, nine mouths, two ears and one horn. Its body is white, it eats spiritual food and is virtuous. And two of its six eyes are in the eyes' place, two on the top of its head and two on its rear; with these six sharp eyes it sees all who do evil and destroy.

Of the nine mouths, three are in the head, three on the back and three on the inner side of the flanks, and each mouth is the size of a house. The animal itself is as big as the mountain called Alvand. Each of its three feet take up as much ground as a herd of a thousand sheep when they are gathered together, and each rear part is of such extent that a thousand men with a thousand horses can be placed within it . . . The single horn is of gold and hollow, and a thousand branches grow out of it . . . With that horn it can strike and shatter all corruption that comes from harmful animals.

When that ass submerges its neck in the ocean its ears will terrify, and all the water in the wild sea will tremble with agitation . . . When it utters a roar, all the she creatures of the sea and Ahura Mazda's animals will teem with young, and all the venomous water creatures will drop their young at that scream. When it makes water in the sea all the water in the seven regions of the earth will be cleansed . . . And the words say: If thou, O three legged ass, had not been created for the water, all the water in the sea would be corrupted by the infection which the Evil Spirit brought down into its waters on the death of Ahura Mazda's creatures.[87]

The religious tradition of ancient Iran, then, sported one supreme god, a counterpoint devil, a holy ghost, a divine son, a heaven, a hell, a last judgement, and a righteous, powerful unicorned ass that purified the waters. Meanwhile ancient Iraq boasted a purifying water-god linked to a pair of apparently one-horned goats and an animalistic force of nature tamed and delivered to the human world by a captivating female – the same fate that befell his similarly gullible Indian cousin, who was a unicorn.

The interconnected traditions of ancient Iraq, Iran, India and Greece hint heavily at the origin of the Judaeo-Christian unicorn. The Abrahamic religions incorporated into their holy texts and

87 Gotfredsen (1999).

associated legendary material many of the themes of neighbouring Old World mythologies, including and especially those of ancient Mesopotamia, Persia and India. Meanwhile, Ctesias of Cnidus wrote an account of a one-horned ass based on tales that originated in Himalaya. A few decades later Aristotle endorsed Ctesias' tale, adding his conviction that the oryx, too, has only one horn. At about the same time people from all over the world headed for the cultural and literary nexus of Alexandria, established in 332 BC by Alexander the Great, who had just imposed Greek tradition on much of the Old World by force of arms. Bilingual Jews in Alexandria translated Hebrew scripture into Greek, in the process replacing the two-horned reem with the one-horned ass, or perhaps the oryx. A few centuries later Alexandria became a gathering-place for early Christians, who set about interpreting everything that was and would ever be within a Christian framework of ideas, the beliefs of Hebrews, Mesopotamians, Persians, Indians and pagan Greeks included or notwithstanding. In the Christian imaginative endeavour lurked at least half a dozen one-horned motifs, linked by earlier and contemporary peoples with ideas of strength, speed, intractability, nobility, cosmic power, the forces of nature, gullible tendencies, ritual purification and the triumph of good over evil. From this melting-pot of past imaginings and creative interpretation emerged a corpus of texts – the Bible, *Physiologus*, the writings of the Christian fathers – that between them contained the unicorn in outline, an animal with four legs, a single horn, a weakness for women, and an intimate con-

nection with Christianity's central character. Replace the generic horn of the early unicorn with a narwhal's tusk, add a dash of equine Greek tradition preserved in medieval heraldry, mix in some Islamic alexipharmacy, and the unicorn that most of us carry around in our heads is resolved. If your unicorn tends towards a meek and diminutive goat, Christianity is probably strong with you. If your unicorn is large and horselike, heraldry and its secular offshoots are probably to blame. If your unicorn hovers uncomfortably between a goat and a horse, you may at least take comfort from being in the majority. If your unicorn shifts disconcertingly between a goat, a horse, a rhinoceros, a marine mammal from the North Atlantic, assorted Tibetan ungulates and a six-eyed ass whose ears will terrify, the work of this book is almost done.

By jumping from one historical stepping stone to another we have followed the unicorn's progress, but we cannot hope to discover its origin. Scholars have stumbled upon some of the unicorn's likely ancestors, but others disappear into the mind's eye. A caveman finding a horn on the ground may well have drawn a unicorn conclusion. He may not have stopped there. Perhaps the one-horned creatures drawn on the walls of African caves, images that swayed no less a man than Sir John Barrow to belief in unicorns,[88] were meant to look that way. We shall never know. Wherever the unicorn came from, it

88 Barrow (1808).

blossomed with the aid of real animals: a narwhal's tusk, a goat's foot, a horse's body, a kiang's personality, an ape's runaway brain. The unicorn binds other threads of the earth's natural history to our own. If the beast is to stand for anything in the modern world, it could do worse than stand for that.

BIBLIOGRAPHY

Aelian. *On Animals* (ed. A. L. Scholfield). Loeb Classical Library (London, 1971).

Aristotle. *History of Animals* (trans. A. L. Peck). Loeb Classical Library (Cambridge, MA, 1965).

Barrow, Sir John. *Travels in South Africa* (London, 1808).

Berridge, W. S. *Marvels of the Animal World* (London, 1921).

Bochart, S. *Hierozoicon* (London, 1663).

Cuvier, G. *Discourse on the Revolutionary Upheavals on the Surface of the Globe* (Paris, 1825).

Dankoff, R. 'A note on khutu and chatuq', *Journal of the American Oriental Society* 93 (1973), 542–3.

Digby, B. *The Mammoth and Mammoth Hunting in North-East Siberia* (London, 1926).

Dines, J. M. *The Septuagint* (London, 2004).

Dove, W. F. 'Artificial production of the fabulous unicorn', *Science Monthly* 42 (1936), 431–6.

Duff, A. and Lawson, A. *Mammals of the World: A Checklist* (London, 2004).

Ettinghausen, R. *The Unicorn*. Freer Gallery of Art Occasional Papers 1 (Baltimore, 1950).

Farmer, S., Sproat, R. and Witzel, M. 'The collapse of the Indus-script thesis: the myth of a literate Harappan civilisation', *Electronic Journal of Vedic Studies* 11-2 (2004), 19–57.

Freeman, M. B. *The Unicorn Tapestries* (New York, 1976).

French, R. *Ancient Natural History* (London, 1994).

Galton, F. *The Narrative of an Explorer in Tropical South Africa* (London, 1853).

Godbey, A. 'The unicorn in the Old Testament', *The American Journal of Semitic Languages and Literatures* 56 (1939), 256–96.

Gosse, P. H. *The Romance of Natural History* (London, 1861).

Gotfredsen, L. *The Unicorn* (London, 1999).

Heffernan, M. J. 'A state scholarship: the political geography of French international science during the nineteenth century', *Transactions of the Institute of British Geographers* 19 (1994), 21–45.

Herodotus, *The Histories* (ed. A. D. Godley). Loeb Classical Library (London, 1922).

Howorth, H. H. *The Mammoth and the Flood* (London, 1887).

Huc, E. and Gabet, J. *Travels in Tartary, Thibet and China 1844–6* (London, 1928).

Jacobsen, T. *The Treasures of Darkness* (New Haven, 1976).

Johnston, A. *The Life and Letters of Sir Harry Johnston* (London, 1929).

Johnston, H. H. *The Story of My Life* (London, 1923).

Katte, A. von. *Reisen in Nubien, Kordofan, etc.* (Frankfurt, 1829).

Landon, P. *The Opening of Tibet* (London, 1906).

Lane Fox, R. *The Unauthorized Version: Truth and Fiction in the Bible* (London, 1991).

Lankester, E. R. 'On *Okapia*, a new Genus of Giraffidae, from Central Africa', *Transactions of the Zoological Society of London* 16 (1902), 279–307.

Latter, Major. Letter reproduced in *Quarterly Journal* 24 (1820), 120–21.

Laufer, B. 'Arabic and Chinese trade in walrus and narwhal ivory', *T'oung pao* 14 (1913), 315–70.

— 'Supplementary notes on walrus and narwhal ivory', *T'oung pao* 17 (1916), 348–89.

Lavers, C. 'The ancients' one-horned ass: accuracy and consistency', *Greek, Roman and Byzantine Studies* 40 (1999), 327–52.

Lavers, C. and Knapp, M. 'On the origin of khutu', *Archives of Natural History* 35(2) (2008).

Mellersh, H. E. L. *Minoan Crete* (London, 1967).

Miller, G. 'The unicorn in medical history', *Transactions and Studies of the College of Physicians of Philadelphia* 28 (1960), 80–93.

Mohacsy, I. 'The Medieval unicorn: historical and iconographic applications of psychoanalysis', *Journal of the American Academy of Psychoanalysts* 16 (1988), 83–106.

Nowak, R. M. (ed.) *Walker's Mammals of the World* (Baltimore, 1999).

Pietersma, A. 'Messianism and the Greek psalter: in search of the Messiah', in Knibb, M. A. (ed.) *The Septuagint and Messianism*, pp. 49–75 (Leuven, 2005).

Pliny. *Naturalis Historia* (ed. H. Rackham). Loeb Classical Library (London, 1936–62).

Przhevalsky, N. *Mongolia, the Tangut Country and the Solitudes of Northern Tibet* (London, 1876).

Purchas, S. *Purchas his Pilgrimes* (London, 1625).

Ratnagar, S. *Encounters: The Westerly Trade of the Harappa Civilization* (Delhi, 1981).

Rawling, C. *The Great Plateau* (London, 1905).

Said, H. M. *The Book Most Comprehensive in Knowledge on Precious Stones* (Islamabad, 1989).

Sandars, N. K. (trans.) *The Epic of Gilgamesh* (London, 2006).

Schaller, G. *Wildlife of the Tibetan Steppe* (Chicago, 1998).

Schaper, J. L. W. 'The unicorn in the messianic imagery of the Greek Bible', *Journal of Theological Studies*, NS, 45 (1994), 117–36.

Shepard, O. *The Lore of the Unicorn* (London, 1930).

Sprague de Camp, L. 'Xerxes' okapi and Greek geography', *Isis* 54 (1963), 123–5.

Stanley, H. M. *In Darkest Africa* (London, 1890).

Topsell, E. *History of Four-footed Beasts* (London, 1607).

Turner, S. *An Account of an Embassy to the Court of the Teshoo Lama in Tibet* (London, 1800).

Walton, J. H. Appendix to Landon, P. *The Opening of Tibet* (London, 1906).

White, T. H. *The Book of Beasts* (London, 1954).

Williams, C. A. 'Oriental Affinities of the Legend of the Hairy Anchorite', *University of Illinois Studies in Language and Literature* 10(2) (1925) and 11(4) (1926).

Wood, J. G. *The Natural History of Man* (London, 1868).

Wurmb, F. von. *Briefe des Herrn von Wurmb und des Herrn Baron von Wollzogen* (Gotha, 1794).

ILLUSTRATION CREDITS

The following images have been reproduced by permission. All other images are in the public domain or are photographs given to the author.

Chapter 1
1.2 Chiru © GB Schaller.
1.3 Kiang © GB Schaller.
1.4 Yak © GB Schaller.

Chapter 2
2.1 Arabian oryx © Getty Images.

Chapter 4
4.1 Illuminations from the Theodore Psalter, 1066. British Museum, London, Ms. Add. 19352 fol 124.
4.2 Scene from the Ashmole Bestiary, *c.* 1210. MS Ashmole 1511, fol.14v. Bodleian Library, University of Oxford.
4.3 'Holy Hunt' tapestry, lower Rhineland, *c.* 1500. © Bayerisches Nationalmuseum.
4.4 Scene from the Verteuil Tapestries, *c.* 1500. The Metropolitan Museum of Art, Gift of John D. Rockefeller Jr., 1937 (37.80.4). Image © The Metropolitan Museum of Art.
4.5 Scene from the Verteuil Tapestries, *c.* 1500. The Metropolitan Museum of Art, Gift of John D. Rockefeller Jr., 1938 (38.51.1, .2). Image © The Metropolitan Museum of Art.

4.6 Scene from the Verteuil Tapestries, *c.* 1500. The Metropolitan Museum of Art, Gift of John D. Rockefeller Jr., 1937 (37.80.5). Image © The Metropolitan Museum of Art.

4.7 Scene from the Verteuil Tapestries, *c.* 1500. The Metropolitan Museum of Art, Gift of John D. Rockefeller Jr., 1937 (37.80.6). Image © The Metropolitan Museum of Art.

Chapter 5

5.1 Two narwhal © Richard Ellis.

Chapter 6

6.1 Walrus © Len Rue.

6.5 Musk ox. Reproduced by permission of the US Fish and Wildlife Service.

6.6 Silver plaque, Noin Ula Mountains, Mongolia, *c.* first century BC. The State Hermitage Museum, St Petersburg.

6.7 Takin © Shutterstock Image Library.

Chapter 8

8.1 Okapi © Shutterstock Image Library.

Chapter 10

10.1a The Unicorn of Persepolis © The Trustees of The British Museum.

10.1b Dragon of Marduk, on the Ishtar Gate, Neo-Babylonian, 604–56, reproduced by permission of the Bridgeman Photo Library.

10.1c Harappan Seal © J.M. Kenoyer, Courtesy Dept. of Archaeology and Museums, Govt. of Pakistan.

10.3 The Mesopotamian god Enki. © The Trustees of The British Museum.

INDEX

INDEX